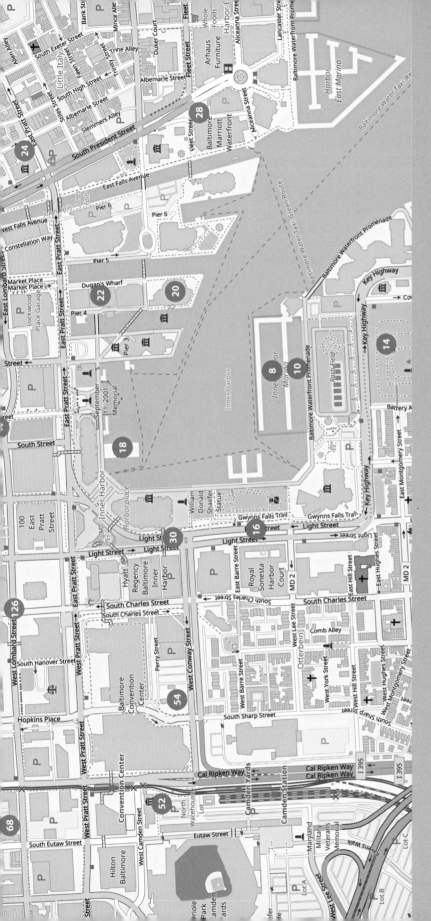

BALTIMORE THEN AND NOW

You can find most of the sites featured in the book on this outline map*

D1223377

Numbers in red circles refer to the pages where sites appear in the book.

* The map is intended to give readers a broad view of where the sites are located. Please consult a tourist map for greater detail.

BALTIMORE

THEN AND NOW®

Pavilion
An imprint of *HarperCollinsPublishers* Ltd
1 London Bridge Street
London SE1 9GF

www.harpercollins.co.uk

HarperCollinsPublishers
1st Floor, Watermarque Building
Ringsend Road Dublin 4
Ireland

10 9 8 7 6 5 4 3 2
Reprinted in 2022

This book is a revision of Baltimore *Then and Now* produced in 2001 by
Salamander Books, a division of Pavilion Books Group.
This edition first published in Great Britain by Pavilion,
an imprint of *HarperCollinsPublishers* Ltd
Copyright ©2016

Alexander D. Mitchell IV asserts the moral right to be identified as the author of this work.
A catalogue record for this book is available from the British Library.

ISBN 978-1-910904-93-0

This book is produced from independently certified FSC™ paper
to ensure responsible forest management.
For more information visit:
www.harpercollins.co.uk/green

Printed and bound in China by RR Donnelley APS

ACKNOWLEDGMENTS

An enormous debt is owed by the author and fellow historians to the earlier generations that
took the vintage photographs and preserved them for future generations, be they commercial
photographers doing a paying job or amateurs answering to their own whims. Thanks are also
due to the archives and historians that preserved and made available the photographs in this
book, in particular the Maryland Historical Society and the Maryland Rail Heritage Library at
the Baltimore Streetcar Museum and to amateur transit historian Edward S. Miller. Thanks are
also due to the many landlords, tenants, superintendents, and employees who cooperated with
the author in permitting access to office windows, hotel rooms, rooftops, balconies, and other
locations generally off-limits to the public, all in the interests of allowing another moment of
history and piece of Baltimore's charm to be preserved.

PICTURE CREDITS

The publisher wishes to thank Karl Mondon for taking all of the "now" photography in this book,
with the exception of: Alexander D. Mitchell IV for pages 15, 121 left, 141, 143 bottom; David Watts
for page 13; Carol M. Highsmith/Library of Congress for page 77 left.

All of the "then" photography was kindly supplied by the Maryland Historical Society, Baltimore,
Maryland, with the exception of: the Maryland Rail Heritage Library at the Baltimore Streetcar
Museum for pages 20, 28, 48, 64, and 116; Edward S. Miller for pages 78, 84, 136, 138; Library of
Congress for pages 24, 34, 44, 56, 76 right, 82, 132; Baltimore Sun for page 94.

Additional text by Salamander Books on pages 24–25, 44–45, 94–95, and 132–133.

Pavilion Books is committed to respecting the intellectual property rights of others. We
have therefore taken all reasonable efforts to ensure that the reproduction of all content
on these pages is done with the full consent of copyright owners. If you are aware of any
unintentional omissions, please contact the company directly so that any necessary corrections
may be made for future editions.

BALTIMORE

THEN AND NOW®

ALEXANDER D. MITCHELL IV

PAVILION

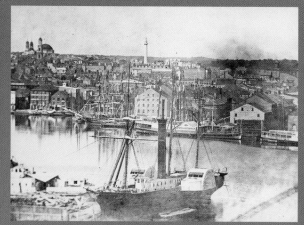

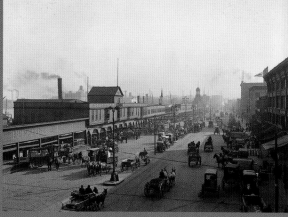

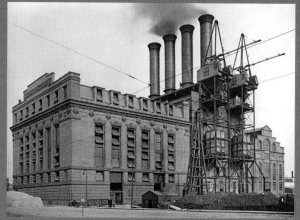

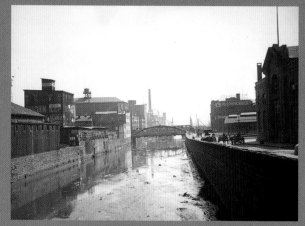

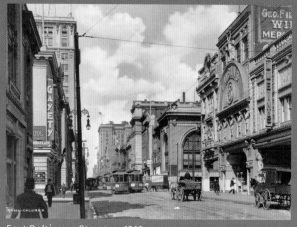

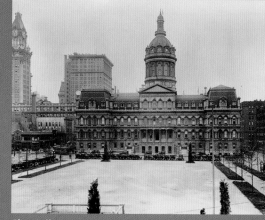

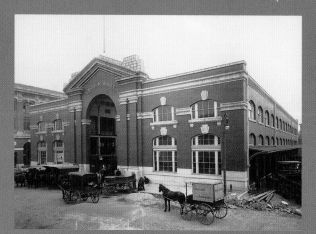

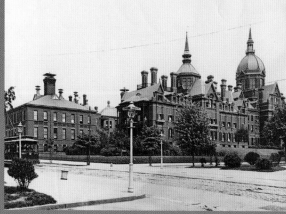

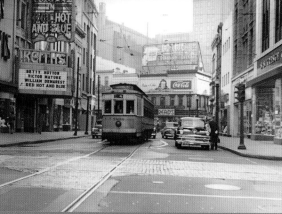

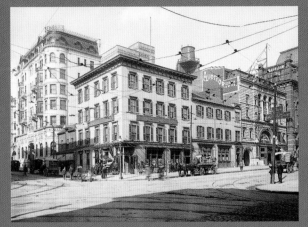

Howard and Franklin Streets, 1914 p. 88

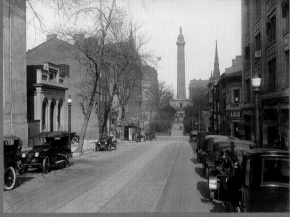

Washington Monument, 1915 p. 102

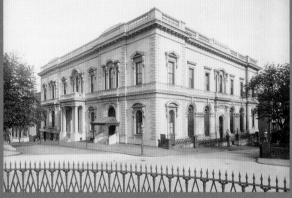

Peabody Institute, 1926 p. 106

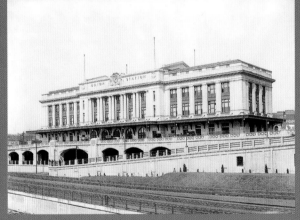

Union Station, c. 1915 p. 110

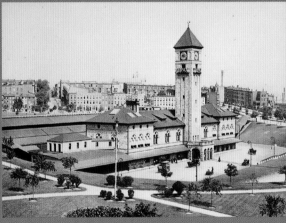

Mount Royal B&O Station, c. 1910 p. 114

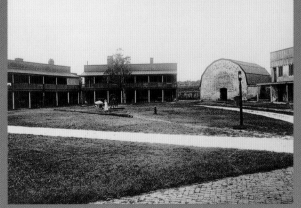

Memorial Stadium, 2000 p. 132

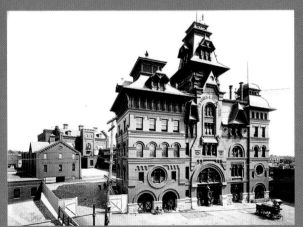

Wiessner Brewery, c. 1890 p. 134

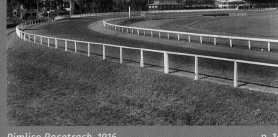

Pimlico Racetrack, 1916 p. 140

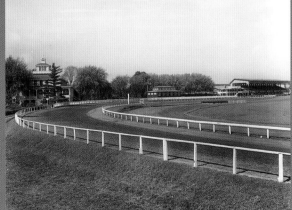

Fort McHenry, c. 1890 p. 142

BALTIMORE

THEN AND NOW INTRODUCTION

The city of Baltimore, Maryland, has many nicknames, old and new. The local dialect terms it "Bawlamer" or even "Balmer." The construction of fast sailing ships in its shipyards in the nineteenth century earned the city the name "Clipper City." Tourists and gourmets have long termed the city "Crabtown" after the Chesapeake Bay's famous edible crustaceans. Those born or raised in Baltimore, however, hold a different nickname for their town: "Charm City."

The area now known as Baltimore was first settled by Susquehannock Indians, then by English explorers around 1661, formally incorporated as a town by English and German colonists in 1729, and incorporated as a city in 1797. It was named for the Irish barony of Baltimore, the seat of the Calvert family who were the proprietors of the Colony of Maryland, which was founded in 1634 as a colony tolerant of the practices of both Catholicism and Protestantism.

Baltimore owes much of its history to geography. Its location at the mouth of the Patapsco River and its estuary, fifteen miles from the head of the much larger estuary of the Chesapeake Bay, assured its role in transportation and commerce in the days of sailing ships. It is a role that Baltimore continues to serve today as a major port and transportation center, now heavily involved in the international container and automobile shipping trades. Originally developed as a tobacco exporting port and later as a flour exporting port, the city's role in commerce would change over the years. The nation's first intercity railroad, the Baltimore & Ohio Railroad, was begun in 1827 with local investment, and the industry in general would

impact American commerce and development for the next century and a half. Flour milling, oystering, ship-building, steelmaking, fishing, sugar processing, coal exporting, and auto manufacturing have all also been prominent in Baltimore commerce over the decades. The Industrial Revolution of the nineteenth century and the two World Wars in the twentieth century also had major roles in the local economy, spurring the construction of thousands of ships and the building of nearby weapons, aircraft, and munitions plants. Serving these industries was a steel plant in nearby Sparrows Point, founded in 1897, which would blossom into a massive steel production facility over the decades.

From December 1776 to March 1777, during the British occupation of Philadelphia, the Continental Congress held court in Baltimore, making the city temporarily the functional capital of the fledgling nation. During the War of 1812 with the British, Baltimore would be one of the few cities directly attacked (unsuccessfully, in this case) by the British. And although today the city's military importance pales, its place in American history would be forever enshrined by "The Star-Spangled Banner," the poem about the bombardment of Fort McHenry that would become the American national anthem over a century later.

Baltimore, like virtually every other American city in the latter half of the twentieth century, would also undergo dramatic changes and a decline in population (by almost one-third in the past century) brought about by changing demographics and the "suburbanization" of America. The

slow and steady national changeover from a manufacturing-based economy to a service economy was helpful to the region of central Maryland surrounding Baltimore, but, save for the tourist development of the Inner Harbor (begun in the 1970s) and sports stadiums (built in the 1990s), rough on a historic city that yielded only slowly to change. "Urban renewal," like elsewhere, did little to halt the exodus and decay, but in recent years many neighborhoods have seen a revival as younger people discover the charms of moderately affordable housing in quaint, waterfront areas, or industrial buildings redeveloped into condominiums. Antique shops, sushi bars, and coffee shops now occupy buildings that a century or two earlier housed furniture warehouses, fishmongers, and coffee importers.

And yes, Baltimore still has its charms. Inspired in part by city government efforts to instill community pride, Baltimore often resembles less a city than a conglomeration of neighborhoods. People don't say they're from "Bawlamer" unless they've been traveling; they're from Hampden, Loch Raven, Edmonson Village, Pigtown, Guilford, or Canton. Sometimes merely crossing a street will change the environment or locale dramatically. A rich variety of local ethnic populations still hold sway in the city, evidenced by neighborhoods such as Little Italy and Greektown, and annual ethnic festivals (Irish, Lithuanian, Polish, and African-American, to name but a few). And certain charms manifest themselves no matter which neighborhood one walks in—the sprawling city parks, marble rowhouse steps kept well polished by proud owners, wide tree-lined boulevards, the unique art of landscape-painted window

screens, authentic sailing fishing vessels and red tugboats docked beside cruise ships and private pleasure craft, horse-drawn "arabber" produce peddler carts, or even a formal sit-down banquet punctuated by the sound of wooden mallets breaking apart freshly-steamed crabs.

A book such as this is all about the fact that, to quote Jonathan Swift, "The only constant is inconstancy." Many scenes in this book changed very little over the course of years or decades, while others changed dramatically, sometimes in a short period. The fire of 1904, the last major city fire in America, destroyed most of Baltimore's downtown historic fabric, yet also gave the city's downtown a fresh start and a new look. Throughout this book, the reader will see the process continuing as several buildings are demolished, in the process of renovation or rebuilding, or even captured on camera just days prior to planned restoration or renovation. A book like this can at best only hope to be a moment frozen in time, and in the future, no doubt both old and new photographs on these pages will end up evoking memories of what was. Today's landmark can well be tomorrow's memory, and today's mundane, tomorrow's survivor.

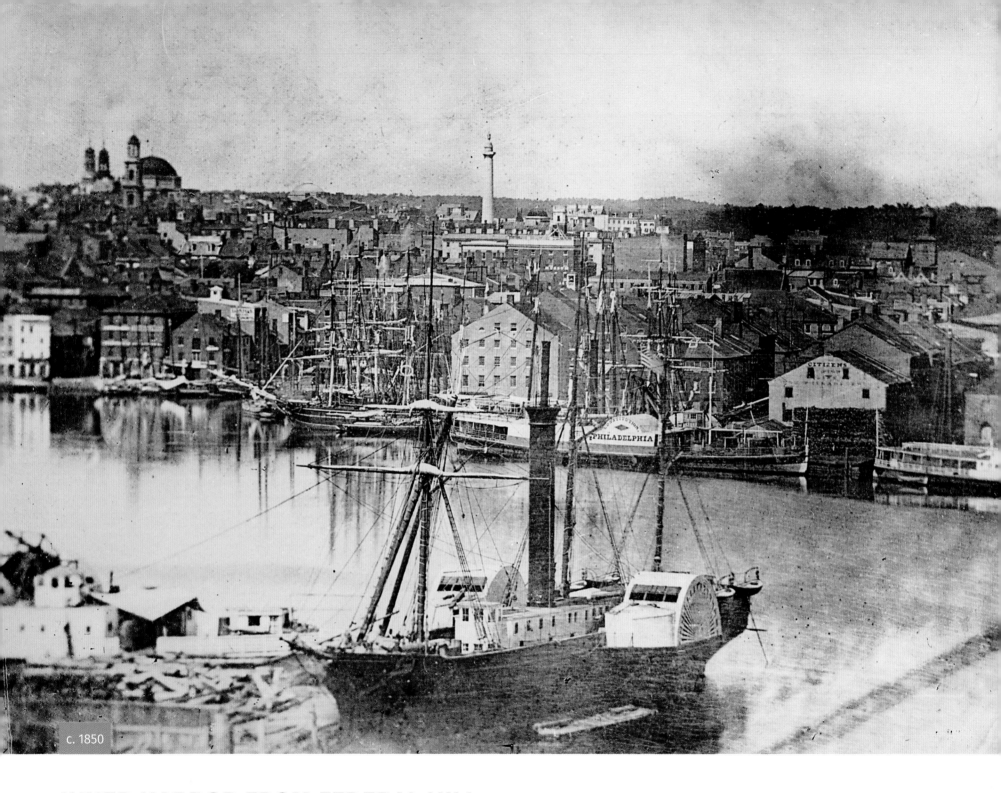

c. 1850

INNER HARBOR FROM FEDERAL HILL

Baltimore's ever-changing skyline was transformed by the fire of 1904

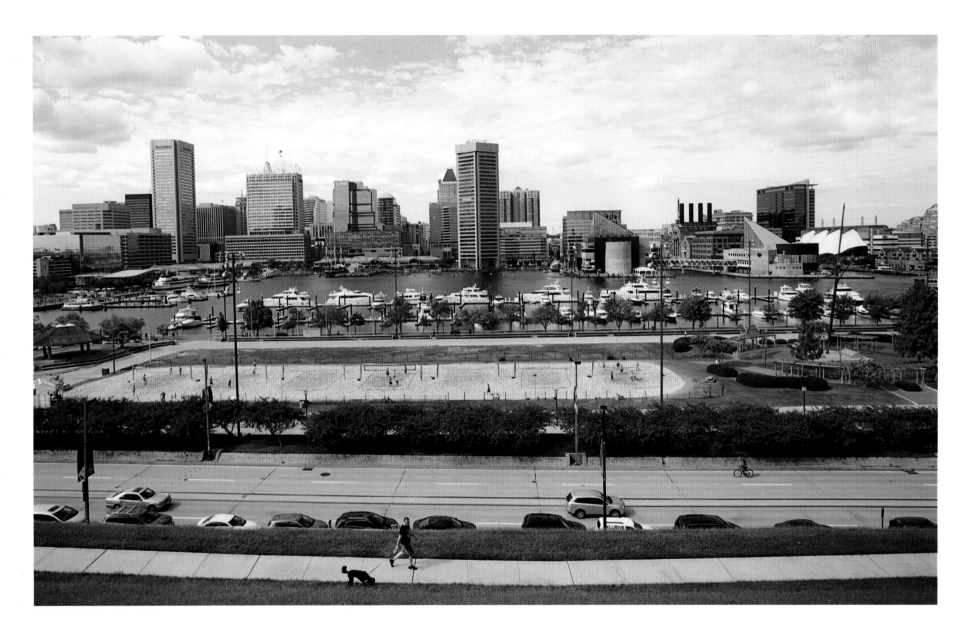

LEFT: Federal Hill, overlooking Baltimore's Inner Harbor, has provided many a scenic panorama of the changing city, starting with this ancient photograph, taken circa 1850. Prominent in the skyline of the bustling port city are (left to right) the Basilica of the Assumption, completed in 1821, and in front of it the steeple of the 1816 St. Paul's Episcopal Church, which burned in 1854; the Washington Monument (1825); and the steeple of the 1796 German Reformed Church, razed in 1866.

ABOVE: Aided in part by the destruction of the fire of 1904, Baltimore's skyline has continued to be ever-changing and vibrant. From left to right, the tallest buildings are the former USF&G Building (1973, sold to Legg Mason in 1997, and owned by Transamerica since 2011); 100 East Pratt Street tower (1992, with the top of the 1929 Art Deco Baltimore Trust Building, now the Bank of America Building, poking up behind it); the tapered roof of the 1992 Commerce Place Building; and the pentagonal 1977 World Trade Center. At far right is the National Aquarium, which opened in 1981.

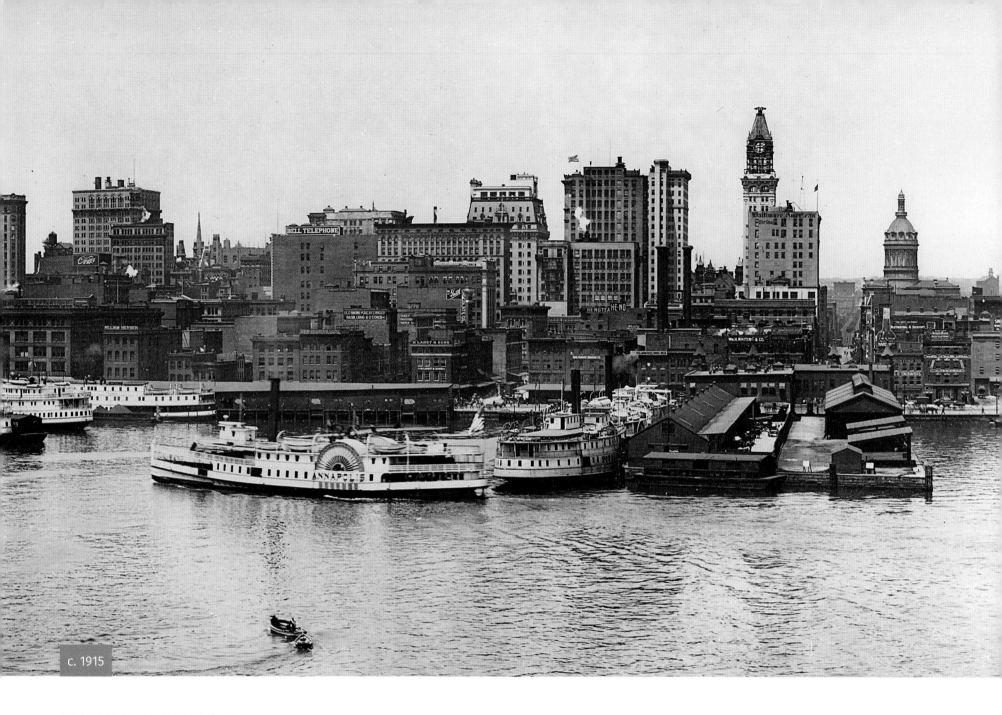

c. 1915

INNER HARBOR
The heart of Baltimore's commerce for centuries

ABOVE: The Inner Harbor, formerly known as "the Basin," has been an economic engine driving Baltimore's commerce for centuries, first as a shipping center and then in recent years as a commerce and tourism center. This view after the fire of 1904, dating to about 1915, shows several Chesapeake Bay steamships, then a major means of transportation to Maryland's Eastern Shore and other points on the Chesapeake Bay, surrounding the Merchants & Miners Pier. The skyline is dominated by the Maryland Casualty Co. Tower Building at Baltimore Street and Guilford Avenue, the tallest structure in the city (341 feet) when built in 1910–1912.

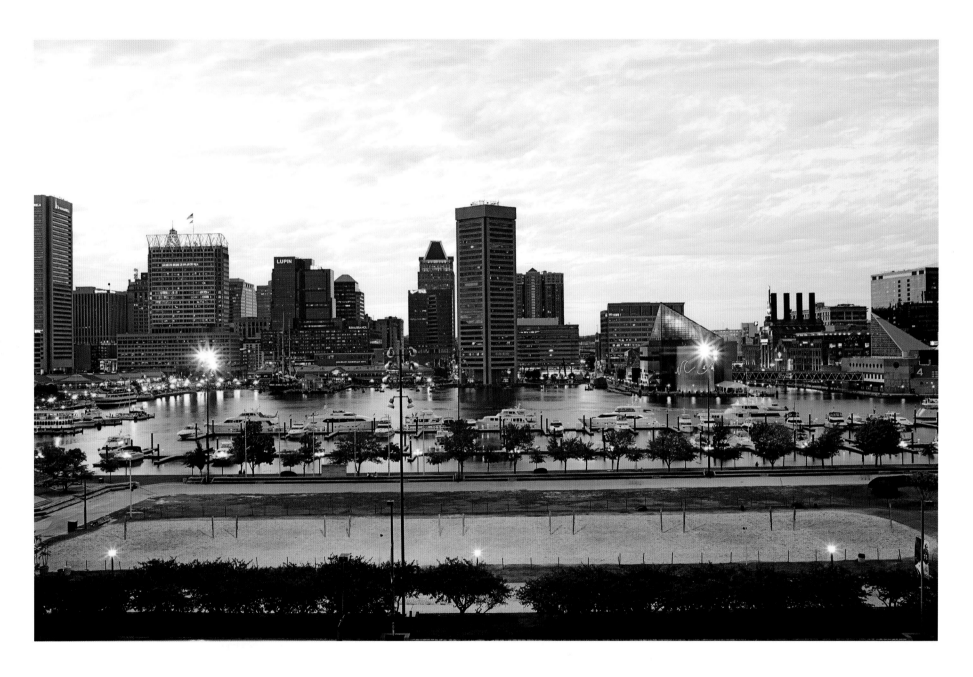

ABOVE: The Merchant and Miners Pier was replaced by the pier that would eventually house the National Aquarium (far right). The Tower Building would be demolished in 1986; a parking lot now stands in its place. The only boats venturing this far into the harbor today are pleasure craft, small cruise boats, and ships on exhibit, such as the 1854 U.S. Navy sailing vessel U.S.S. *Constellation*, a permanent historical exhibit. There are also several ships at the Baltimore Maritime Museum—a Coast Guard cutter that was at the Japanese attack on Pearl Harbor, a submarine, and a lightship—as well as the restored Seven Foot Knoll Lighthouse (out of view), moved into the harbor from Chesapeake Bay in 1987.

INNER HARBOR

Shipyards have been replaced by condominium developments

BELOW: Another picture taken from atop a building on Federal Hill from about 1930 shows a view looking east down the harbor toward Chesapeake Bay. At the left, on the far shore, can be seen the Allied chromium plant, located between Fells Point and the foot of Jones Falls, established in 1845 and closed in 1985. In the foreground are the Bethlehem Steel shipyards and drydocks, where more than 2,600 ships were built or repaired during World War II.

RIGHT: The modern view, taken from the rooftop of Southern High School, shows Tide Point, an office and technological center developed in a former Procter and Gamble plant on the south side of the harbor, in the distance. The Domino Sugar plant, with its landmark neon sign, is also visible to the right. The shipyards were closed in 1983, replaced by marina and condominium development on a massive scale, most prominently the twenty-seven-story, 249-unit 100 Harbor View tower (opened in 1993) to the left. The Baltimore Museum of Industry, which opened on the site of an 1865 oyster cannery, occupies the shoreline to the rear where a crane is preserved. The museum is home to the *Baltimore*, the oldest operating steam tugboat in the United States. Built in 1906 by the Skinner Shipbuilding Company, the tugboat was declared a National Historic Landmark in 1993.

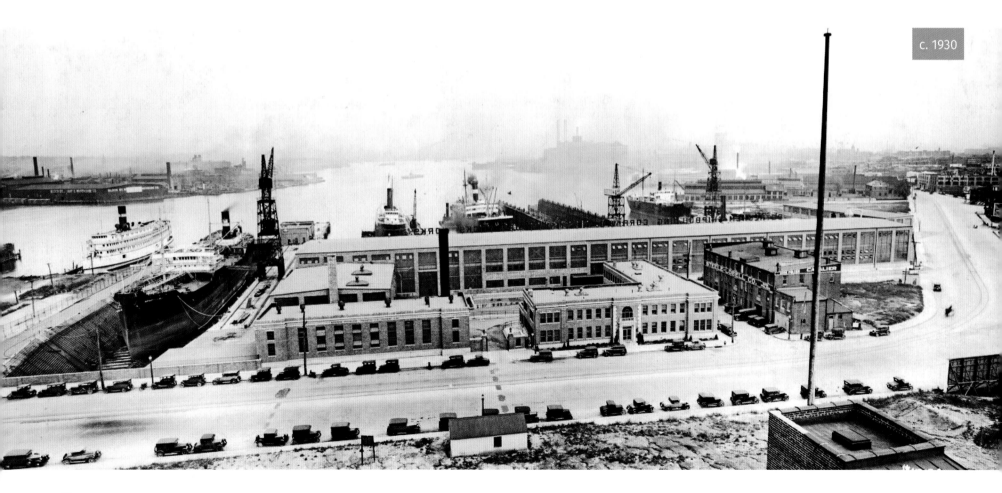

c. 1930

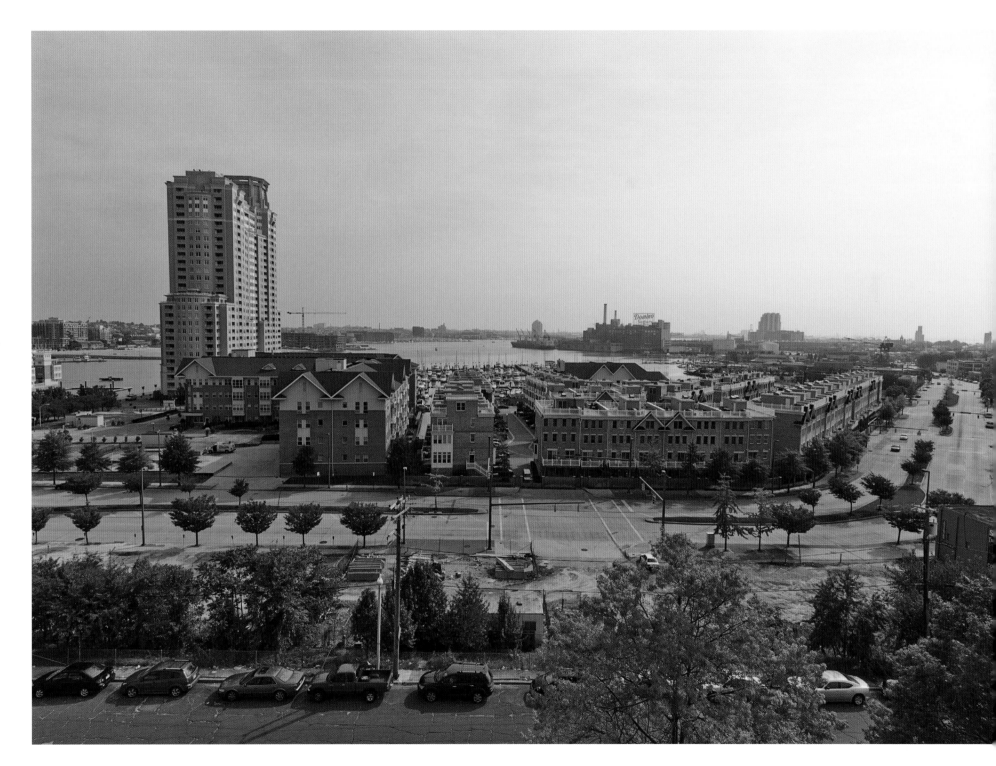

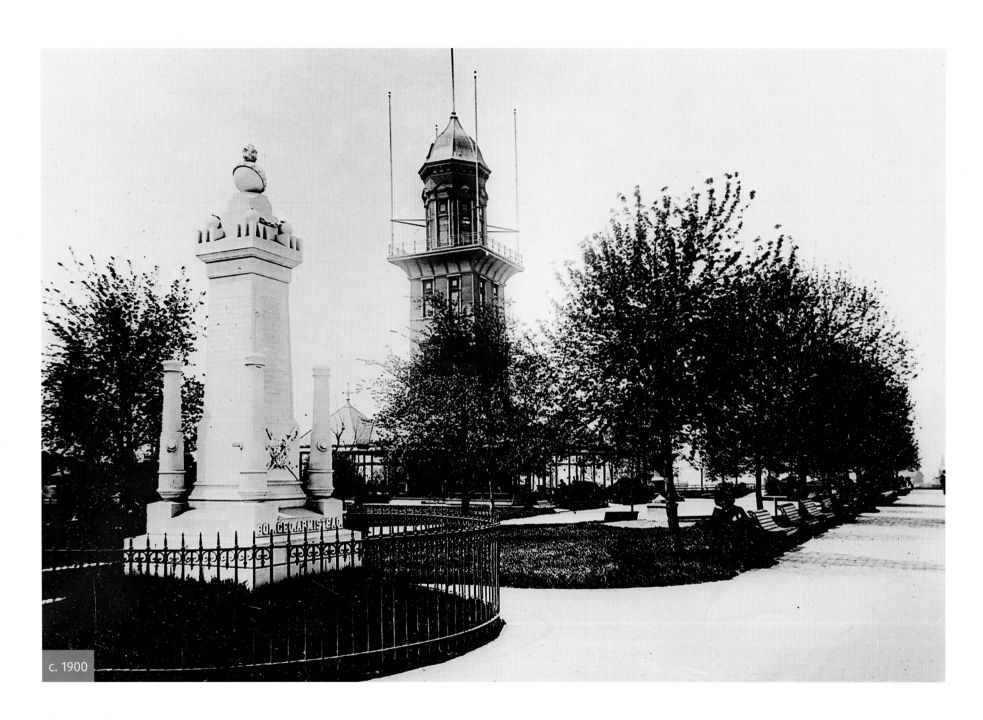

c. 1900

FEDERAL HILL

The site of a former maritime observatory

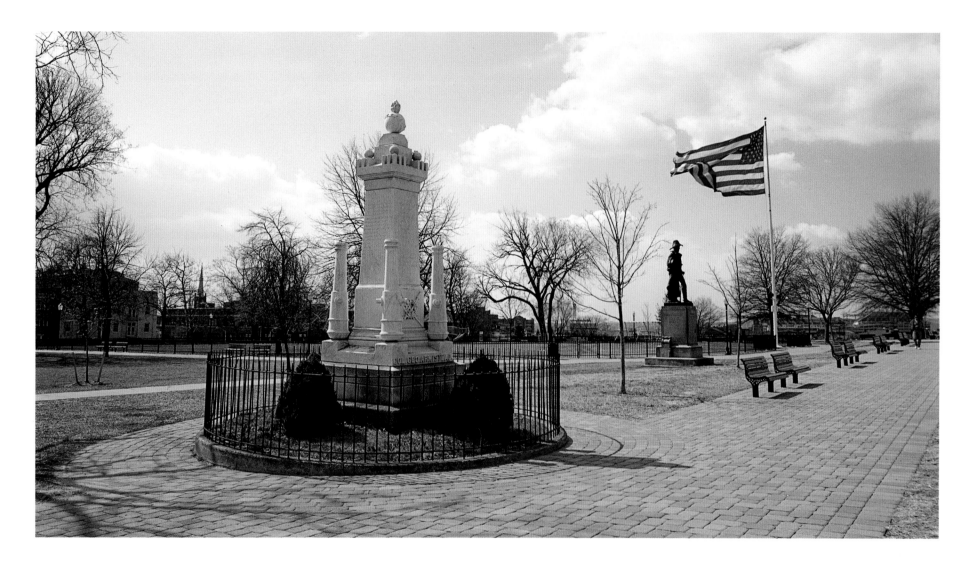

LEFT: The name "Federal Hill" stems from Baltimoreans' celebration of the state's ratification of the Constitution atop this hill in May 1788. An observatory was constructed by Daniel Porter on Federal Hill in 1797, which was subsequently known as the "Signal Service Observatory." It identified ships approaching the harbor and passed the information to those involved in commerce, typically by means of raising the merchant flag of the company owning the approaching ship. The original crude structure was replaced by this more modern and elegant one in 1887. Also in the photo is a monument to George Armistead (1780–1818), the military officer in charge of Fort McHenry during its bombardment in 1814. The marble monument was initially erected at the City Spring near Saratoga Street and dedicated in 1882; in 1886 it was relocated to Federal Hill.

ABOVE: After many years of being mined for sand and clay for industrial purposes, Federal Hill was made a city park in 1880. The observatory's function in an era of more modern communications was clearly obsolete, and it was demolished in 1902. Today, a view southwest from the northeast corner of Federal Hill still shows the Armistead monument, as well as a newer monument to Samuel Smith (1752–1839), a noted Revolutionary War officer and Maryland politician who served in many duties from U.S. senator to mayor of Baltimore. A flagpole now stands at the observatory's former site.

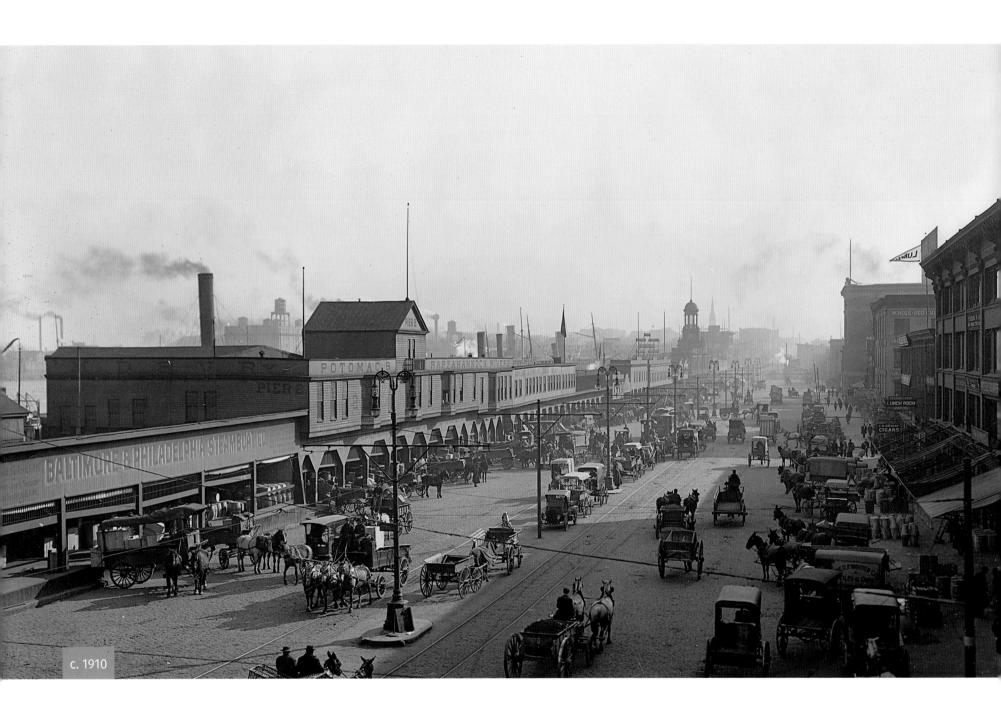

c. 1910

LIGHT STREET

The bustling commercial center is now a busy thoroughfare

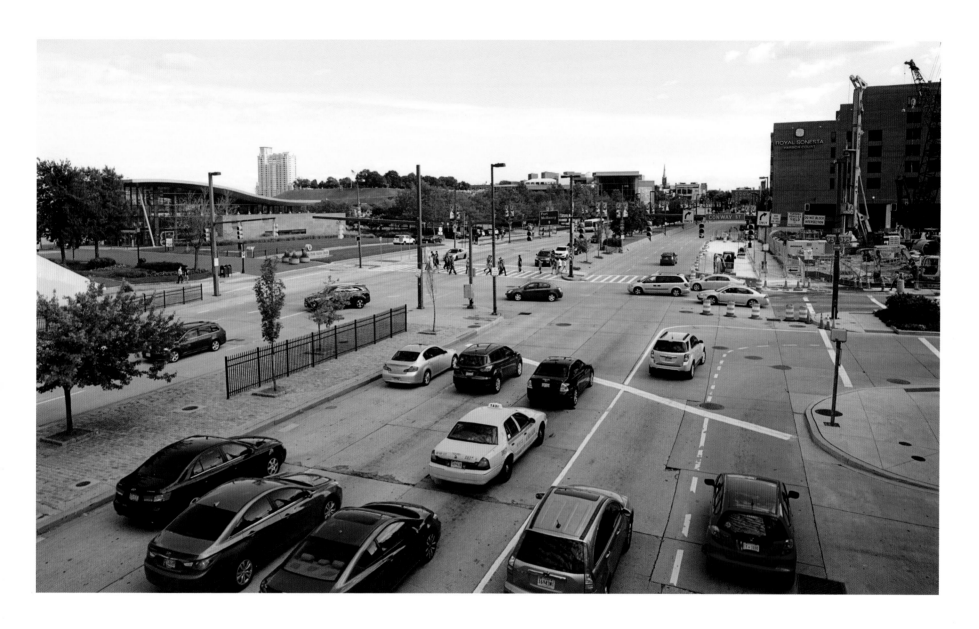

LEFT: Light Street runs south past the western edge of the harbor, and thus became one of the major commercial thoroughfares, jammed with wagons going to and from ship docks. Formerly a narrow, traffic-choked street, it was widened to a broad street in the wake of the 1904 fire. Steamboats to the Eastern Shore, Norfolk, and Philadelphia departed from the Light Street terminals. Most famous of the carriers was the Baltimore Steam Packet Co., or the "Old Bay Line," founded in 1817, whose piers are prominent at left in the distance. Note that both streetcar tracks and freight railroad tracks lie in the street. This view dates from approximately 1910.

ABOVE: Today Light Street remains jammed with automobile traffic passing through, not freight going in and out. The Light Street piers would start to disappear in the late 1940s after steamboat traffic withered; the last Old Bay Line steamer departed in 1962. Extensive landfill has pushed the harbor's edge back from the original street line. The curving roof on the left belongs to the state-of-the-art Baltimore Visitor Center. In the distance can be seen the Maryland Science Center, an interactive science museum opened in 1976. The tower beyond is the Holy Roman Catholic Church in Federal Hill. Railroad service to the few industries left in this area ended in the 1970s.

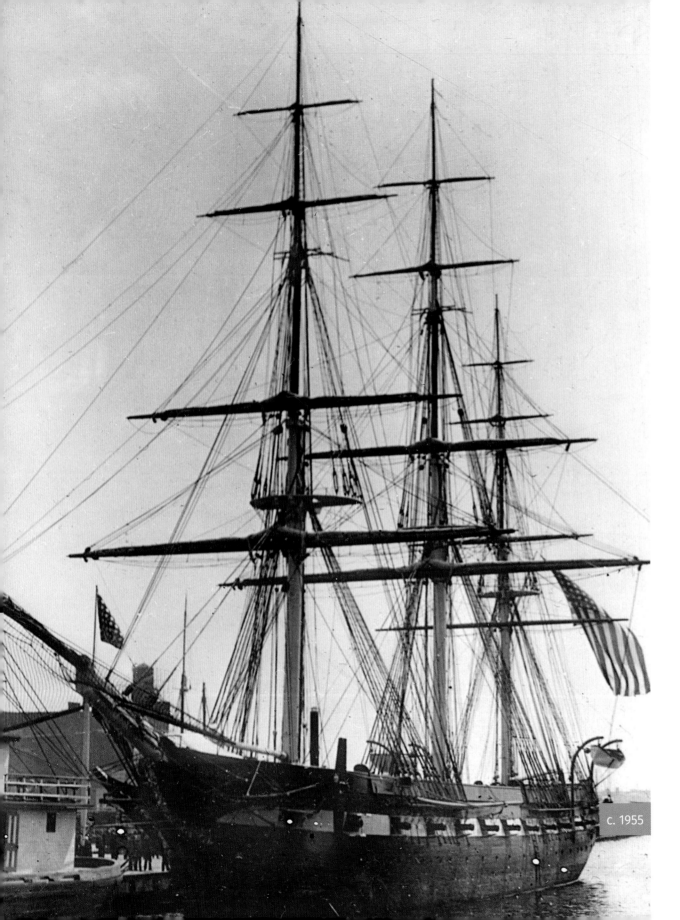

c. 1955

U.S.S. *CONSTELLATION*
The only Civil War–era U.S. Navy ship still afloat

LEFT: The U.S.S. *Constellation* has been an Inner Harbor institution since 1955, when the wooden ship was rescued from years of storage at Boston Navy Yard and installed as a historical display in Baltimore. The ship in question was thought for years to be the more-or-less original frigate of the same name, built nearby in 1797 as part of the original U.S. Navy. However, extensive research would prove that the original vessel was broken up and scrapped at Portsmouth, Virginia, in 1853 and replaced with a newly built sloop of war built in 1854. This subterfuge was apparently done to hide the construction of a new ship at a time when the U.S. Congress prohibited the construction of new Navy ships. The last all-sail Navy vessel built, the new *Constellation* would play an important role in both American interdiction of the slave trade and the Civil War.

RIGHT: After decades of floating in the still waters of the Inner Harbor, the ship was removed to drydock in 1996 for what would prove to be a complete rebuilding of the original vessel. During the restoration, historians confirmed that the ship was completely a creation of the nineteenth century. It was returned to the Inner Harbor in July 1999, and it is now preserved more accurately as the only Civil War–era U.S. Navy ship afloat.

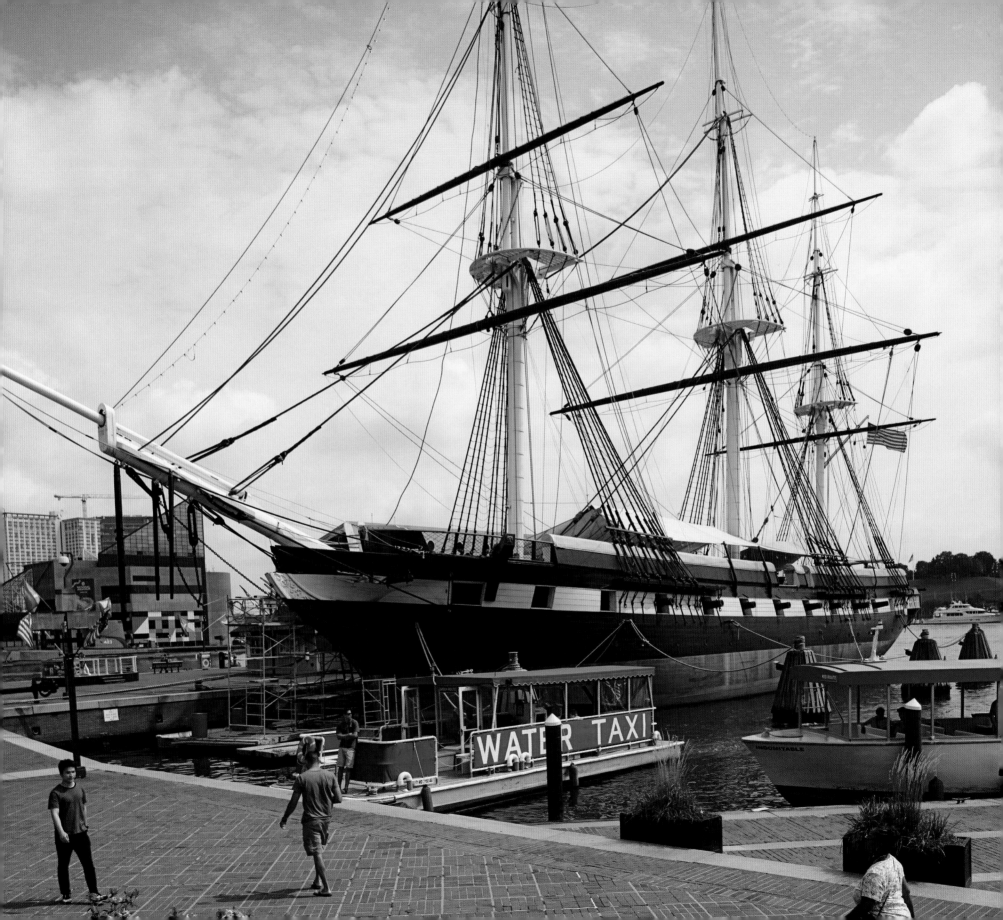

PIER 4, INNER HARBOR

Now home to the Marine Mammal Pavilion of the National Aquarium

BELOW: Earlier known as Dugan's Wharf and one of many Inner Harbor piers located off Pratt Street, this pier originally sat empty until the construction of the Merchant & Miners Co. Pier around 1910. It later served as a cargo loading and unloading pier for several companies, and later yet as a ship-repair dock for Maryland Drydock Co.

RIGHT: Construction on the National Aquarium in Baltimore on Pier 3 was begun in 1978; it opened in August 1981, and expanded with the addition of the Marine Mammal Pavilion to Pier 4 in 1990. The two buildings combined hold over 10,000 animals, from tropical birds and reptiles to hundreds of saltwater and freshwater fish, dolphins, and seals, as well as a tropical rainforest exhibit. The aquarium attracts well over a million visitors a year.

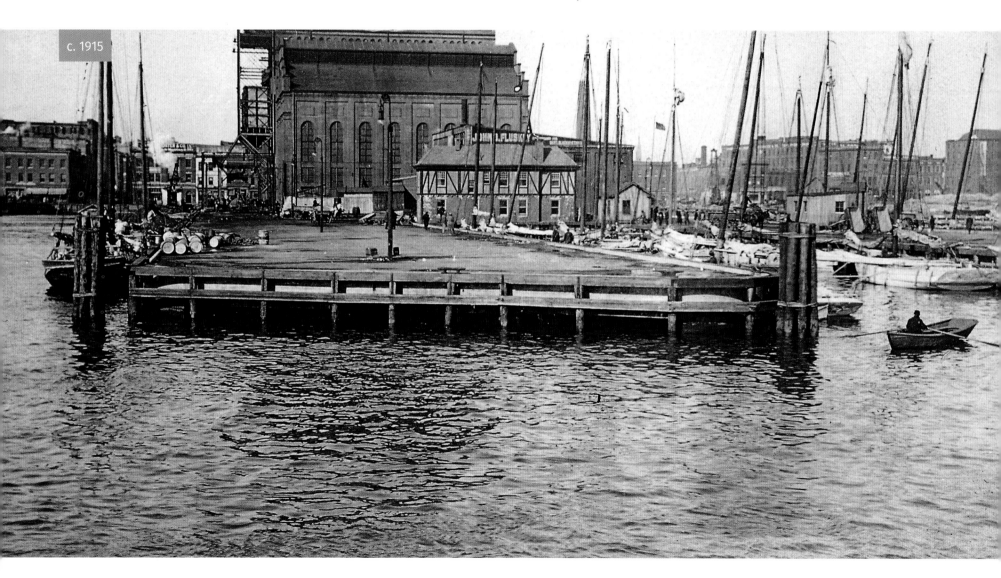

c. 1915

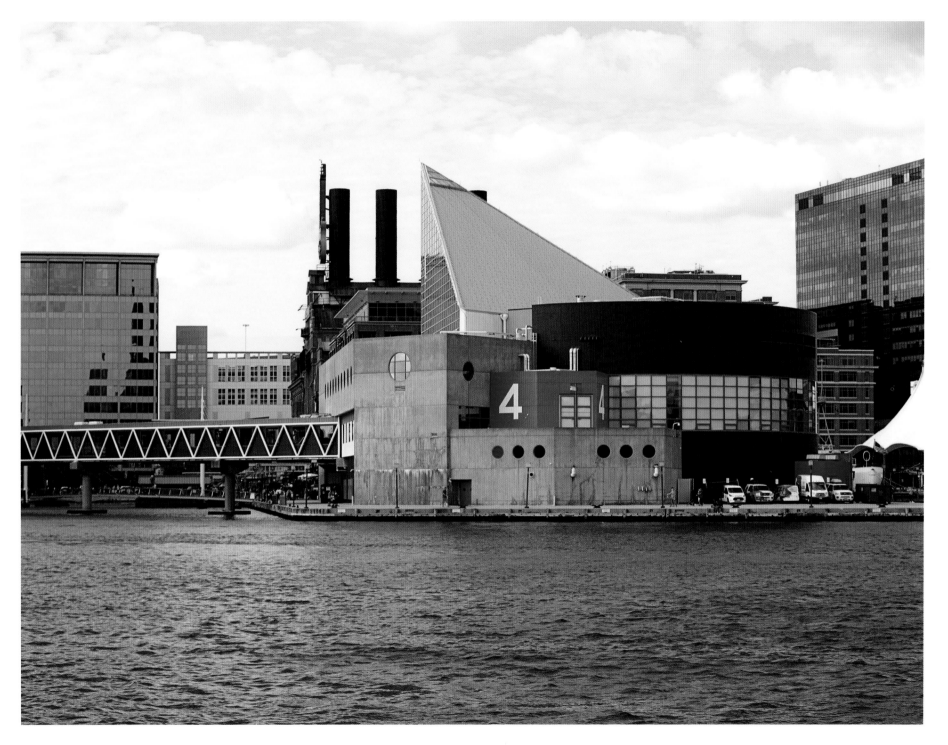

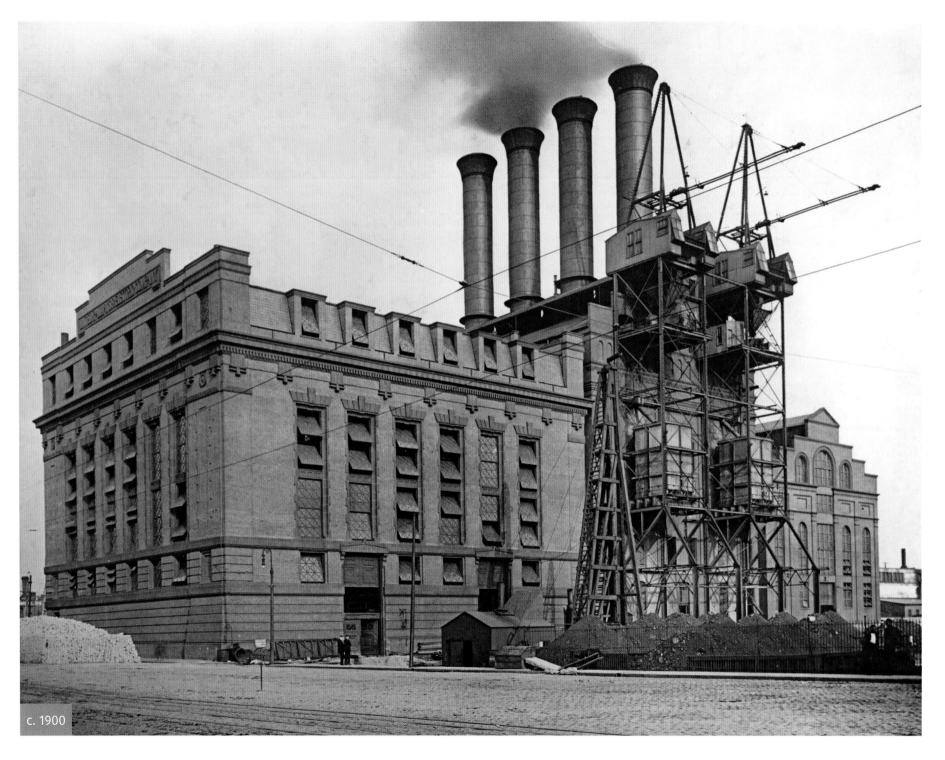

c. 1900

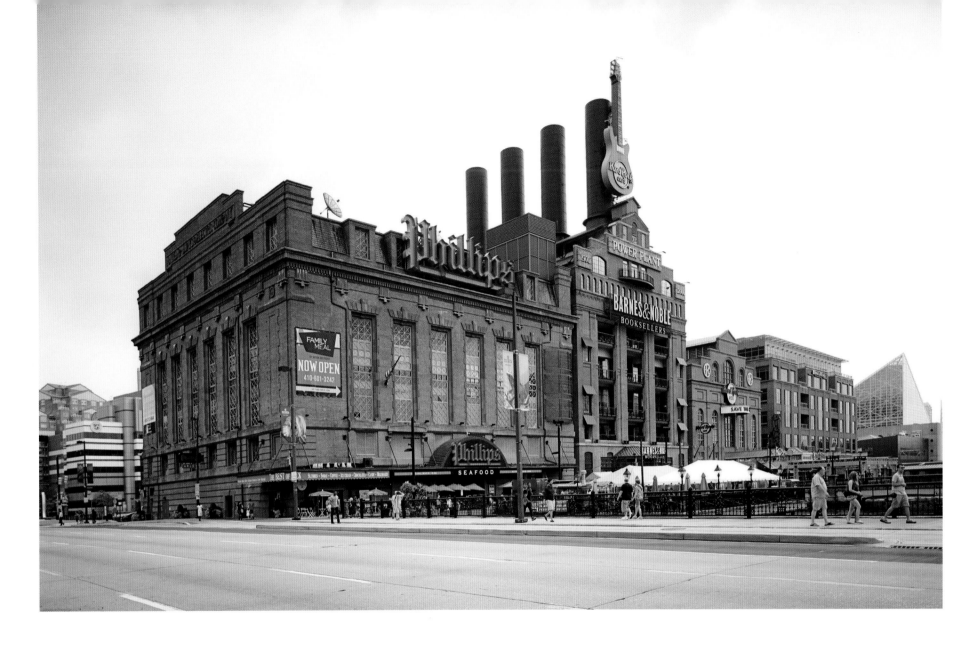

UNITED RAILWAYS POWER PLANT
Saved from the wrecking ball and reborn as a retail center

LEFT: The United Railways & Electric Co., the city's streetcar transit company, erected this massive power generating station at Dugan's Wharf (later Pier 4) on Pratt Street at the Inner Harbor. Construction began about 1895, but it was completed in at least three sections at varying stages. It not only supplied power to the entire streetcar system (which extended deep into the suburbs), but also some power to the city as well. The large cranes shown removed coal from harbor coal barges to an elaborate conveyor system; the plant also received coal via the railroad tracks on Pratt Street.

ABOVE: The power plant would find itself an obsolete relic even before streetcars were discontinued in 1963, but escaped the wrecking ball (which might have had difficulty with its thick walls anyway) when it was sold to the city in 1977. Several unsuccessful commercial amusement ventures started and failed within its walls during the mid-1980s until its successful (thus far) redevelopment in 1997 as a retail center, now hosting a Barnes & Noble bookstore, a Hard Rock Cafe, and a Phillips seafood restaurant. The Paul McCartney–styled guitar sign on the smokestacks is sixty-eight feet tall and weighs more than 3,000 pounds.

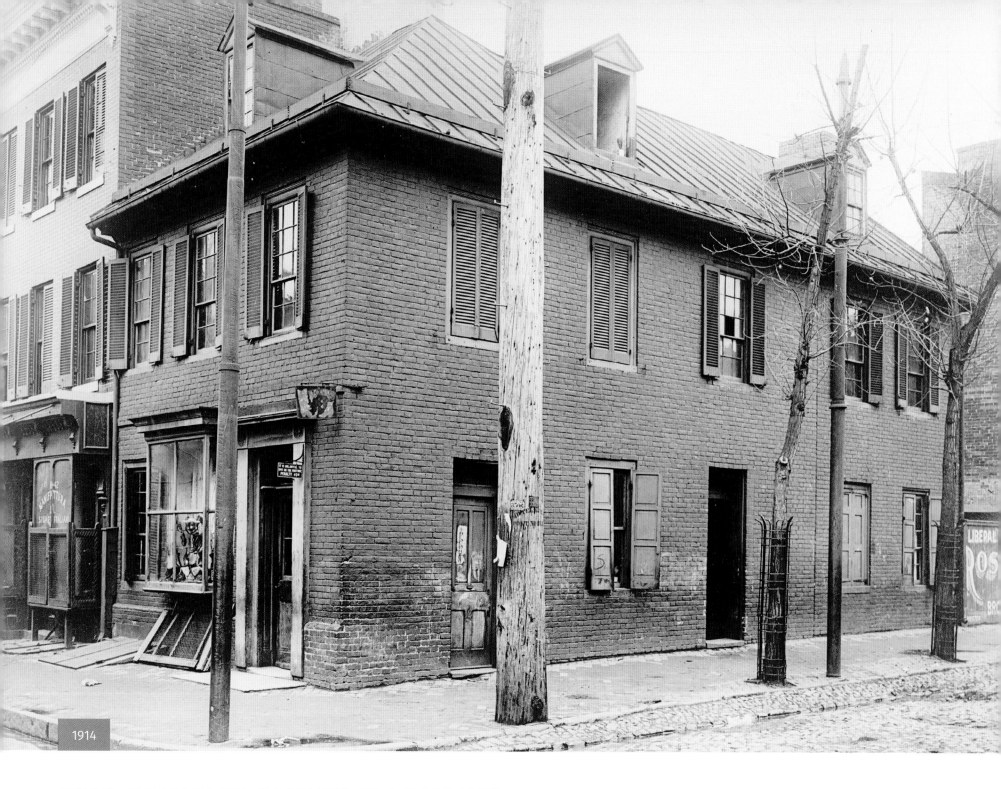

1914

STAR-SPANGLED BANNER FLAG HOUSE

Home and workplace of the noted flag maker Mary Pickersgill

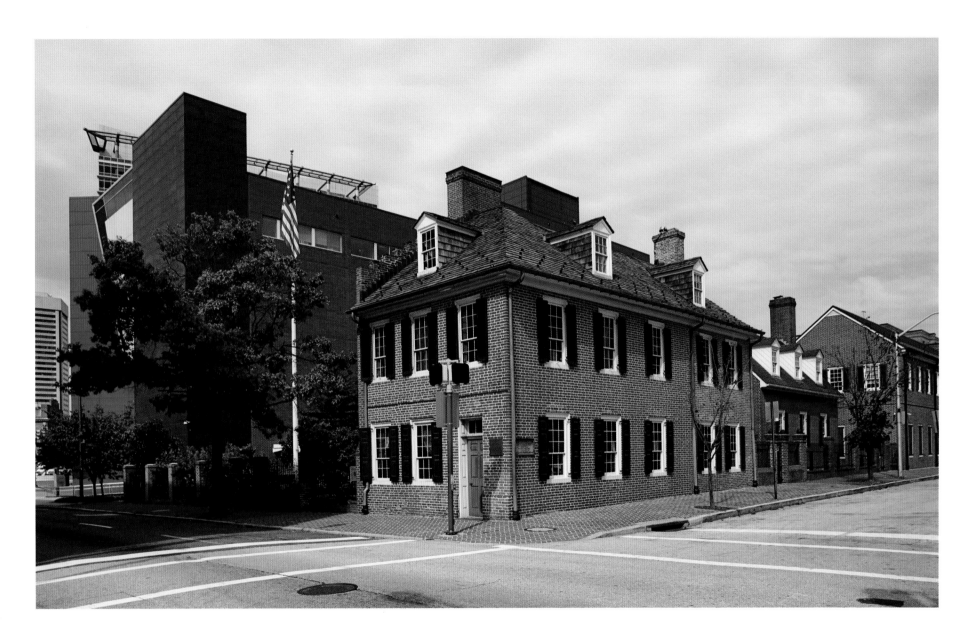

LEFT: Built in 1793, the house on the corner of East Pratt and Albemarle Street, was once home to the noted flag maker Mary Pickersgill (1776–1857). Pickersgill sewed the flag that Francis Scott Key saw flying over Fort McHenry and that inspired him to write the United States National Anthem. At the time this photograph was taken the house was being used as a shoe shop.

ABOVE: In 1927 the house was sold to the City of Baltimore and a museum was established at the site by the Star-Spangled Banner Flag House Association. The museum houses exhibits on the War of 1812 and the Battle of Baltimore and features a life-size stained-glass replica of the Star-Spangled Banner made by Pickersgill. Pickersgill's actual flag is now on display at the Smithsonian Museum of American History. The modern building on the left is the Reginald F. Lewis Museum of Maryland African American History & Culture, which opened in 2005.

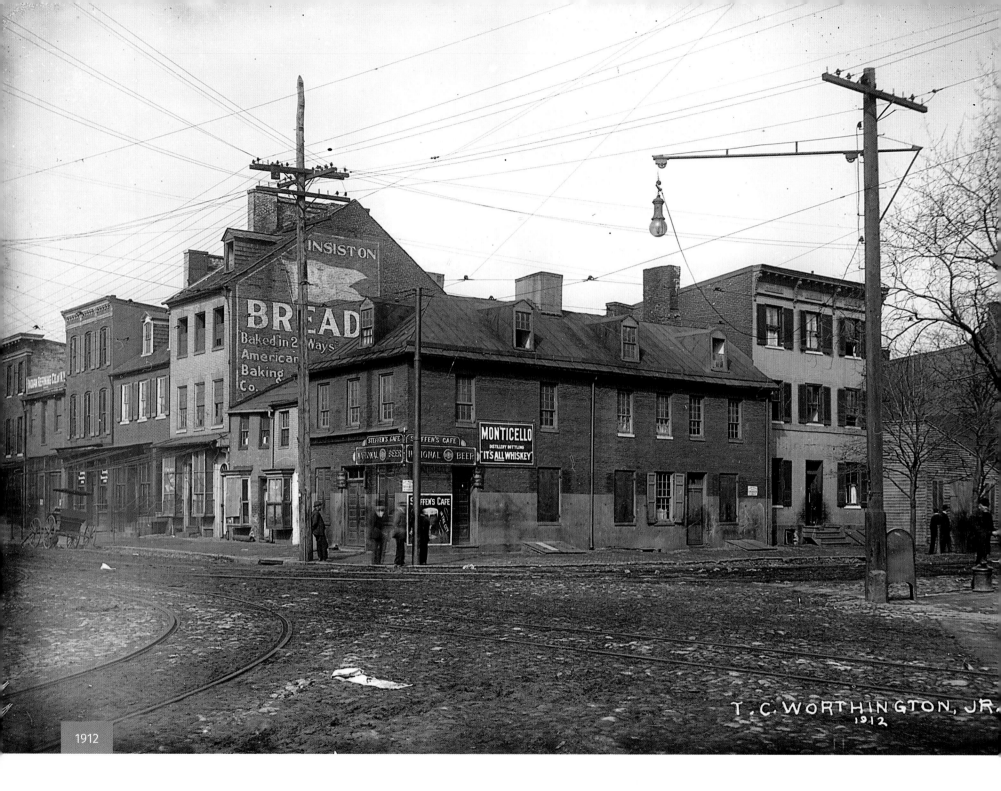

FELLS POINT

The 1765-built Robert Long House is the oldest dwelling in Baltimore

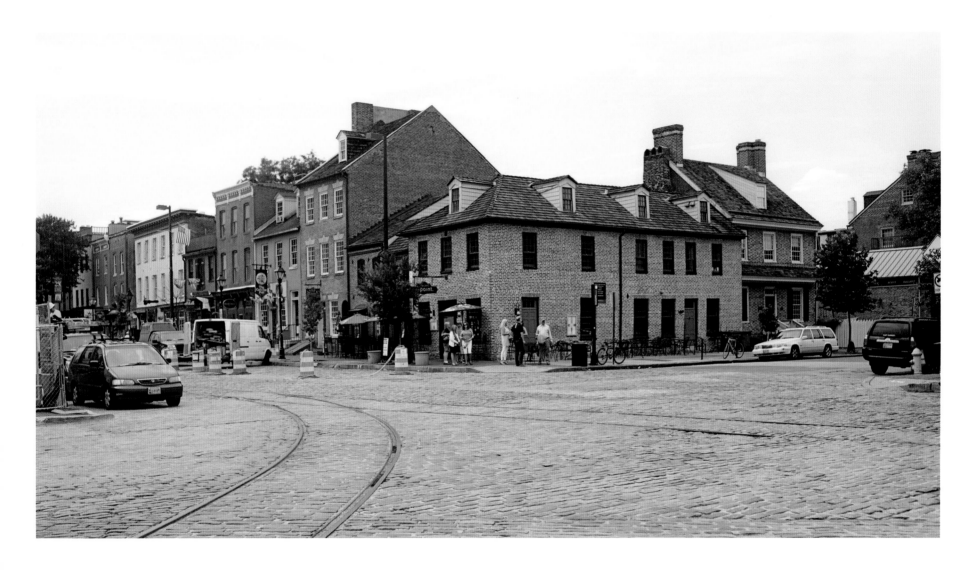

LEFT: Admiral William Fell, an English Quaker, first purchased the peninsula that would bear his name in 1726. The town was founded in 1763 as a separate port community to the east of Baltimore proper, but was annexed by Baltimore Town in 1773. It would become the primary port for Maryland's agricultural exports and a home to seaman, sailmakers, prosperous merchants, and sea captains. It continued to be a vital and thriving port area in the twentieth century, featuring deeper water at its docks than the Inner Harbor.

ABOVE: The area gradually transformed itself from a gritty industrial and marine community to a trendy, upscale residential and commercial neighborhood over the later part of the twentieth century. It now attracts tourists and locals alike with its historic colonial charm and many taverns and shops, some of which line Thames Street to the left. To the right of the Point in Fells, the restaurant on the corner of Ann and Thames, is the 1765-built Robert Long House, the oldest dwelling remaining in Baltimore. Following a fire in 1999, the second floor was restored and is now home to Baltimore's Preservation Society. Tours of the first floor are available by reservation. Amazingly, the freight railroad tracks (not streetcar tracks) in the streets throughout the neighborhood remained in use, with road tractors towing freight cars until the beginning of 1983.

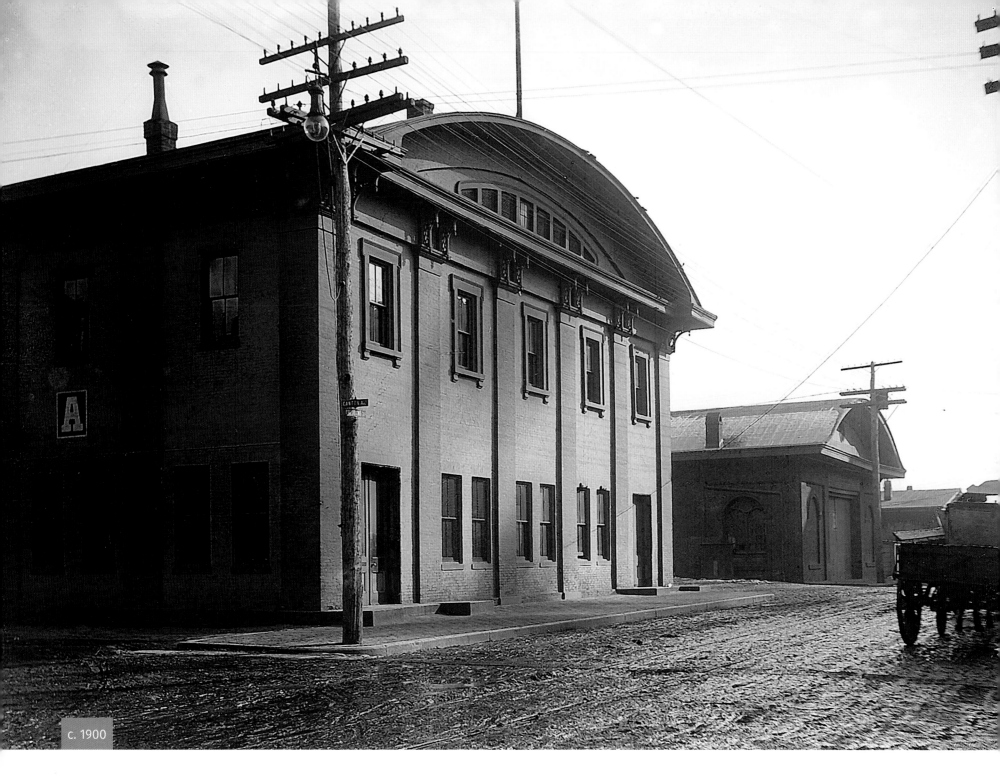

c. 1900

PRESIDENT STREET STATION / CIVIL WAR MUSEUM

The derelict station was given new life as Baltimore's Civil War Museum

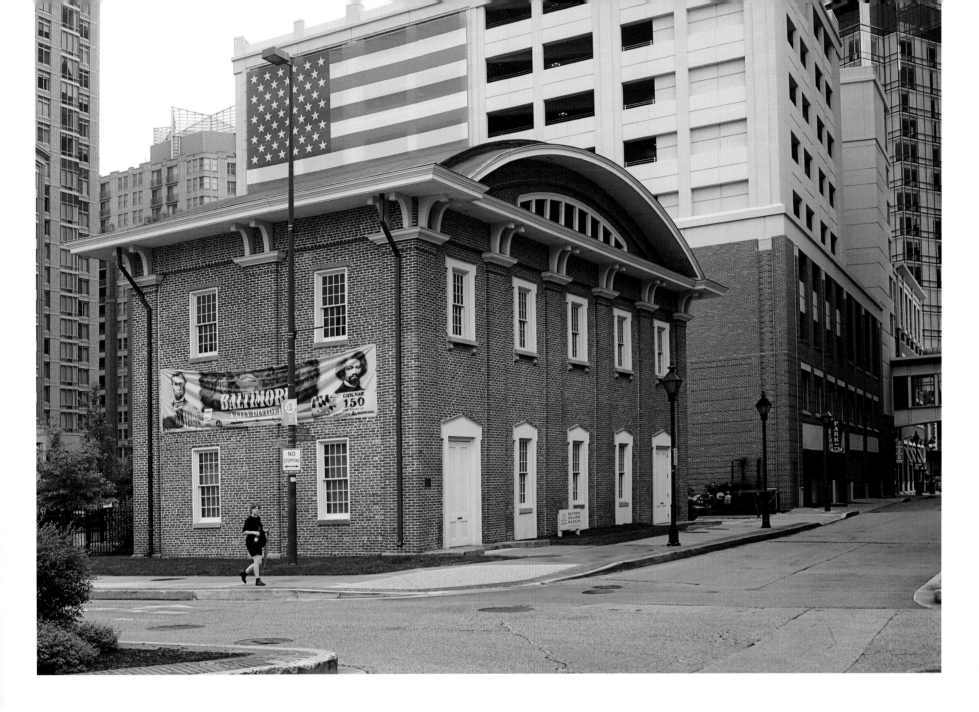

LEFT: Built in 1849–1850, this classical-style building was the original terminal for the Philadelphia, Wilmington & Baltimore Railroad, which later merged into the Pennsylvania Railroad. This humble station received its claim to fame as the site of the first actual fatalities of the Civil War on April 19, 1861, when a mob attacked a trainload of Union soldiers en route to battle after the nonfatal bombardment of Fort Sumter in South Carolina. After abandonment for passenger use by the PRR in the 1920s, the station became an increasingly derelict freight station, with the unique wooden arch roof finally collapsing in a 1989 snowstorm.

ABOVE: Historians refused to let the station die, and the building was renovated as the Baltimore Civil War Museum, opening in 1997. Construction of a new Marriott hotel complex in 1999–2000, however, literally and figuratively overshadowed the historic gem and rendered it almost inaccessible for nearly two years during construction. Archaeological digs in 1998 uncovered early nineteenth century iron-topped wooden rails and tracks still buried beneath the street level.

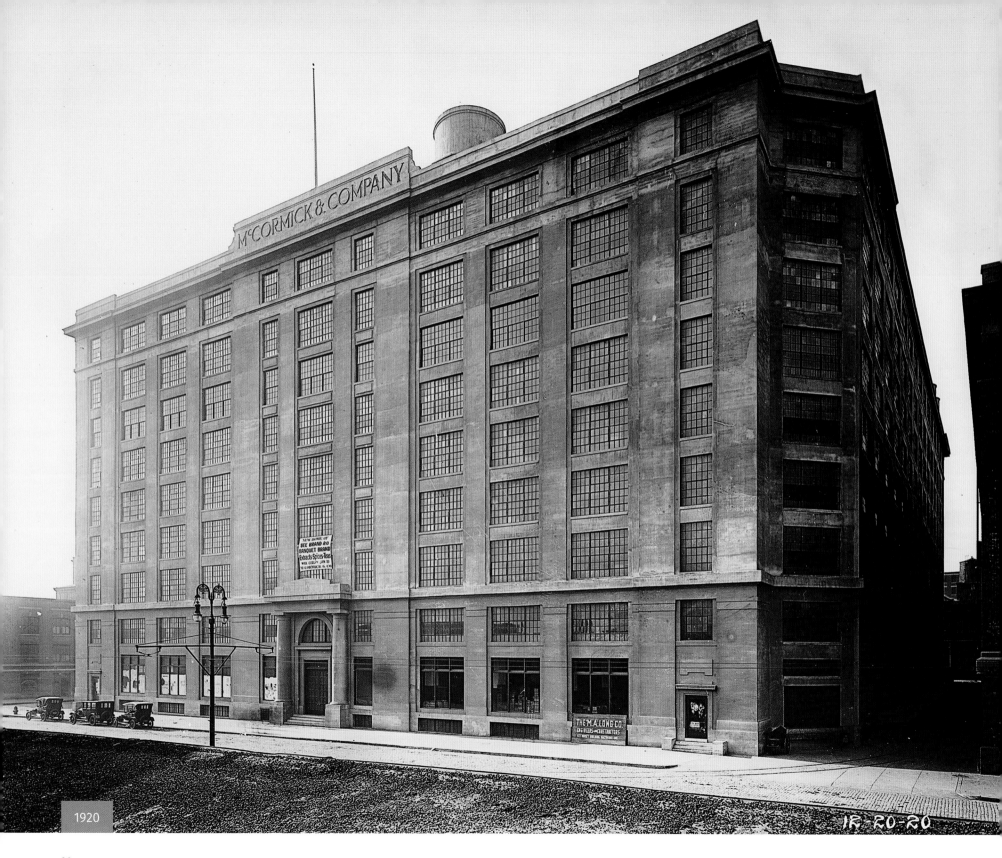

McCORMICK & COMPANY

1920

IR-20-20

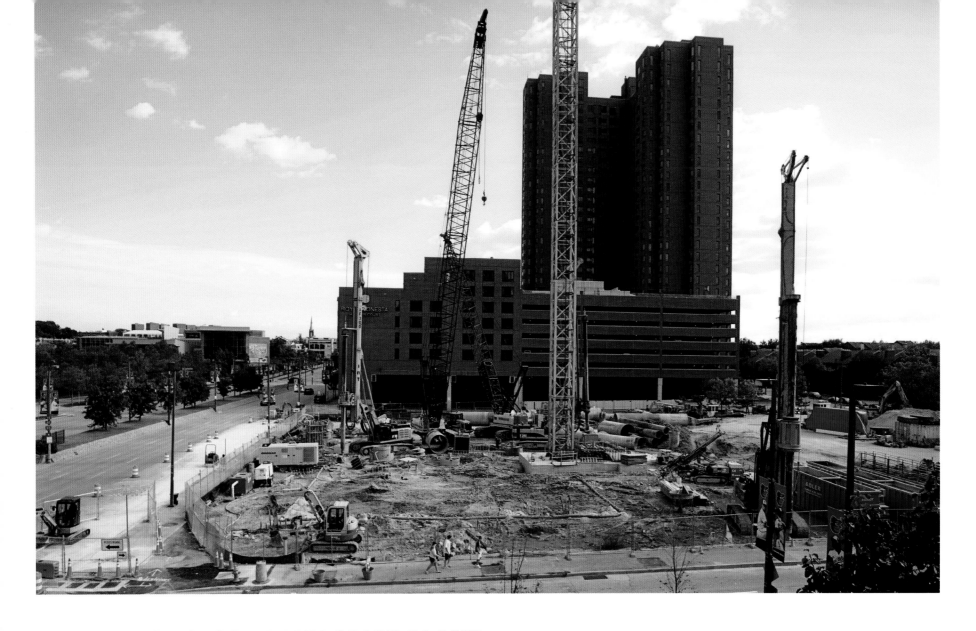

McCORMICK & COMPANY SPICE PLANT
The building was demolished after McCormick relocated in the 1980s

LEFT: This building would become one of the last vestiges of both the industrial side and the international shipping side of the Inner Harbor. The McCormick Spice and Tea Co. built the nine-story building, seen here in December 1920, to house both its packaging operations and an "Olde English" tea room and fake village street, popular for civic events. The processing of cinnamon, nutmeg, and other spices created aromas that were a pleasant foil to the typical industrial and nautical odors of the harbor and center city.

ABOVE: The company would relocate its operations to the suburbs north of Baltimore in the 1980s and sell the property to the developers of the Harborplace emporium. The building was demolished in 1989 and replaced by a parking lot. Construction on a new apartment tower, 414 Light Street, began in 2016 and is expected to complete in 2018. To the rear of the view is the 1986-built Royal Sonesta Harbor Court hotel, office, and condominium complex.

JONES FALLS

This stretch of the Jones Falls waterway is now covered by its namesake freeway

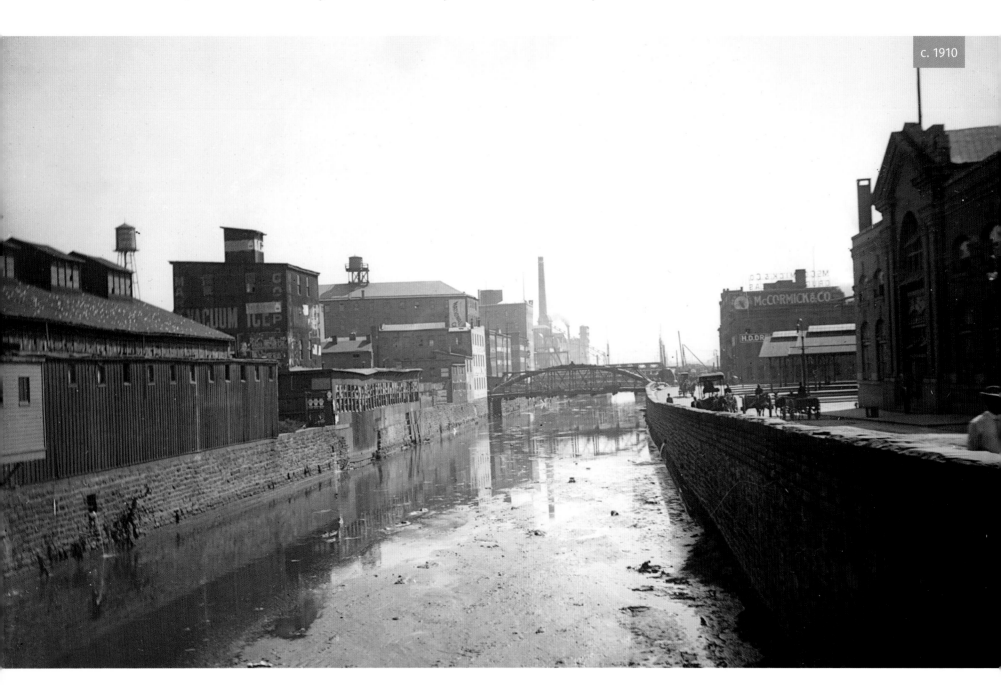

c. 1910

LEFT: The Jones Falls is not a waterfall in the popular sense, but rather a local stream that drains the center of Baltimore City. It empties into the Inner Harbor at the harbor's eastern edge. By the 1900s, the frequent flooding and pollution caused by urban congestion and rainfall made the lower stretches of the waterway essentially an open sewer, despite the waterway being an important firebreak in the fire of 1904. Efforts were then launched to both contain the falls and use the natural valley as a transportation artery (an idea bandied about since the early 1800s). This view south from the Baltimore Street bridge in about 1910 shows stone walls dating back to the previous century, as well as the recently-completed Fish Market to the right.

BELOW: The two million dollar Fallsway, a highway built over the lower Jones Falls, opened in 1915. In 1962, the fifty-five million dollar Jones Falls Expressway (Interstate 83), stretching from the city north to the outer suburbs and built in and above the Jones Falls valley, would be opened, further hiding the waterway. It would be extended to this spot—technically, a widened President Street—in the mid-1980s, demoting the Fallsway to side-street status and funneling thousands more cars daily to the Inner Harbor area. The Fish Market building on the right remains and has been home to the Park Discovery Children's Museum since 1998. The waterway opens to the air a couple hundred feet directly in front of the photographer. At the foot of President Street can be seen the 1987-built Scarlett Place condominium, and behind it the tower of the Marriott Hotel, built in 1999–2000. To the right of center stands a well-disguised Baltimore Gas & Electric power substation, now a subsidiary of Constellation Energy.

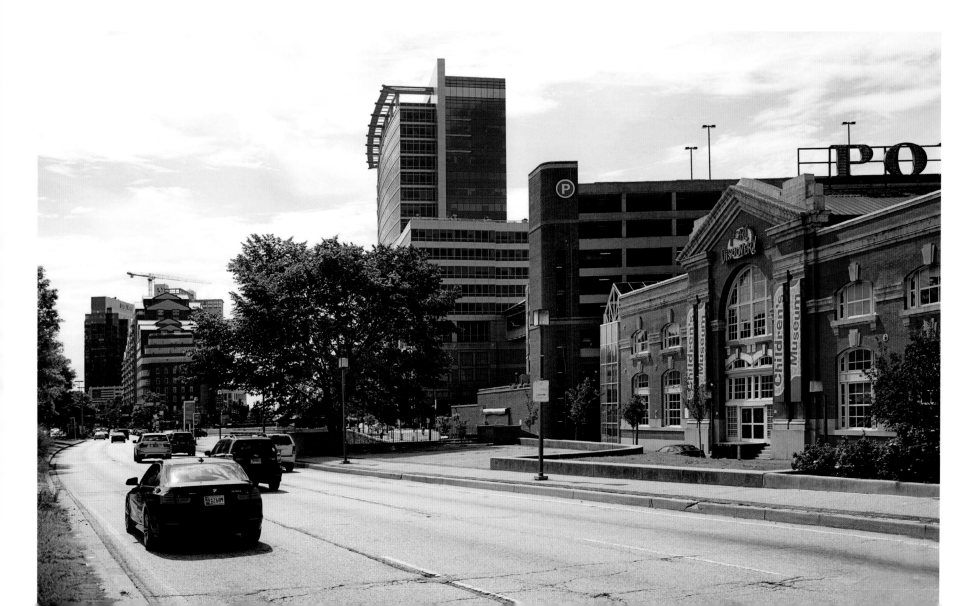

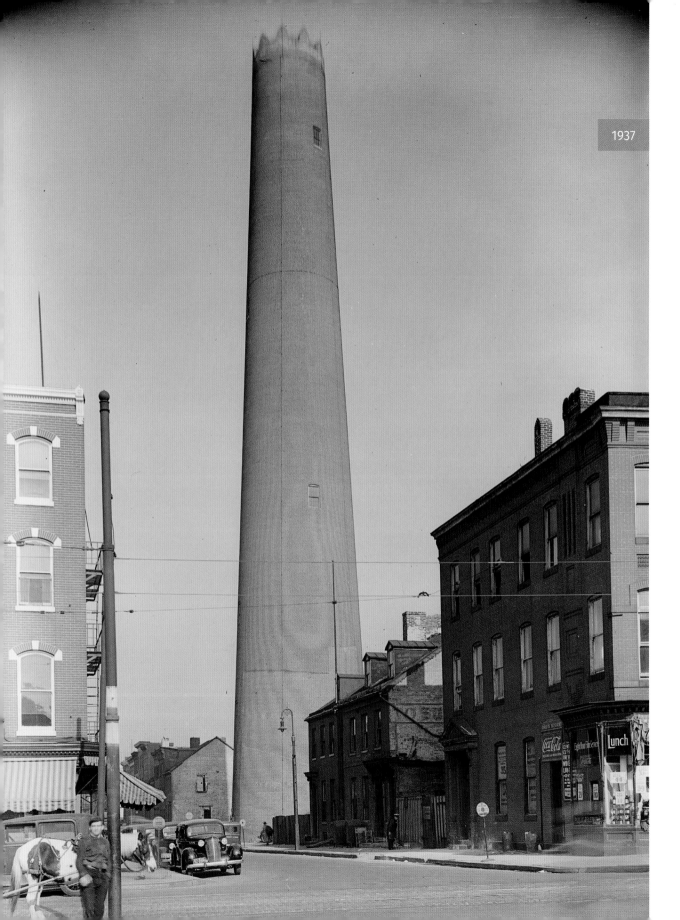

1937

SHOT TOWER

The tallest structure in the United States when it was built in 1828

LEFT: One of Baltimore's several vertical architectural antiques, the Shot Tower, built in 1828 by the Phoenix Shot Tower Co., was actually one of three built in the city. Over 234 feet in height, the Shot Tower was the tallest structure in the United States until the Washington Monument in Washington, D.C. was completed after the Civil War. Inside, molten lead was dropped through sieves at the top, to fall and solidify into round shot by the time it reached the water pool at the bottom.

RIGHT: In use until 1894, the tower was purchased in 1921 for demolition to make way for a gas station, but public outcry led to its preservation by the city as an historic landmark. Restored in 1976, it is currently administered by Carroll Museums, Inc., which also manages Carroll House, the last home of Charles Carroll, a signer of the Declaration of Independence. The eighteenth-century townhouse on the right, at 9 North Front Street, was home to Thorowgood Smith, the second mayor of Baltimore.

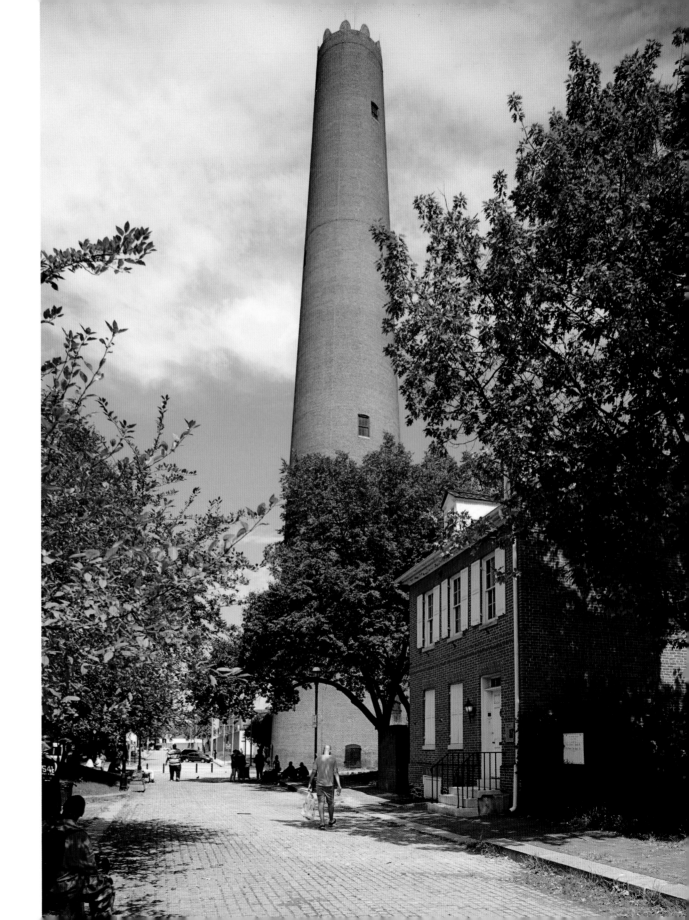

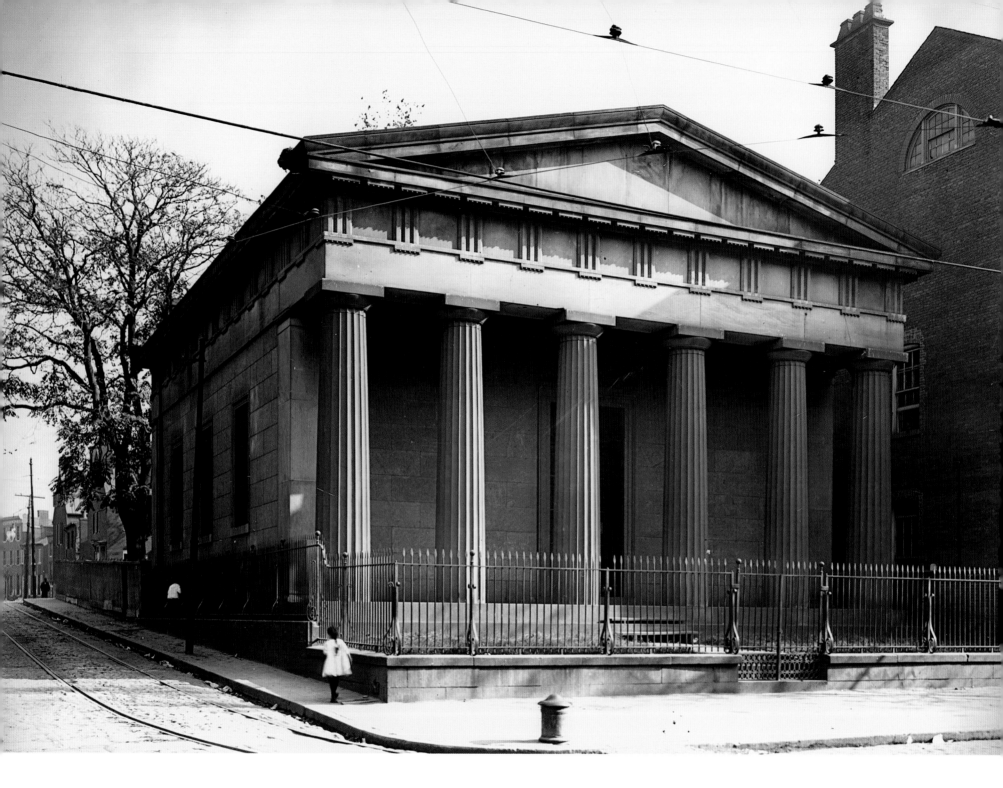

McKIM FREE SCHOOL / McKIM COMMUNITY CENTER
Serving the local community since 1833

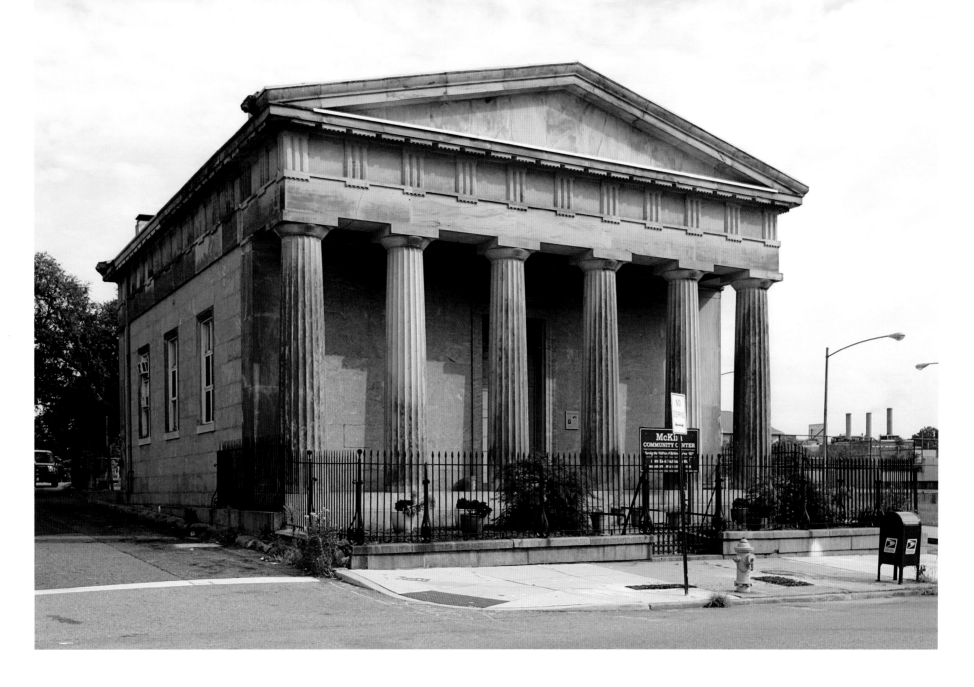

LEFT: When John McKim, a local merchant and Quaker, died in 1819, he left a bequest of six hundred dollars to provide a school for children whose parents were unable to pay for their education. Under the direction of his sons Isaac and William, trustees selected from the nearby Friends Meeting House (also still standing) organized a school they hoped would "prove the basis of extensive and lasting benefits to the poor, and to the interests of society, by the diffusion of useful knowledge, and moral instruction among a class of society who have not the means of procuring these advantages for themselves." Baltimore architects William F. Small and William Howard designed the school in the Greek Revival style then popular with American architects.

ABOVE: The school opened at the corner of Baltimore and Aisquith streets in 1833 and continued to serve the indigent youth of the city until after the Civil War. Today the structure still stands as a local community center amid a neighborhood that in recent years has seen a heavy concentration of subsidized low-income housing. The building was placed on the National Register of Historic Places in 1973.

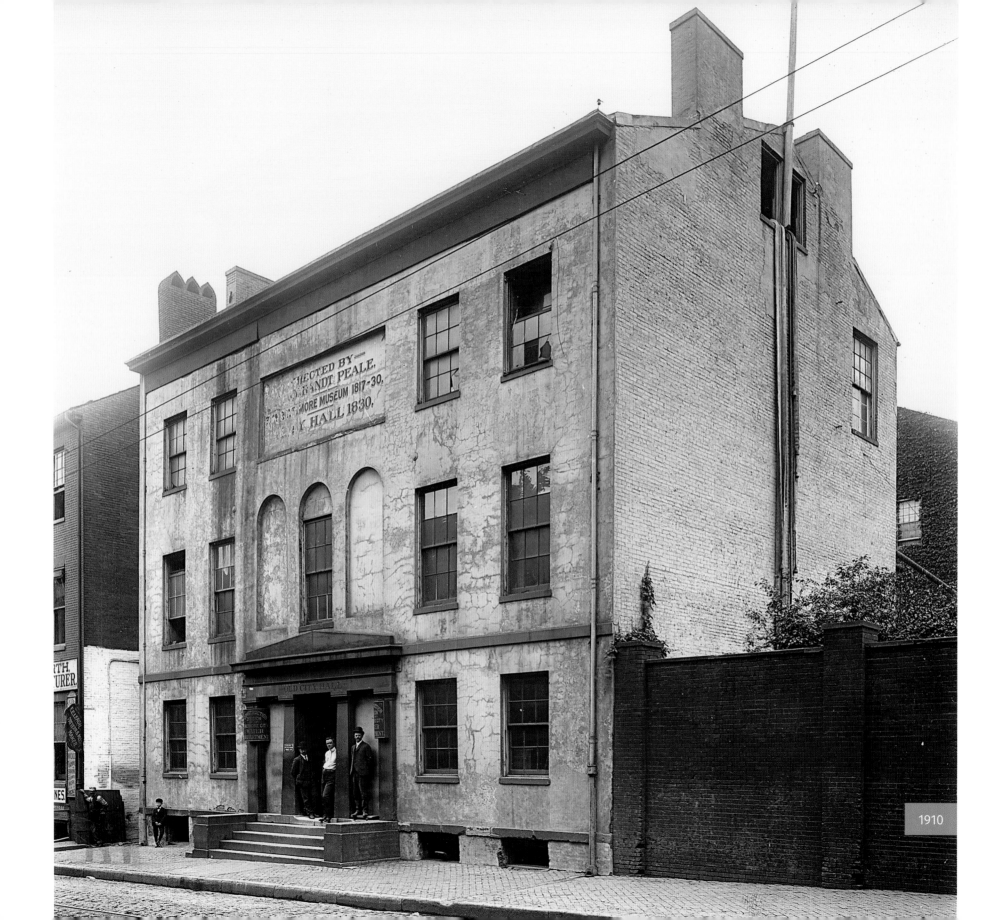

ERECTED BY
REMBRANDT PEALE.
BALTIMORE MUSEUM 1817-30.
CITY HALL 1830.

OLD CITY HALL

1910

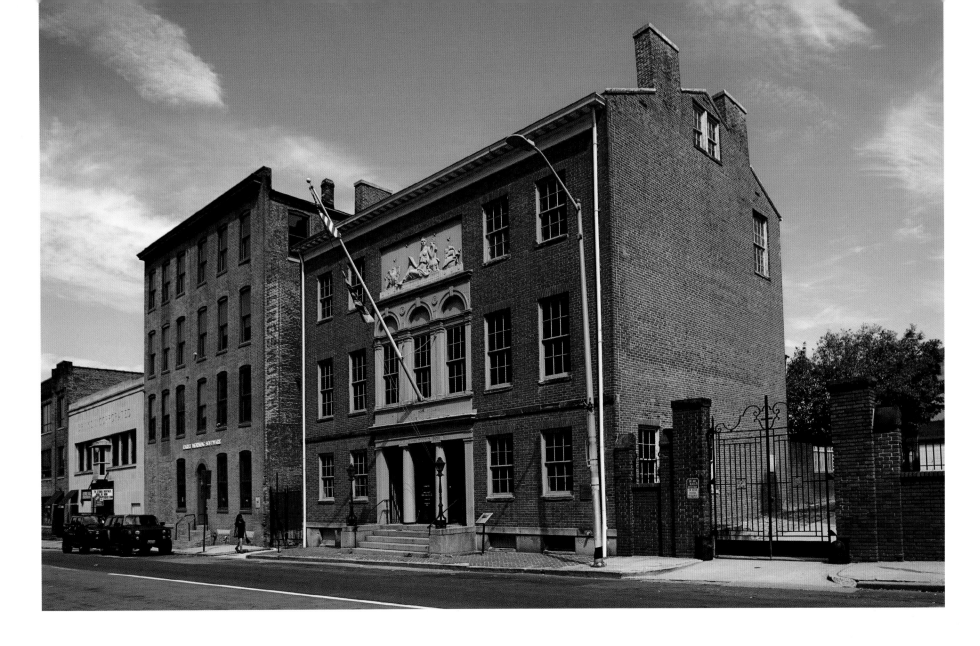

PEALE MUSEUM

The first building in America specifically designed as a museum

LEFT: Built in 1814 by Rembrandt Peale as a tribute to his father, Charles Wilson Peale, this house at 225 Holiday Street was the first building in America specifically designed as a museum. Later used as Baltimore's City Hall between 1830 and 1875 (when replaced by the current City Hall), it would also be the first building in the United States to be lighted with natural gas, in 1816.

ABOVE: The building was later used as a school, an office for the water board, and even factory space. It was condemned by the city in 1928, but rescued by preservationists who reopened it as a city museum in 1931. Its collections have since been transferred to the Maryland Historical Society, but the Peale Museum still stands as the oldest museum building in the Western Hemisphere. However, it sits vacant, having last been used as meeting and conference space by the city government in the 1990s. A nonprofit organization, the Peale Center for Baltimore History and Architecture, is hoping to reopen the building as a museum.

c. 1890

EXCHANGE PLACE

The body of Abraham Lincoln lay in state here in 1865

LEFT: The Merchant's Exchange, at Exchange Place on Lombard Street between South and Gay streets, was another Benjamin Latrobe building of Greco-Roman design. Begun in 1815, but under construction for years afterward, it contained a great many civic functions such as the post office, the customs house, a hotel, and a bank. The body of Abraham Lincoln lay in state under the dome while en route from Washington, D.C. to Illinois in 1865. It is seen here in a view looking east on Lombard Street.

ABOVE: The Merchant's Exchange would become obsolete by the twentieth century, with its functions replaced by individual buildings—including a new post office and a custom house; it was slowly dismantled beginning in 1901. The fire of 1904 would lay waste to this area, changing the buildings and the street layout noticeably. Presently, a modern office high-rise stands at 300 East Lombard Street at left; it incorporates the historic three-story stone structure of 301 Water Street (shown right) on the opposite side. The north side of the 400 block houses the U.S. Custom House (begun in 1903 and delayed by the fire of 1904) and its reserved parking lot.

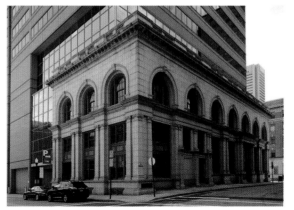

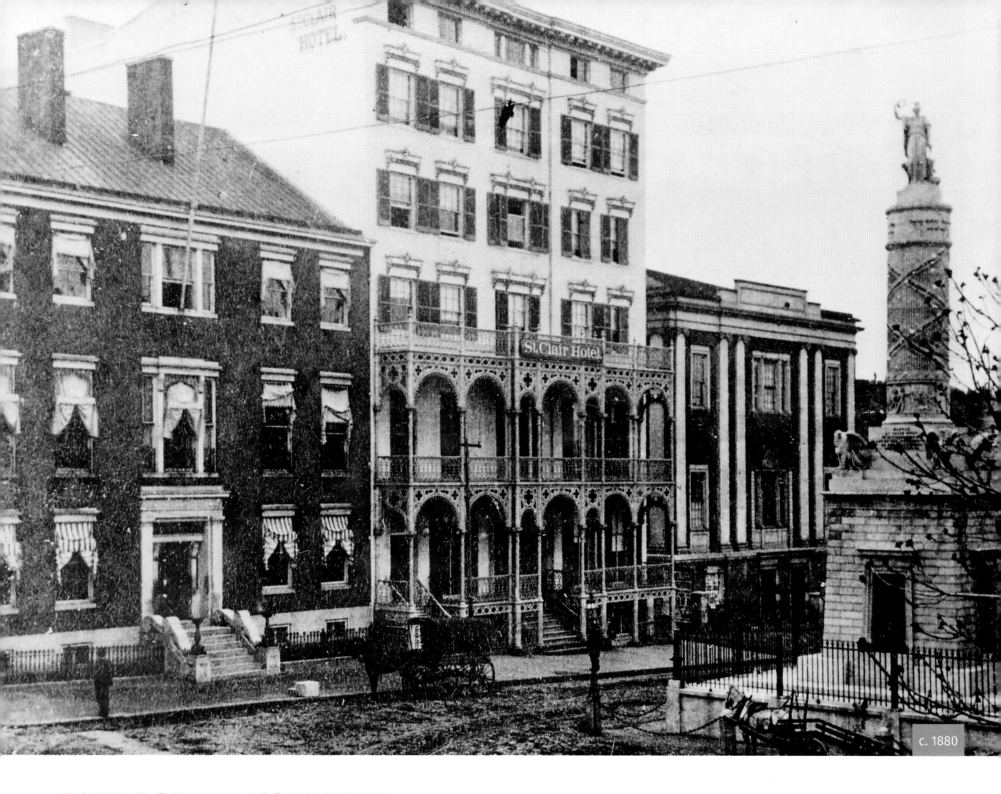

c. 1880

BATTLE OF 1814 MONUMENT

A symbol of the city since 1827

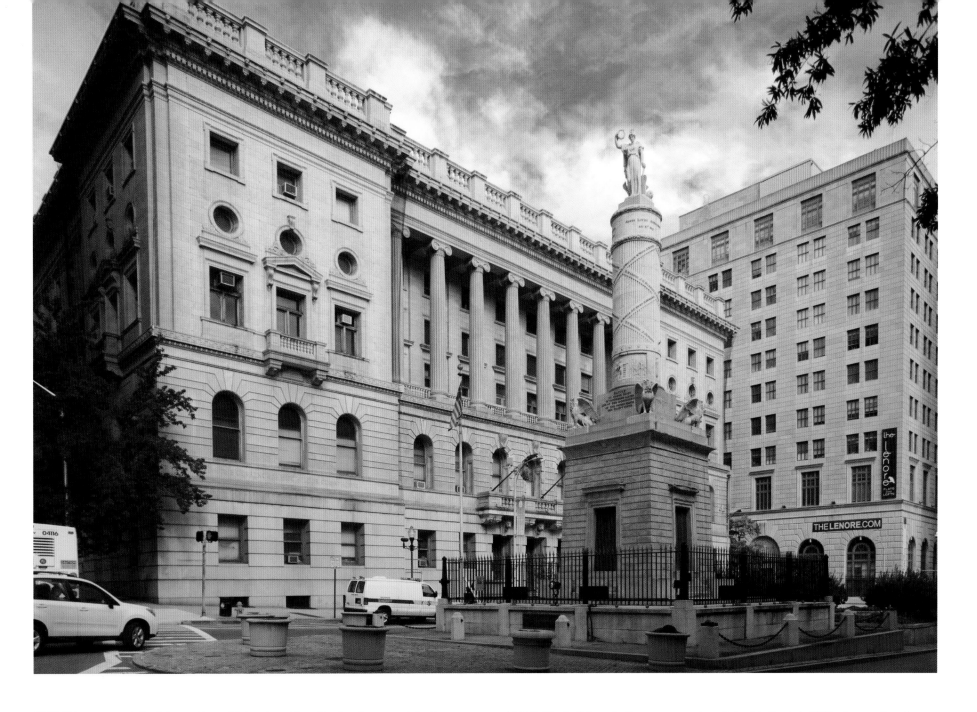

LEFT: This square, at the intersection of Calvert and Fayette streets, was originally slated to receive a monument to George Washington (instead placed on Charles Street). Instead it saw the erection of a memorial to the soldiers who fought at Fort McHenry and the lesser-known Battle of North Point in 1814, designed by Maximillian Godefroy and completed in 1825. Behind the Monument, on the west side of Monument Square, can be seen the Gilmor House, later the St. Clair Hotel. Built about 1840, it was flamboyantly decorated with wrought iron in a style reminiscent of the antebellum South.

ABOVE: The buildings to the rear were demolished in the late 1890s for construction of the present-day French-Renaissance design Baltimore City Courthouse, opened in 1900 and now named the Clarence T. Mitchell Courthouse. The city landscaped the square in 1964 and installed the Memorial to the Black Soldier at the other end of the plaza facing north on Calvert Street in 1971. The Battle of 1814 Monument has been a symbol of the city on documents and coats-of-arms since 1827.

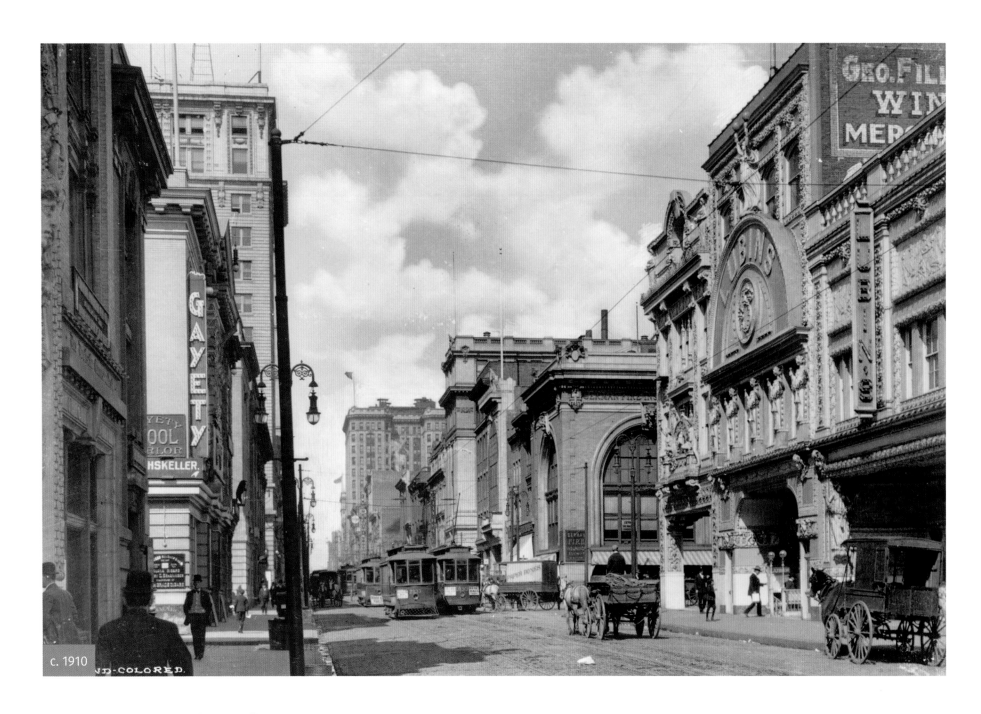

c. 1910

EAST BALTIMORE STREET
From theater district to red-light district

LEFT: In the early twentieth century Baltimore was home to a number of elegant theaters. Two of them feature in this photo of East Baltimore Street's 400 block. Lubin's on the right was opened in 1907 as part of a chain of theaters owned by German-born, Philadelphia-based motion picture pioneer Siegmund Lubin. The lower hall screened movies while the theater upstairs was devoted to vaudeville. The Gayety on the left opened as a burlesque theater in 1906 and went on to feature famous comedians such as Jackie Gleason and Abbott and Costello, as well as talents such as Gypsy Rose Lee and Margie Hart. The tall building in the distance is the 1906 B&O Building on the corner of Charles Street.

ABOVE: "The Block," as this stretch of Baltimore Street is known, has become the city's red light district with many of its former theaters turning into strip clubs and adult stores. Lubin's was renamed the Plaza in 1927 and then the Gayety Show World, a lap-dancing club. The building was gutted by fire in 2010 and remains vacant. The Gayety across the road went on to show X-rated movies and is currently home to an adult store and the Hustler Club. The B&O Building, which is obscured by new skyscrapers, is still standing on the corner of Charles Street and is now occupied by the Hotel Monaco.

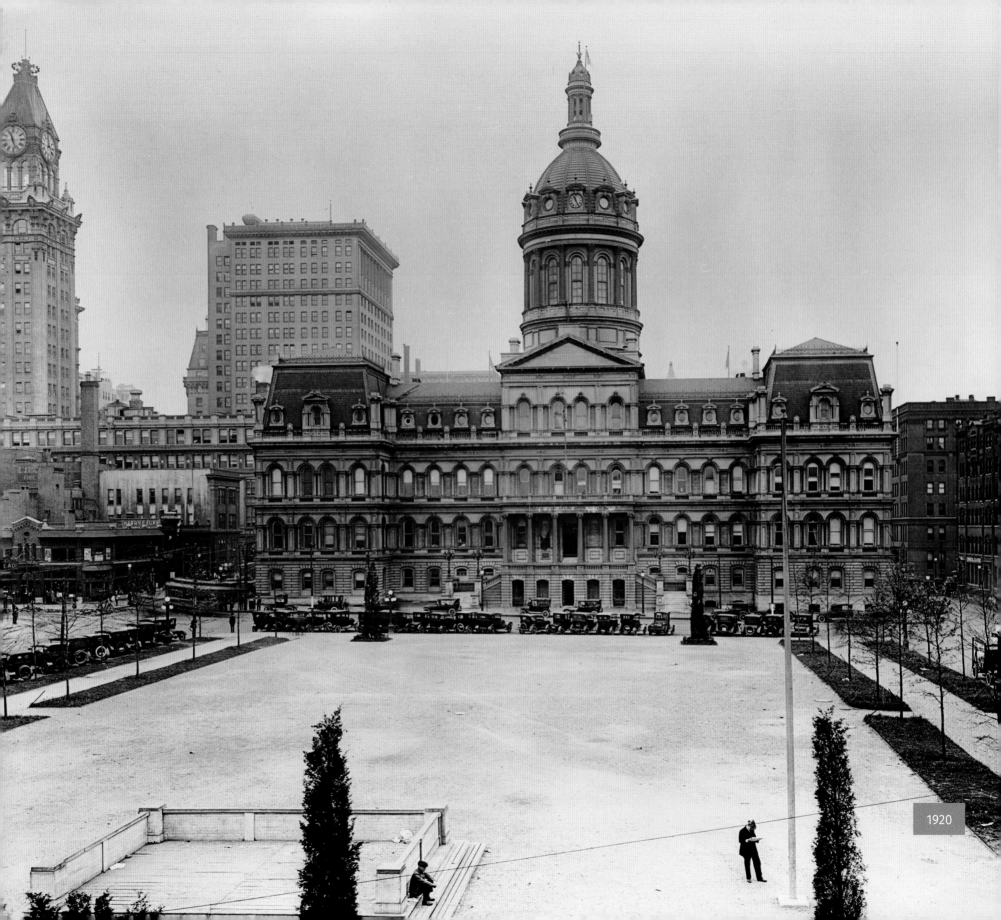
1920

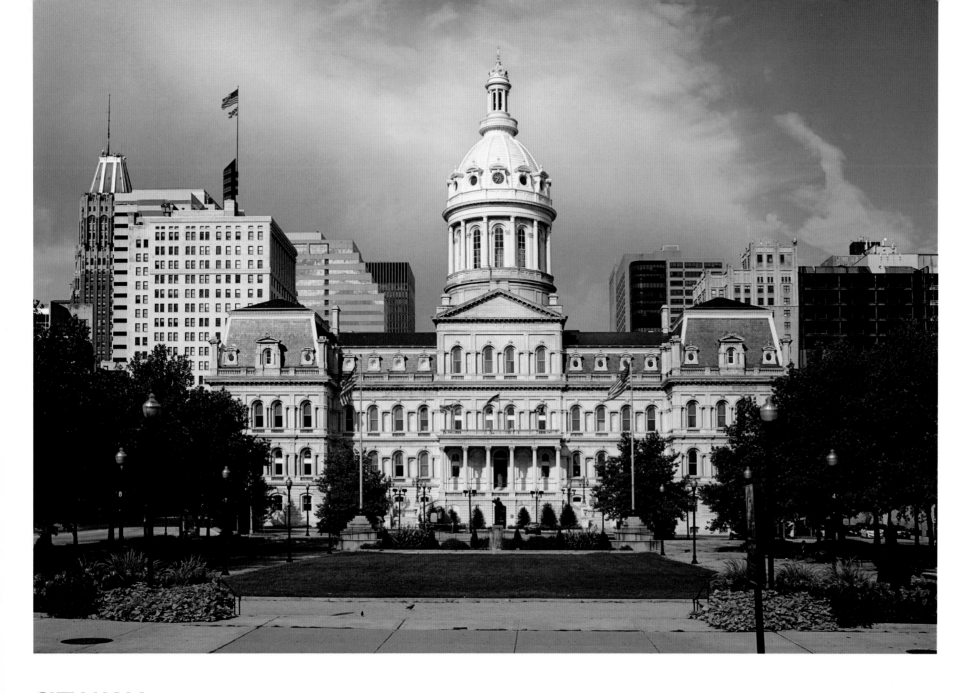

CITY HALL
The official seat of government of the City of Baltimore

LEFT: The original City Hall, now the Peale Museum, was replaced by this majestic structure designed by George Frederick. First proposed in 1851, its construction did not begin until 1867; it was completed in October 1876 at a total cost of over a quarter of a million dollars. The plaza in the foreground was added in 1920 as part of the War Memorial, behind the photographer.

ABOVE: City Hall, although much modified and expanded, continues to serve its original function today. Its brick and marble structure is topped by an iron dome that rises 227 feet above the ground. It received a renovation and makeover in 1975–1977 for the U.S. Bicentennial. Another plaza occupies the land between City Hall and the War Memorial (behind the photographer), built in 1921–1925.

CALVERT STATION / *BALTIMORE SUN* OFFICES

The station served as the terminus for trains to Pennsylvania and Lake Ontario

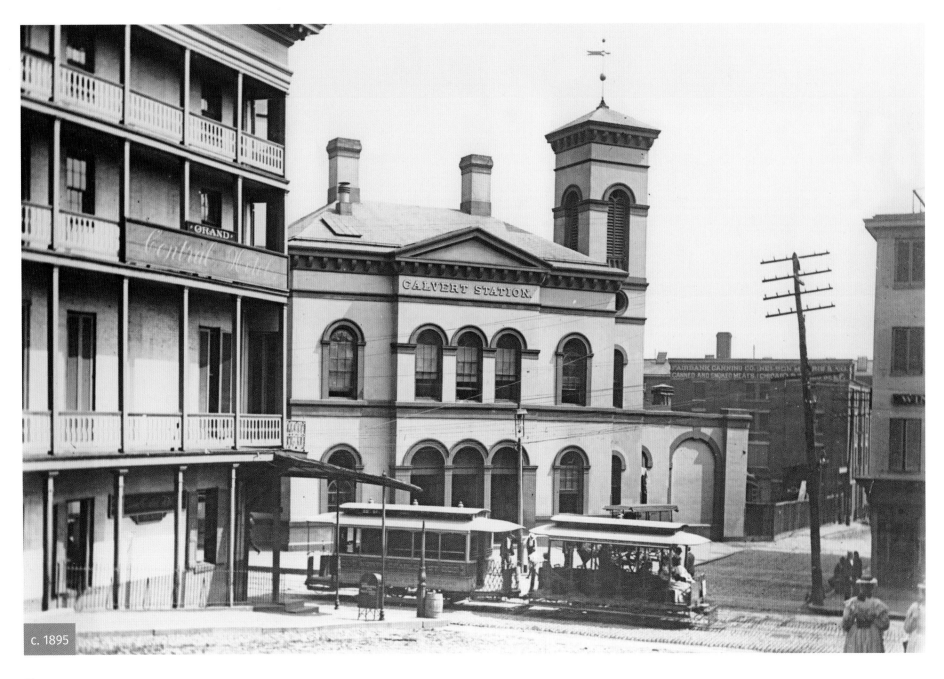

c. 1895

LEFT: Built in 1848–1850 for the Baltimore & Susquehanna Railroad, which was later absorbed by the Northern Central RR and then the Pennsylvania RR, this oddly-slanted Italianate building at the northeast corner of Calvert and Bath streets served as the terminus for trains operating north to Pennsylvania and Lake Ontario, as well as headquarters for the Northern Central. A massive brick train shed, built in 1865 to add additional freight facilities, later stretched behind this headhouse. When the PRR built another route through the city via two tunnels and Union Station in the early 1900s, this station became primarily a commuter station. To the left is the old Grand Central Hotel; to the right stands the Windsor Hotel. The streetcars in the foreground of this photo are not electric cars, but examples of the Baltimore City Passenger Railway's short-lived cable car operation, similar to the still-surviving system in San Francisco.

BELOW: The depot was razed in 1948 for construction of the new offices and printing plant of the *Baltimore Sun* newspaper, which were opened in 1950. The *Sun*'s building was remodeled in later years and expanded in 1981; the main entrance is just out of sight to the left of the far wall. The 1865 freight trainshed to the north was saved, albeit in altered form, and now houses the Baltimore Athletic Club, which was formerly a neighbor of Pennsylvania Station further north. The *Baltimore Sun* newspaper would erect a new building in the 1990s in Port Covington, also atop former railroad property in South Baltimore.

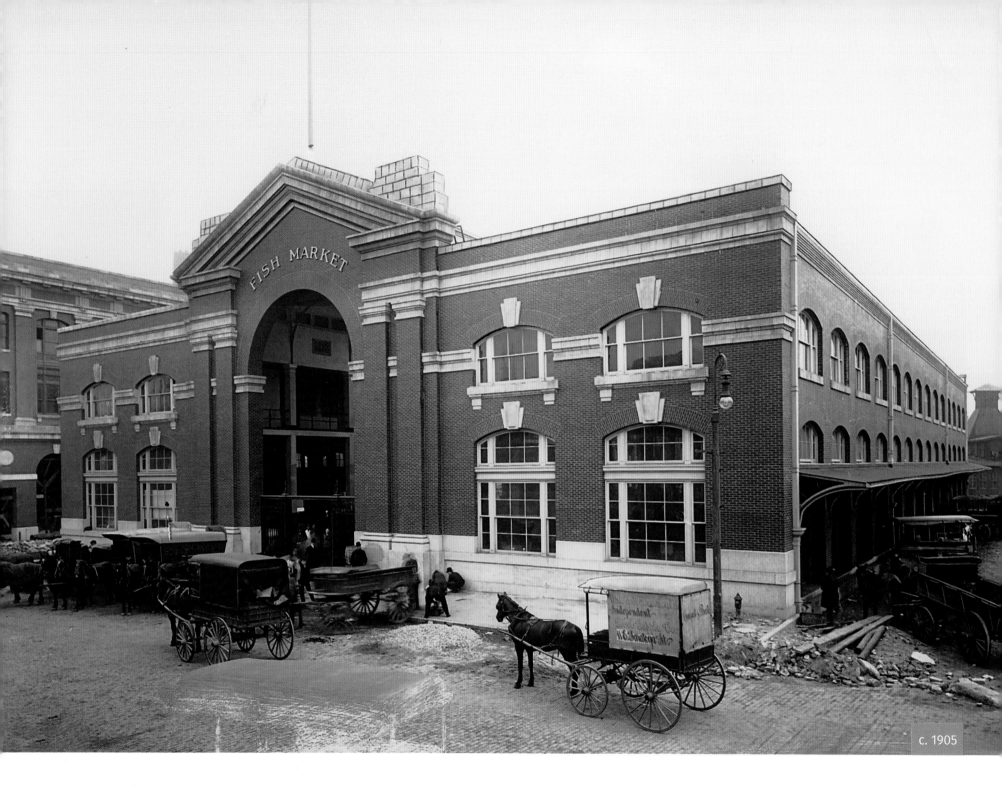

c. 1905

FISH MARKET / PORT DISCOVERY

The former market is now a children's educational museum

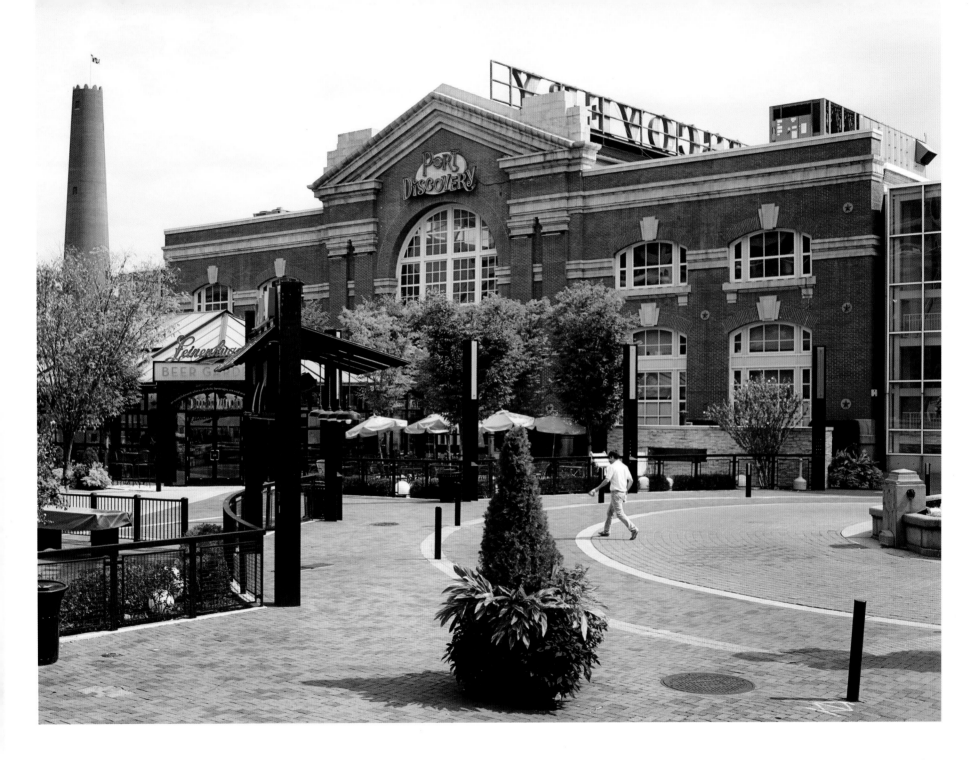

LEFT: The Fish Market was built after the fire of 1904 as an official wholesale seafood marketplace in a city long a hotbed of fish-selling, due to its proximity to the Chesapeake Bay. The Fish Market would be replaced by more modern facilities, most notably a facility in Jessup, Maryland, by the 1980s. The original building was then developed into a nightclub, mall, and entertainment hall, but that would close in 1989.

ABOVE: The hall would stand vacant for nearly a decade until Port Discovery, one of the largest children's educational museums in the nation, opened at the end of December 1998. The nonprofit enterprise was developed in conjunction with commercial developers, including the Walt Disney Company. The 1828 Shot Tower is to the left.

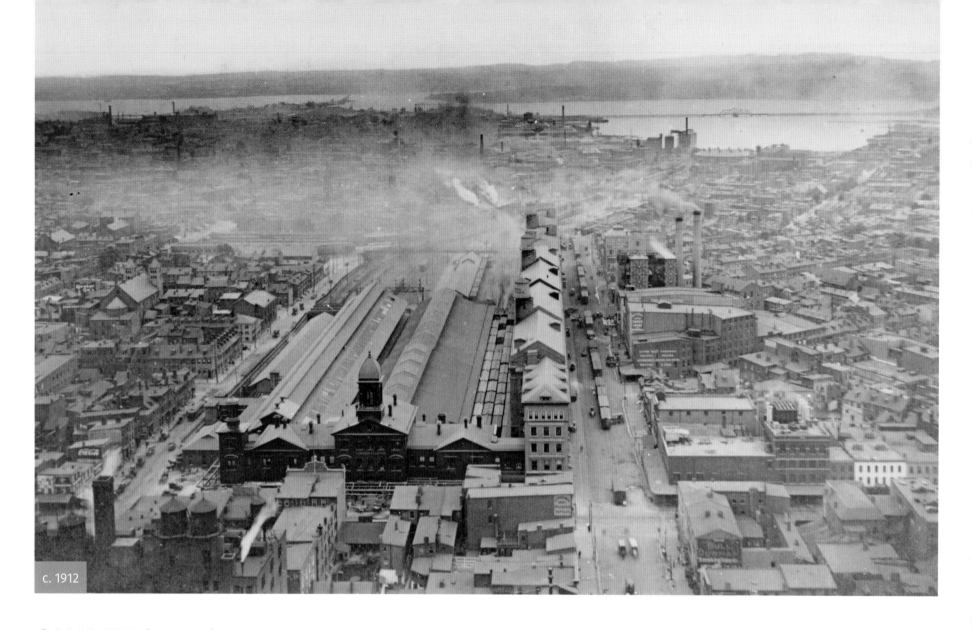

c. 1912

CAMDEN STATION

Commuter trains and Light Rail transit cars still use the station

ABOVE: This spectacular photograph, taken around 1912 from the recently completed Emerson Tower (better known as the Bromo-Seltzer Tower), shows the Baltimore & Ohio Railroad's Camden Station and surrounding facilities stretching almost to the water (a roundhouse for locomotives is at upper right). Camden Station, built from 1857 to 1866, was the B&O's major terminal in town, and dozens of freight cars can be seen between the passenger shed and the railroad's long (1,100 feet) and narrow 1899–1905 warehouse, as well as on Eutaw Street to the warehouse's right. To the upper left of the trainshed can be seen a train heading into or out of the Howard Street Tunnel, which still runs under downtown Baltimore to the Mount Vernon area

and Mount Royal Station. The air in the distance is thick with coal smoke from the B&O's steam locomotives and local industry such as the Baltimore City Cold Storage Co., whose smokestacks are to the right. Formerly a heavily residential area, the Camden neighborhood held a large number of English and German immigrants. Among them was a tavern owner named George Herman Ruth, Sr., the father of baseball legend Babe Ruth. Through the distant haze, the Western Maryland Railroad can be seen crossing the Middle Branch of the Patapsco River on trestles and a swing bridge to access Port Covington.

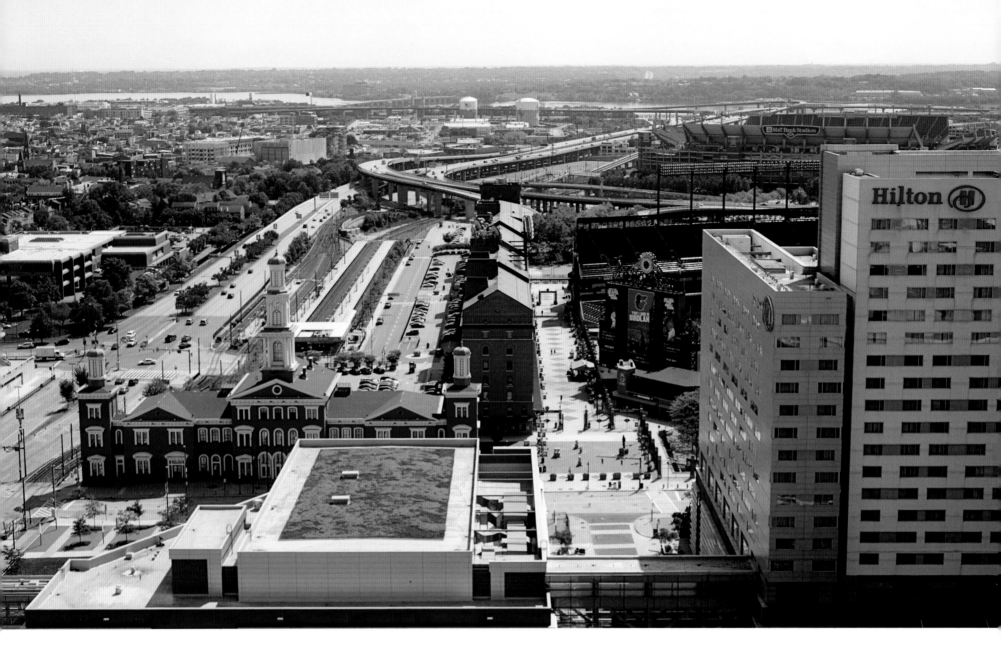

ABOVE: The air is clearer in this modern view from the Bromo-Seltzer Tower. Far left is the red-brick Federal Reserve Building, built in 1980. Urban renewal robbed the Camden area of many residences and businesses; by 1980 the railroad company had proposed another high-rise office and residential complex on the former railroad yard site. City and state officials, however, wanted a sports stadium to replace the aging Memorial Stadium uptown, and from 1986 worked to acquire the site and build the 48,000-seat Oriole Park at Camden Yards, opened in April 1992. The design, which also incorporated the B&O Warehouse and former Eutaw Street, has been hailed as one of the most successful and popular stadium designs in America. It was followed by the opening in September 1998 of the 69,000-seat PSINet Stadium (now M&T Bank Stadium), built for use by the new Baltimore Ravens football team and seen in the distance. The station building, which was altered many times over the years, was completely restored to a close approximation of the original (Italianate) design and is now occupied by Geppi's Entertainment Museum, which spans 250 years of American pop culture. Commuter trains to and from Washington, D.C. still use the station, as do Light Rail transit cars on the tracks to the left. The Hilton Hotel and conference center on the right opened in 2008.

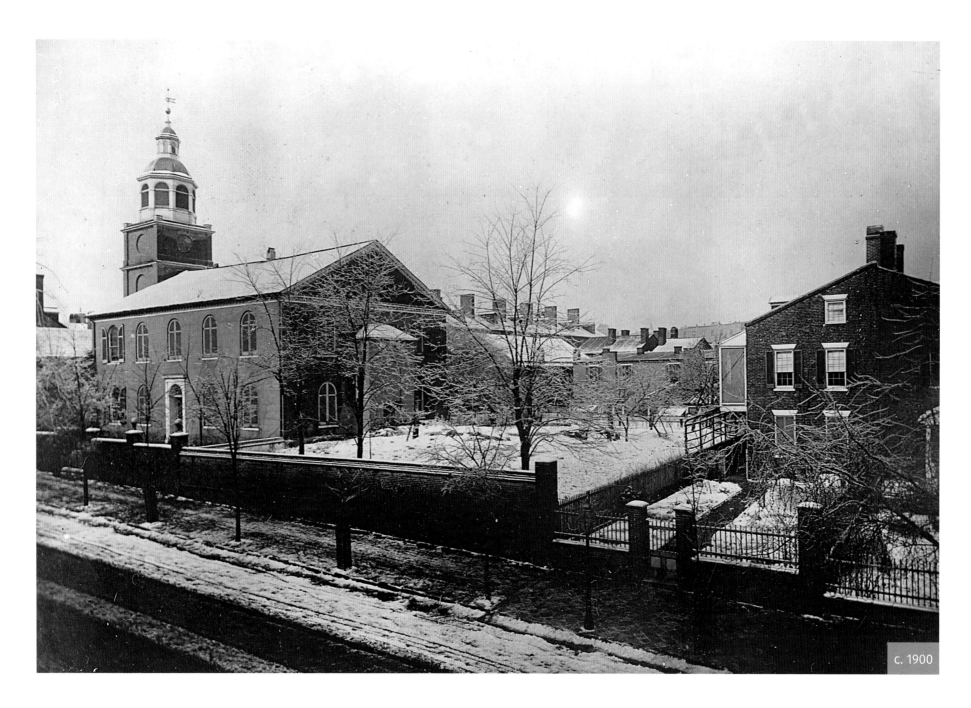

c. 1900

OLD OTTERBEIN CHURCH

The oldest church building in Baltimore

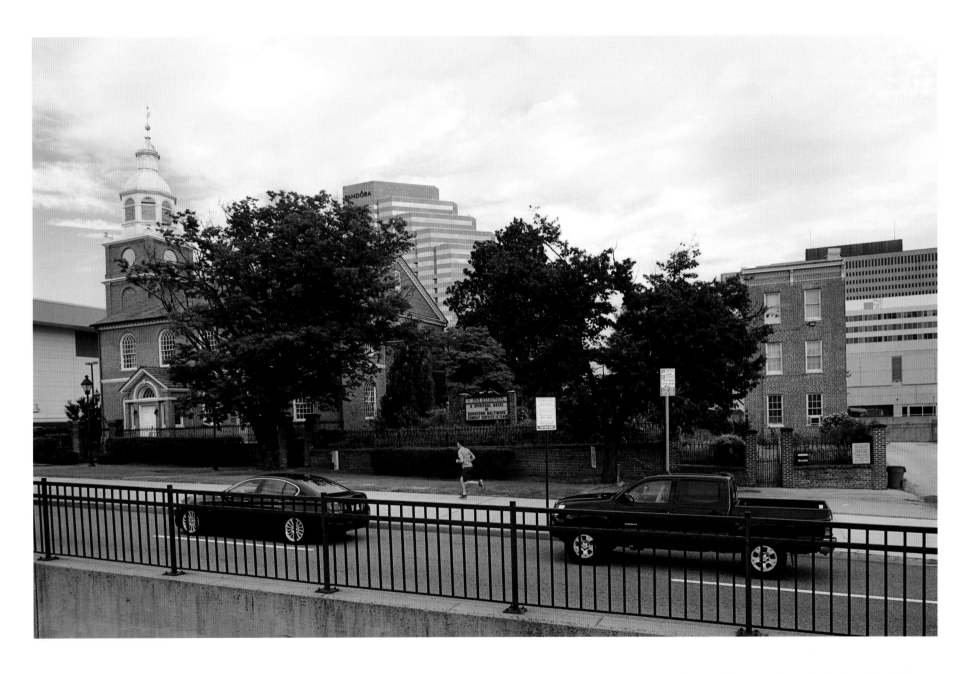

LEFT: Built with imported English brick as the German Evangelical Reformed Church at the corner of Sharp and Conway streets in 1785, this church would hold all its services in German until anti-German sentiment ran rampant during World War I. The church and the neighborhood would be named for Phillip Wilhelm Otterbein, the preacher buried outside the church.

ABOVE: Now the oldest church building in Baltimore, Old Otterbein Church (which became United Methodist in 1968) proudly holds its own against the surrounding Baltimore Convention Center (built in 1979 and expanded in 1996) and the nearby highways and ballpark.

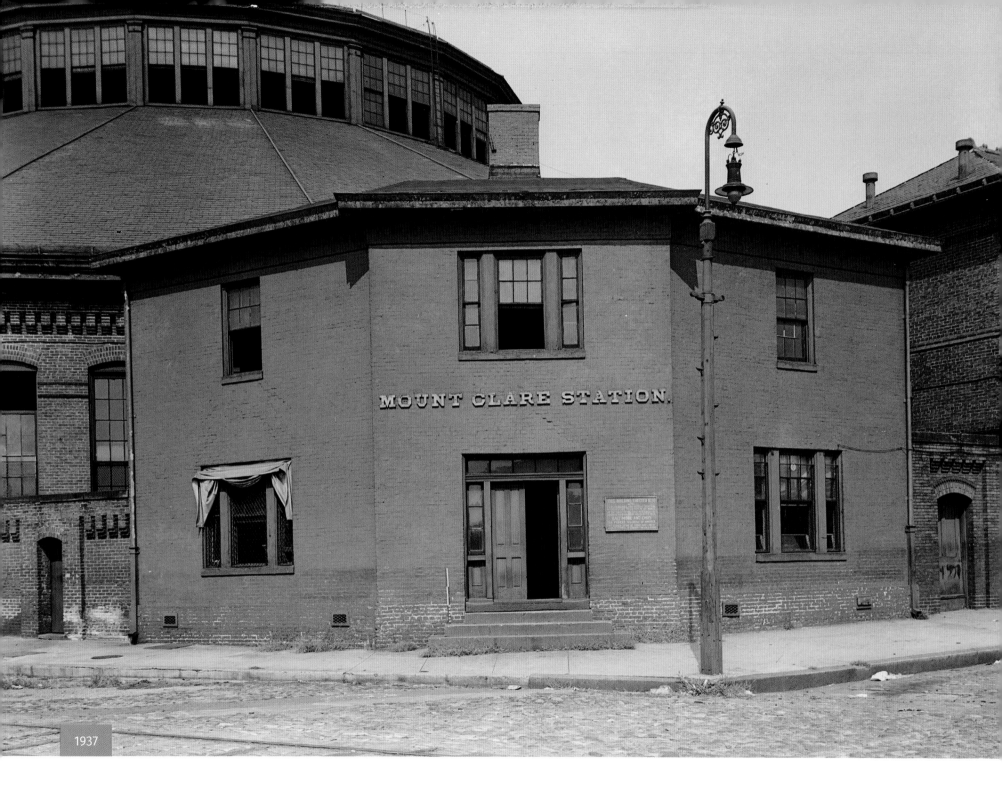

1937

B&O MOUNT CLARE STATION / MUSEUM
The Baltimore terminus of America's first major railroad

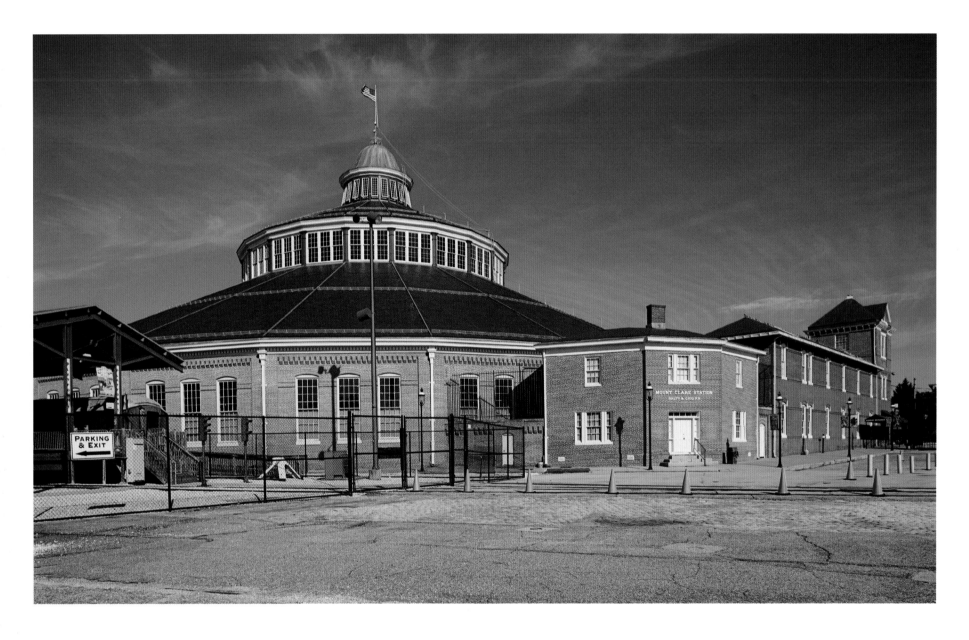

LEFT: The small red-brick attachment to the "roundhouse" is at the approximate location of the original 1827 Baltimore terminus of the Baltimore & Ohio, America's first major railroad. (Although often referred to as the oldest station in America, the current structure on the site dates to approximately 1851.) Around it grew the railroad's Mount Clare Shops, where thousands of railroad locomotives and cars were built and maintained over the course of 120 years. On May 24, 1844, Samuel F. B. Morse sent the first long-distance telegraph message from Washington, D.C. to Mount Clare Station.

ABOVE: The roundhouse, built in 1884 as a passenger car shop and one of the few such steam-era structures preserved in the nation, had been used by the B&O for storage of vintage rolling stock since the 1920s. Upon the closure of the shops, the B&O Transportation Museum was opened in the roundhouse by the railroad's public relations department in 1953. In 1989 the B&O Railroad Museum became independent from the railroad, and continues to function today as one of the world's largest and finest railroad museums.

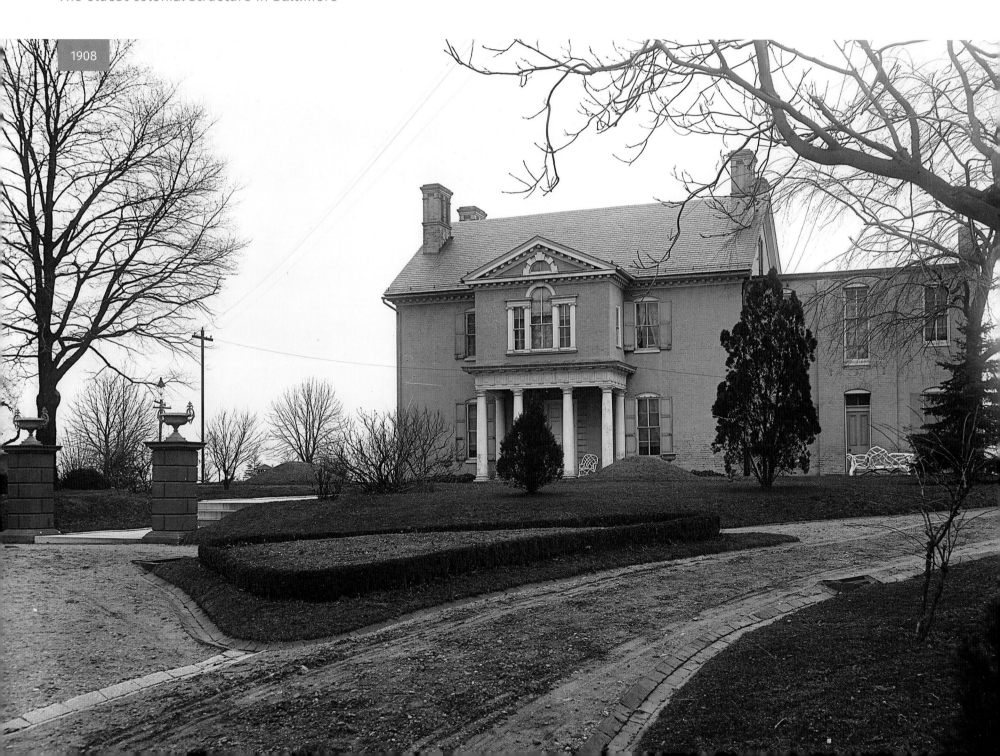

MOUNT CLARE MANSION
The oldest colonial structure in Baltimore

1908

LEFT: The Mount Clare Mansion in Carroll Park in southwest Baltimore, the oldest extant colonial structure in Baltimore, was built by Charles Carroll in 1760. A five-part Georgian mansion, Mount Clare was the center of Carroll's 800-acre Patapsco River plantation. The estate supported wheat fields, a grist mill, an orchard, racing stables, flour mills, brick kilns, and a shipyard. Charles Carroll inherited the family plantation upon the death of his brother and eventually began constructing a two-story Georgian brick house with a partial basement and attic.

BELOW: Mount Clare remained in the Carroll family until 1890, when it and the remaining estate property was sold to the city of Baltimore for use by the Department of Recreation and Parks. In 1917, The National Society of the Colonial Dames of America in the State of Maryland, through an agreement with the city of Baltimore, became custodians of the Mount Clare Mansion. The Society houses a collection of over 1,000 objects, including rare pieces of Chippendale and Hepplewhite furniture, silver, crystal, Chinese-export porcelain, and family portraits by noted artists of the time. Mount Clare was listed in the National Register in 1970.

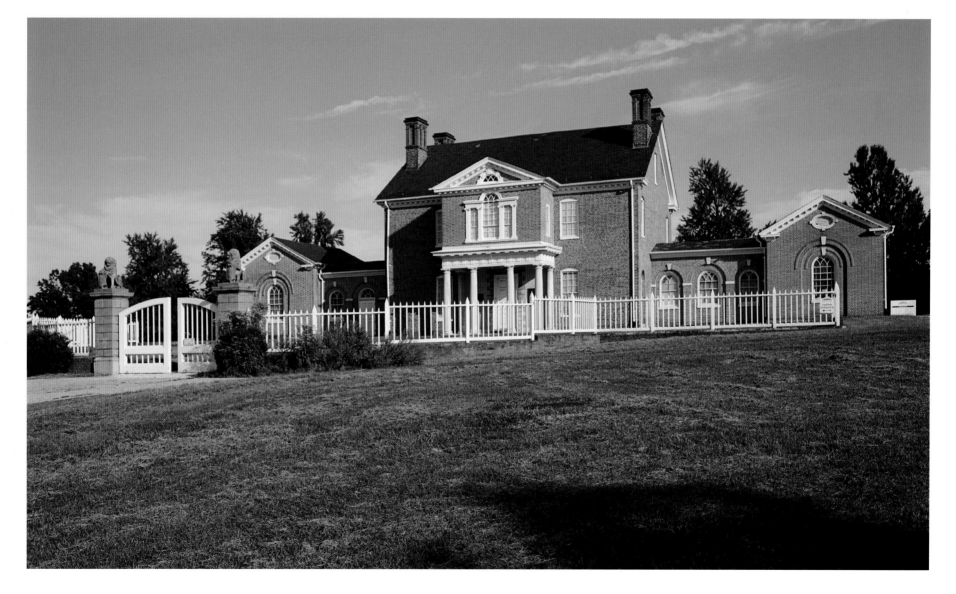

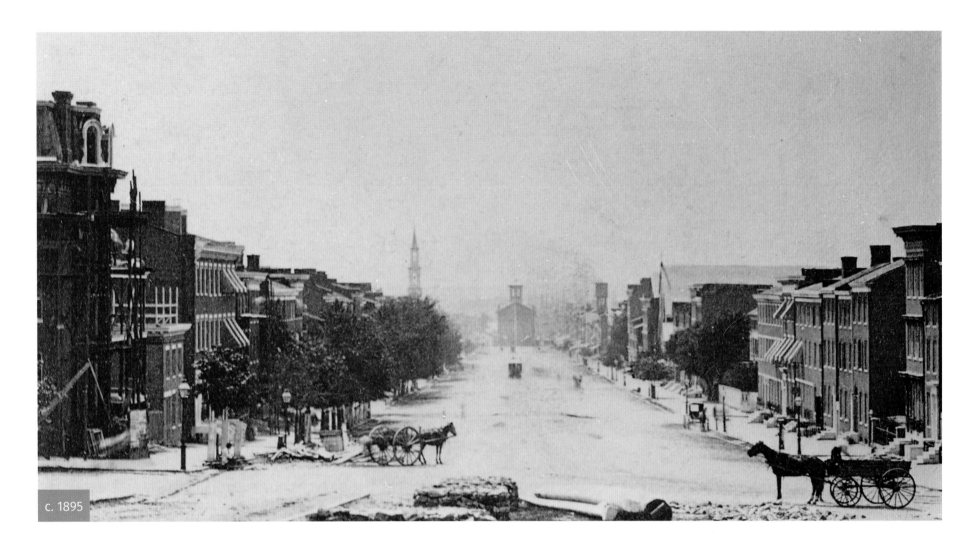

c. 1895

BROADWAY

Comparatively little has changed since the 1890s

ABOVE: At the distant center of this late-1800s view of Broadway south from Baltimore Street toward Fells Point can be seen the Broadway Market, one of several city markets. To its left is the spire of the original St. Patrick's Roman Catholic Church, built in 1806–1807 and replaced by a Gothic Revival building in 1897. The house to the left, at 1701 East Baltimore Street, is being remodeled with a Victorian makeover.

RIGHT: Today, comparatively little has changed physically, save for the traffic and vehicles. The stretch of Broadway nearest the camera has become Baltimore's unofficial Hispanic district, with many restaurants and shops catering to a Central American immigrant population. A different Broadway Market building—one of five still remaining in the city—still occupies the foot of its namesake street at Fells Point. Just visible on the right, the Holy Cross Polish National Catholic Church, built in 1897–1901, has added its spire to the west side of Broadway. The antebellum house at left would be remodeled once again in the 1970s into apartment units.

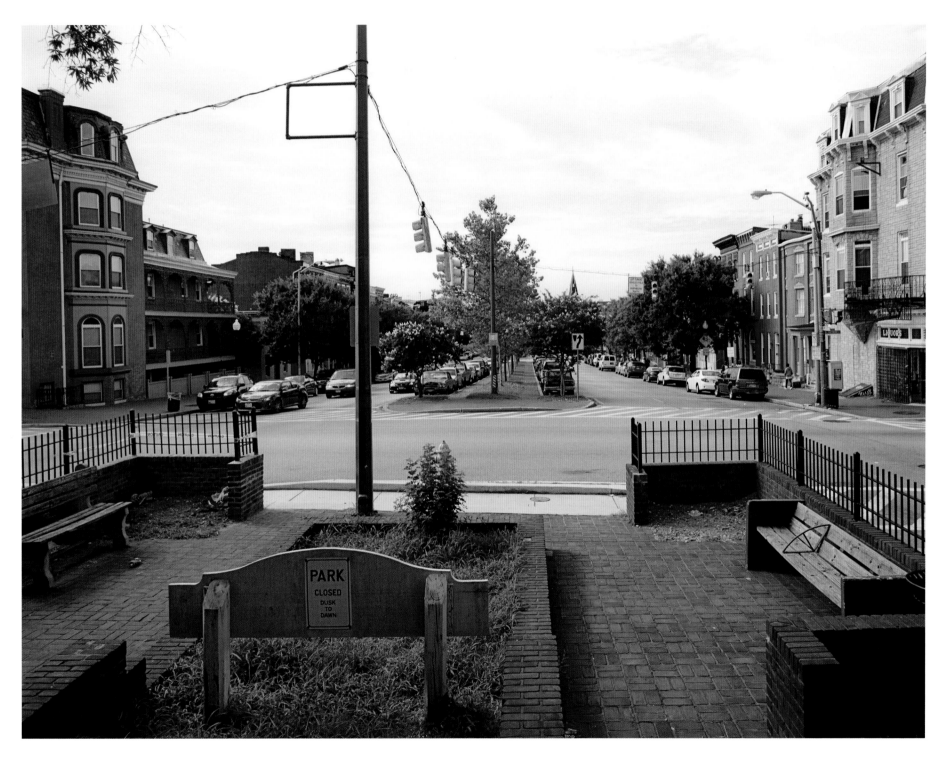

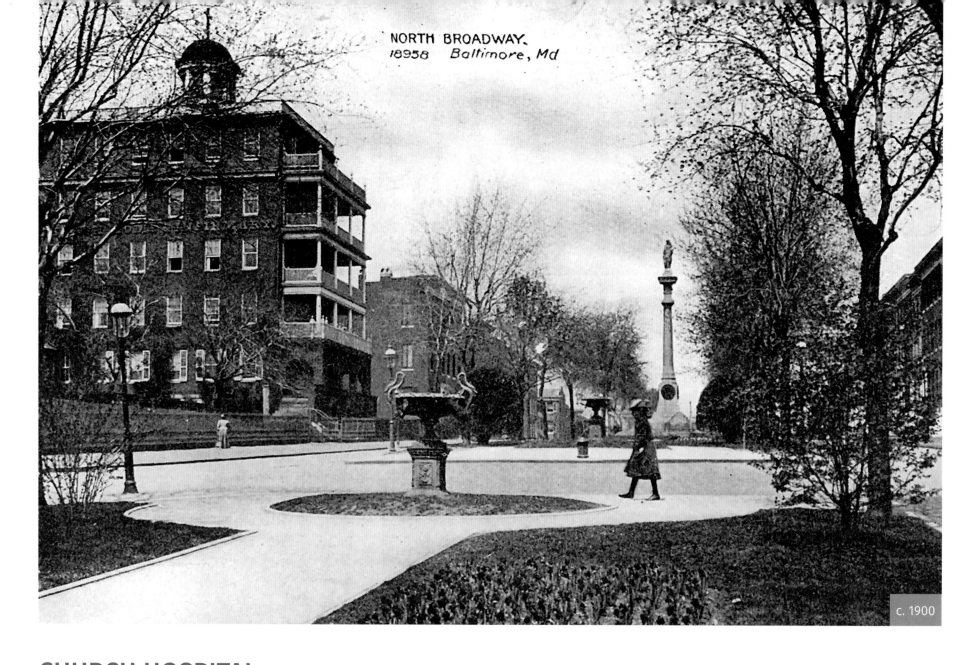

NORTH BROADWAY.
18958 Baltimore, Md

c. 1900

CHURCH HOSPITAL

Absorbed by Johns Hopkins Hospital

ABOVE: Looking north from the previous photo, we see to the left the cupola of the former Washington Hill Hospital, later known as the Church Hospital. This hospital would oddly find its place in history from a death. The famous writer Edgar Allan Poe, who lived in Baltimore at the time, staggered to the hospital ill with pneumonia and died within its walls in 1849. The monument was erected in 1865 as a memorial to Thomas Wildey (1782–1861), who founded the International Organization of Odd Fellows in Baltimore in 1819.

RIGHT: The Church Hospital would survive into the 1990s, but was eventually absorbed by its comparatively behemoth neighbor The Johns Hopkins Hospital and is now known as the Church House and Hospital. The hospital's former grounds are occupied by a townhouse development known as Broadway Overlook. The Wildey monument is obscured by trees in this view.

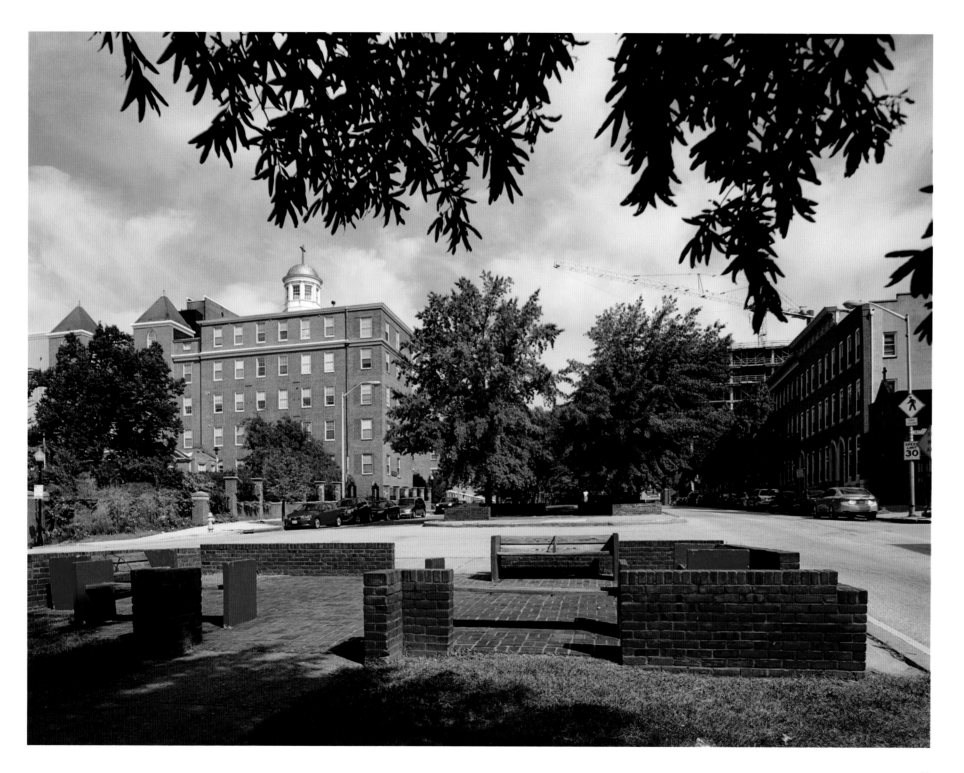

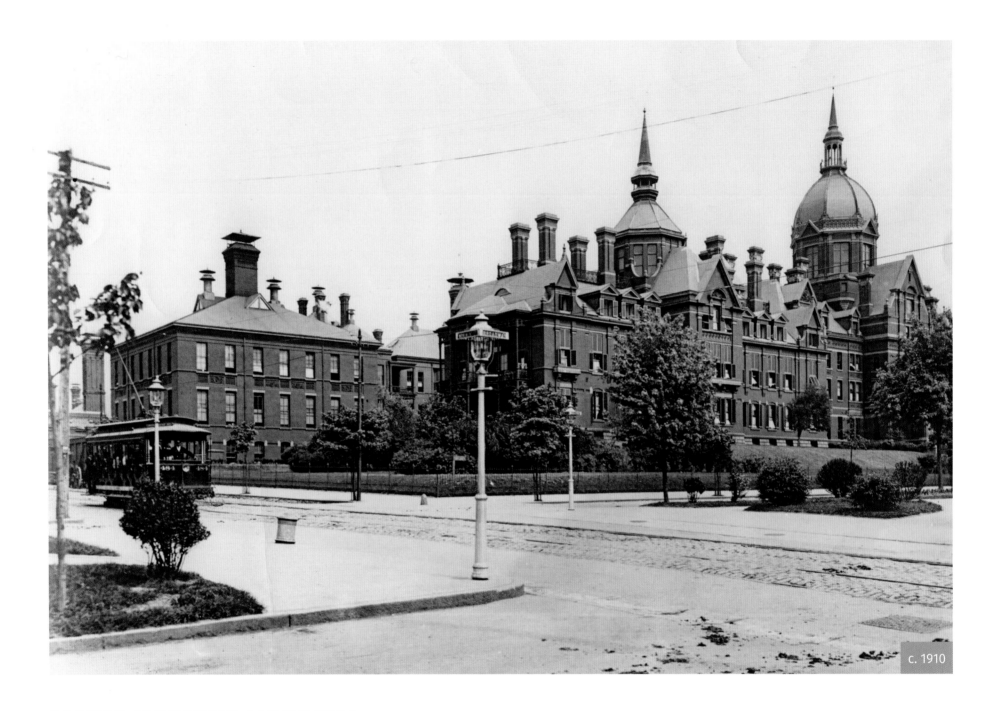

c. 1910

JOHNS HOPKINS HOSPITAL

One of the world's greatest hospitals

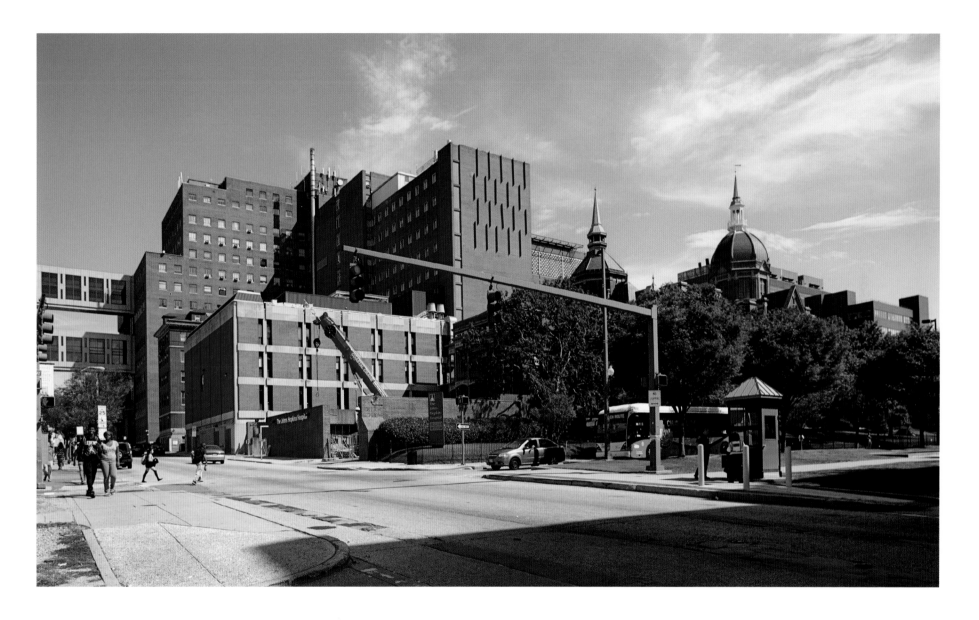

LEFT: In 1867, Baltimore merchant, banker, and philanthropist Johns Hopkins arranged for the incorporation of Johns Hopkins University and Johns Hopkins Hospital. He died on Christmas Eve 1873, leaving seven million dollars—half his fortune—to be divided equally between the two institutions. It was, at the time, the largest philanthropic bequest in U.S. history. The university, opened in 1876, was the first research university founded in the United States. The hospital, which opened in 1889, quickly rose to national prominence and has remained there ever since.

ABOVE: Today Johns Hopkins Hospital and University are among the world's finest graduate-level medical institutions. The Johns Hopkins Hospital Complex, built in phases from 1877 to 1889 and designed by John Niernsee and Cabot & Chandler, contains three Queen Anne–styled brick, sandstone, and terra-cotta buildings—the Administration Building, the Marburg Building, and the Wilmer Building, designed after extensive research in hospital design and construction techniques. The original buildings at the southeast corner of Broadway and Monument streets were listed in the National Register of Historic Sites in 1976.

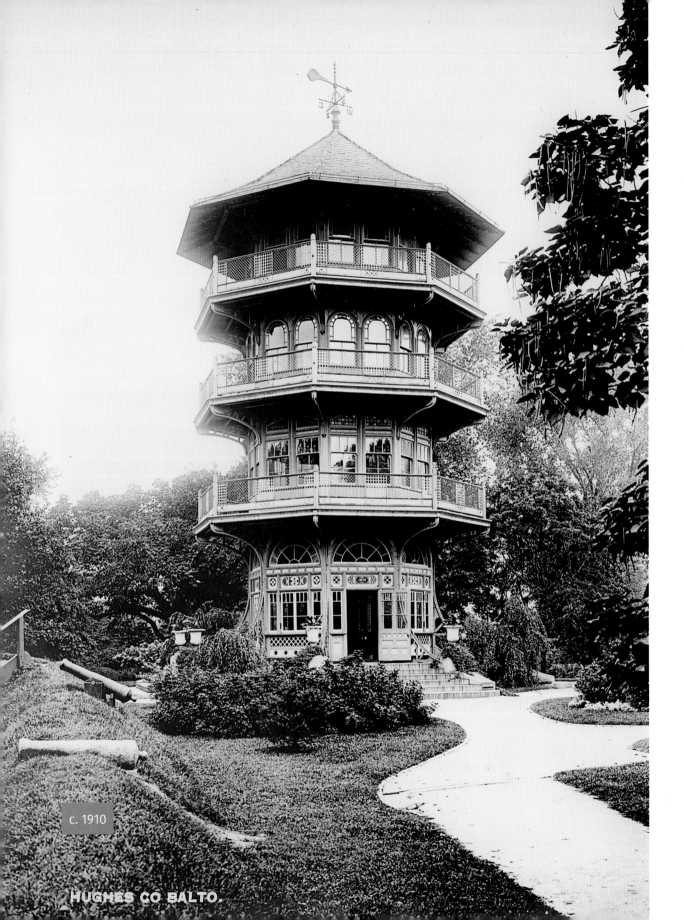

c. 1910

HUGHES CO BALTO.

PATTERSON PARK PAGODA

The park's most distinctive feature

LEFT: In 1827, William Patterson donated five acres of land in East Baltimore for a public park, but it would not be opened as an official city park until 1853. Its most distinctive feature, a multistory (sixty-feet high) observation tower, built in 1892 using Charles H. Latrobe's Pagoda-like design, would reside atop Hampstead Hill, the highest part of the park. This hilltop also saw militia action during the 1814 battles with the British.

RIGHT: Patterson Park was enlarged over the years to 155 acres and is now popular with local dog-owning residents. The pagoda fell into disrepair but was restored and reopened to the public in 2002. It remains at the high point of Patterson Park just off the intersection of Pratt Street and Patterson Park Avenue, adjacent to the Butchers Hill neighborhood. Two marble lions, donated Two marble lions, donated in 1983, stand sentinel over the former entrance, and a cannon from the 1814 war is also preserved adjacent. Below is the park's 1914 memorial to the writing of the "Star-Spangled Banner."

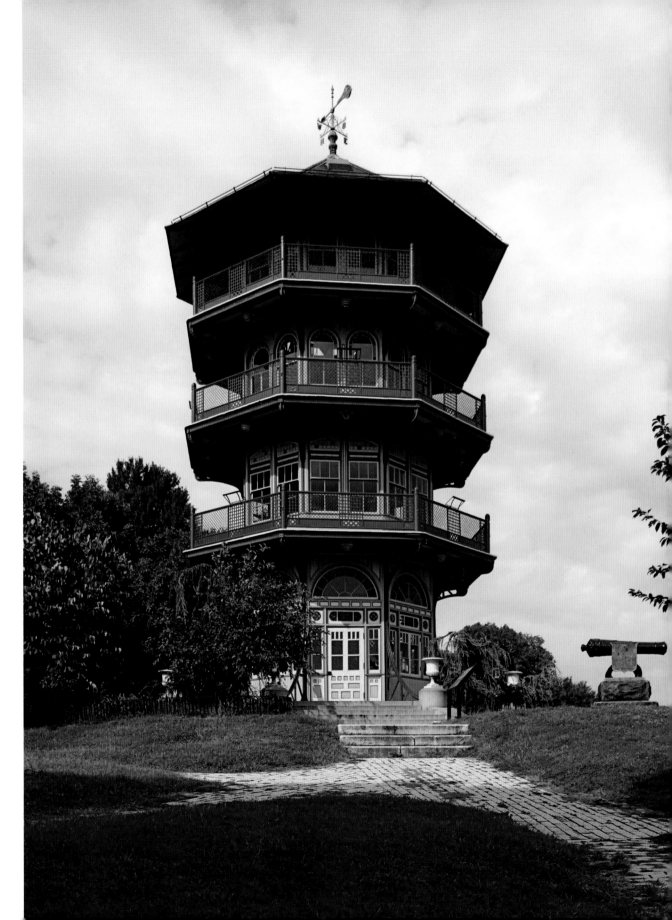

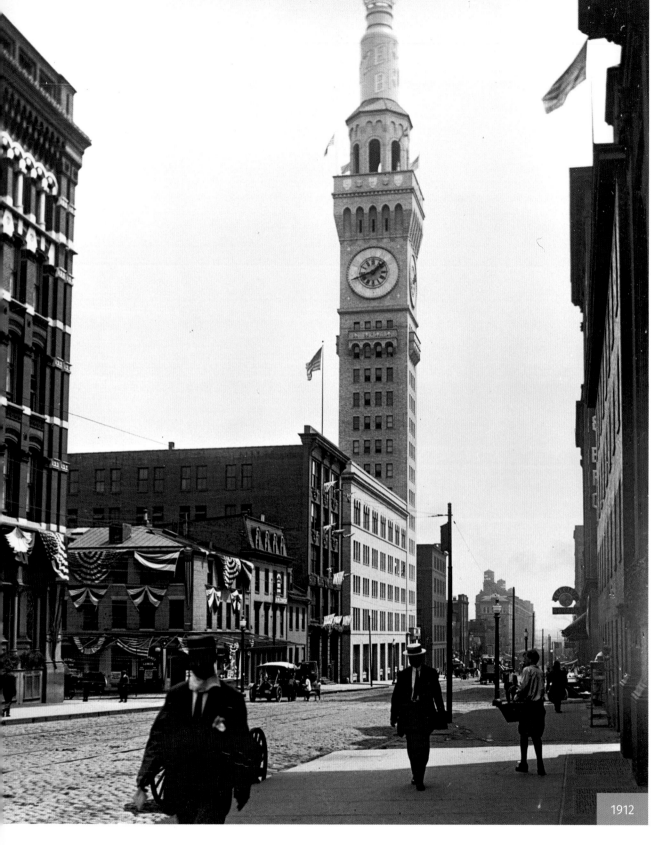

1912

BROMO-SELTZER TOWER
A Baltimore landmark

LEFT AND BELOW: Baltimore has its share of quirky architecture, but probably none is as well-known as the 306-foot-high tower of the Emerson Drug Co. Building. The tower was built in 1911 by Captain Isaac Emerson, the inventor of Bromo-Seltzer, and designed by Joseph Evans Sperry. Modeled on the tower of the Palazzo Vecchio in Florence (although much larger), the tower was originally topped by a fifty-one-foot revolving replica of the blue Bromo-Seltzer bottle. The bottle was illuminated with 596 lights and could be seen twenty miles away.

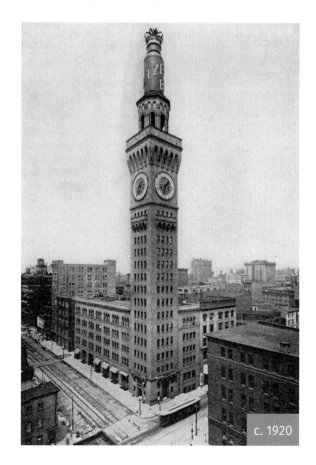

c. 1920

RIGHT: The revolving Bromo-Seltzer bottle had to be removed from the top of the tower in 1936 due to structural concerns—fortunately or unfortunately, depending on tastes. The tower originally adjoined the Emerson Drug Co. Building and the Bromo-Seltzer factory, which is no longer standing. The surrounding structure was replaced by the Baltimore City Fire Department's Central Station, which houses the city's largest and most specialized firefighting equipment. The tower is now home to thirty-three artists' studios and was renamed Emerson Tower. However, its renaming will probably never undo the Bromo-Seltzer Tower name, either on the clock faces or in the hearts of Baltimoreans. The property was listed in the National Register of Historic Places in 1973. The tower is open to the public for tours of the artists' studios and the clock room (shown below).

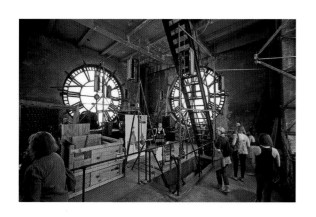

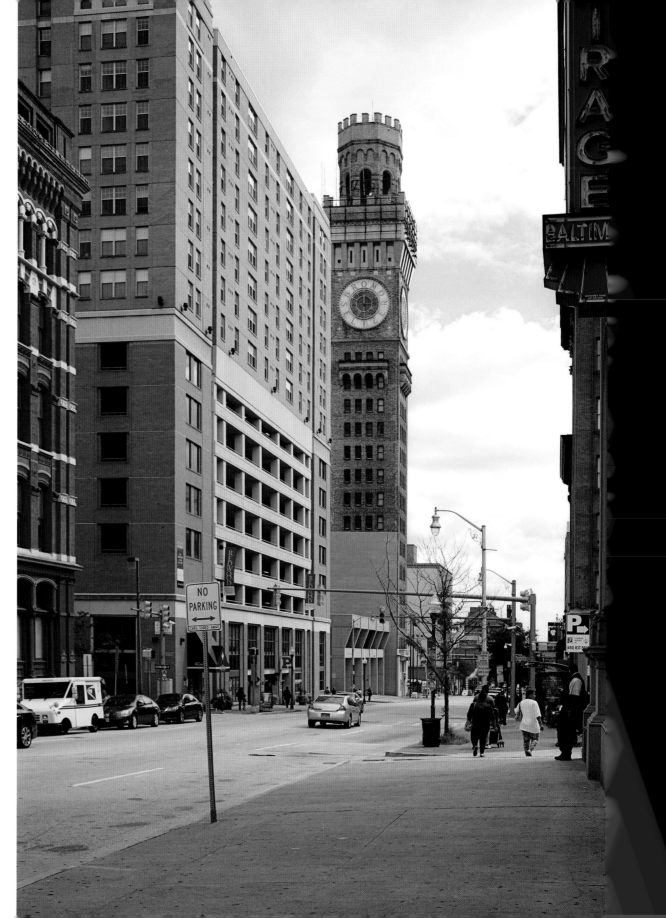

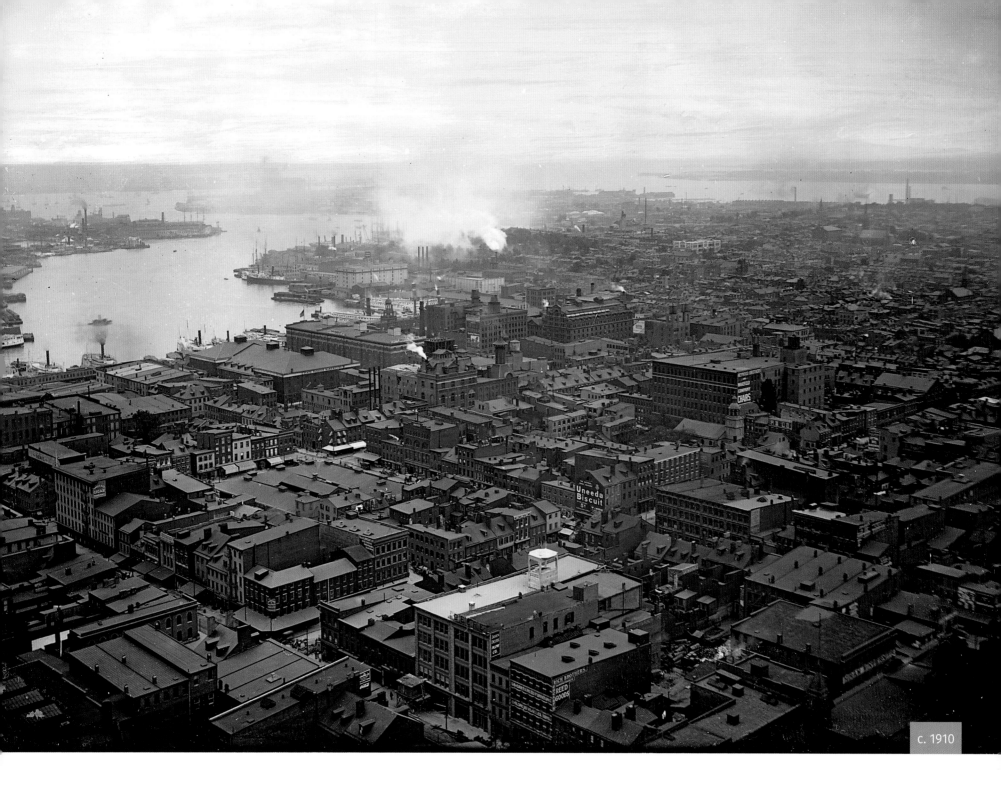

c. 1910

VIEW FROM THE BROMO-SELTZER TOWER
Almost everything in view has changed since the early twentieth century

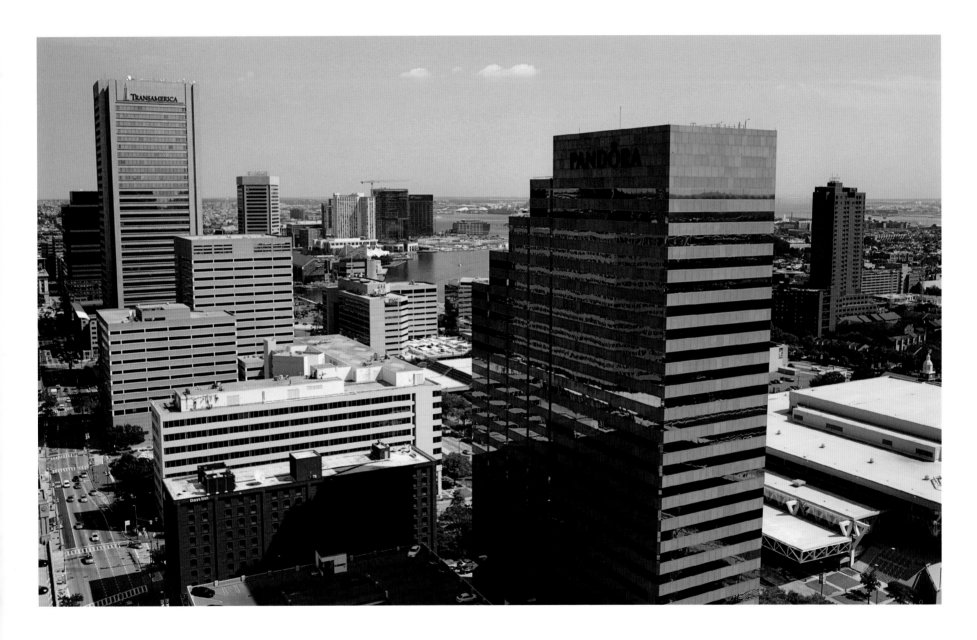

LEFT: A view from the Bromo-Seltzer Tower toward the Inner Harbor shows the district between the waterfront and the B&O terminal facilities. Relatively unscathed by the fire of 1904, it would pick up some of the businesses left homeless by the disaster. The view of the tower itself, in particular its revolving, illuminated replica of a Bromo-Seltzer bottle, could be seen from up to twenty miles away and was often used as a navigational tool by ships approaching Baltimore harbor.

ABOVE: A modern view from the same tower shows almost nothing to match. The Convention Center's new wing occupies the lower right, and the view of the harbor is partly obscured by the 250 West Pratt Street office building, built in 1986 and currently leased out to the Danish jewelry company Pandora. Rising to the left is the 1974-built USF&G Tower, sold to the Legg Mason investment firm in 1997 and now owned by Transamerica.

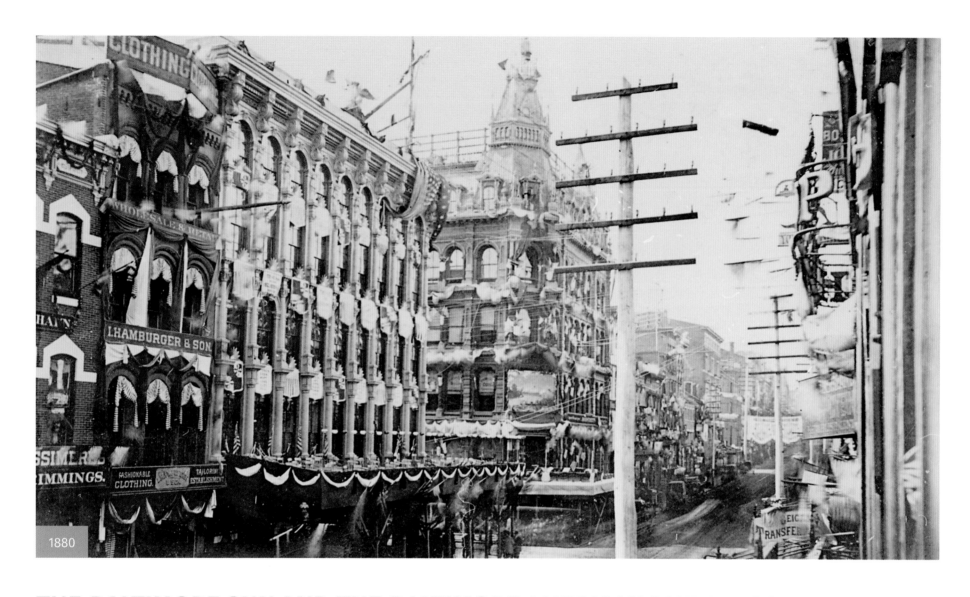

1880

THE *BALTIMORE SUN* AND THE *BALTIMORE AMERICAN* BUILDINGS
The rivalry between these daily newspapers extended to their buildings

ABOVE: This view shows the two largest city newspaper offices decorated for the city's 150th anniversary in 1880. On the left, at the southeast corner of Baltimore and South, are the offices of the *Baltimore Sun*, located in a spectacular and innovative building covered with cast iron. The building, which was constructed for the newspaper in 1850, would be a victim of the 1904 fire and would be replaced by a massive stone structure at the southwest corner of Baltimore and Charles, opened in November 1906. Across South Street are the offices of the *Baltimore American*, located in a cast-iron, cupola-topped building from 1875 that would also be destroyed in the 1904 fire. To the left is Hamburger & Sons' Clothing store, a local institution that grew throughout the twentieth century but ceased business in its last location over Fayette Street in the 1990s.

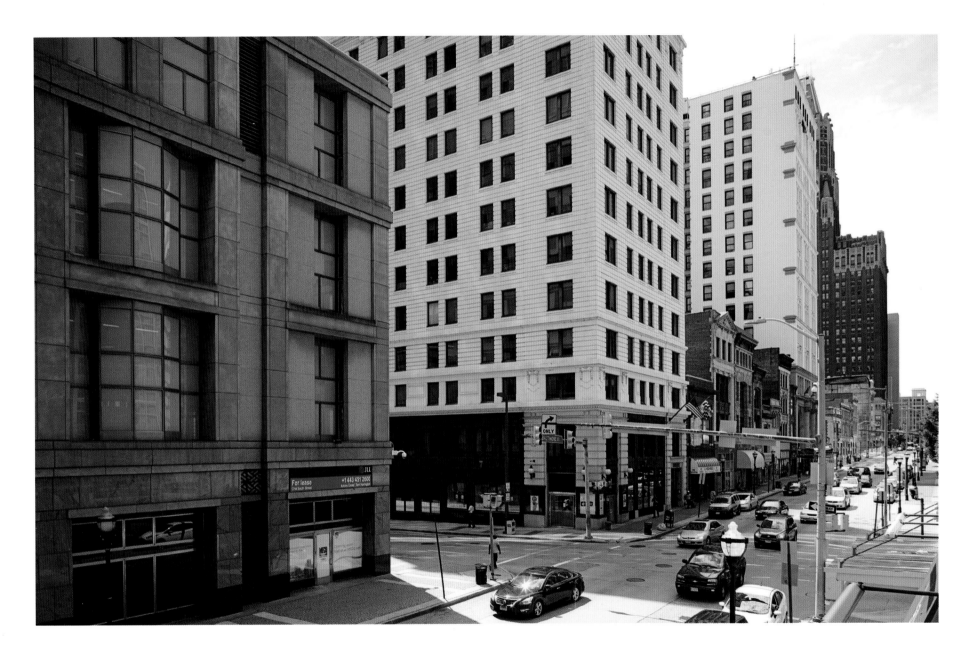

ABOVE: The modern photo in the same location shows the northwest corner of the thirty-one-story Commerce Place Building, opened in 1992. It is mostly used as commercial office space with six floors of parking. The *Baltimore American* offices were rebuilt after the 1904 fire. The newspaper (later the *News American*) folded in May 1986, but their 1904 office building still features the *Baltimore American* logo cast into the facade.

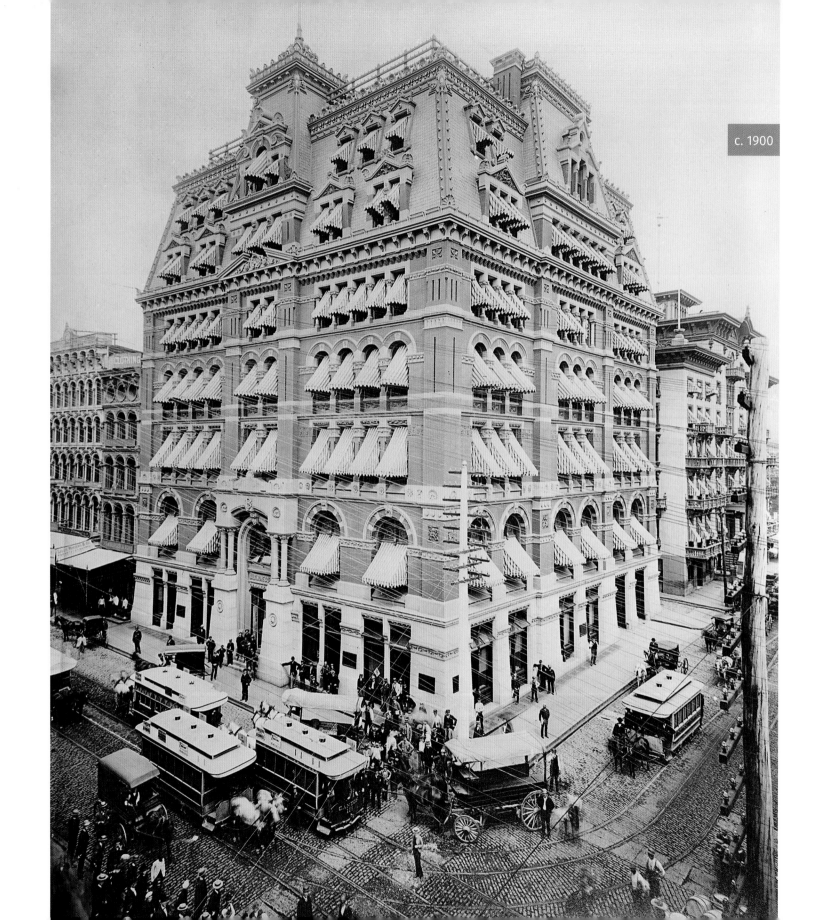

B&O RAILROAD BUILDING / SUNTRUST BUILDING

The B&O headquarters were another casualty of the fire of 1904

LEFT: The Baltimore & Ohio Railroad Building, at the northwest corner of Baltimore and Calvert streets, was built in 1881–1882 under the auspices of B&O president John W. Garrett. It employed flamboyant Second Empire styling, reminiscent of such buildings as the Old Executive Office Building in Washington, D.C.

RIGHT: The building was burned to a hollow shell in the fire of 1904; bricks from the hulk were reportedly reused in row-house construction on Patterson Park Avenue between Chase and Eager streets in East Baltimore. The B&O relocated to a new site at Charles Street, and the Emerson Hotel, built in 1911 by Captain Isaac Emerson (of Bromo-Seltzer Tower fame) and razed in 1971, replaced it. The Crestar Bank building, built in 1989 and now known as the SunTrust Building after a 1998 bank merger, currently occupies the site.

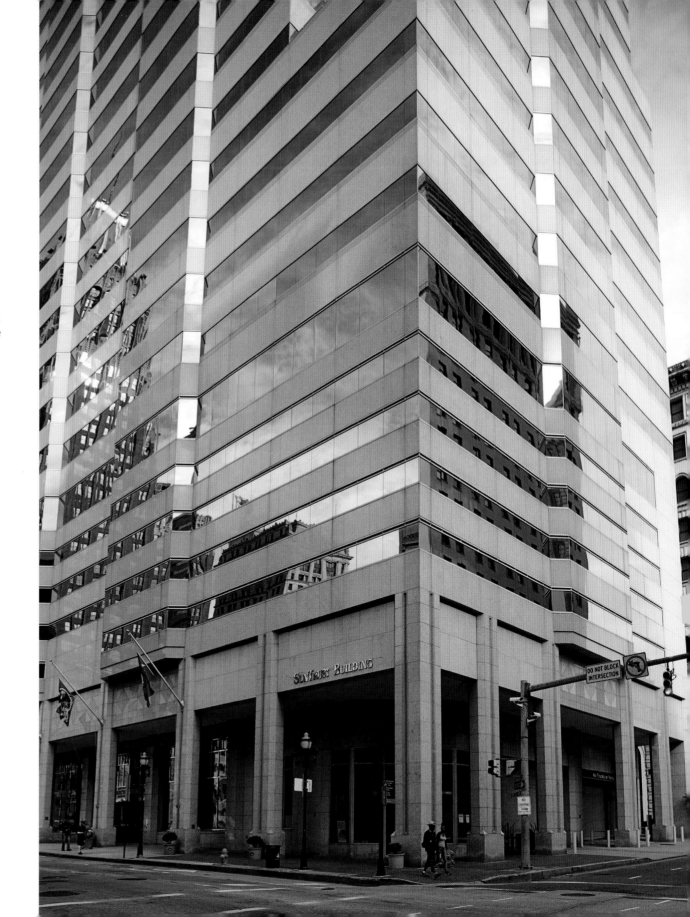

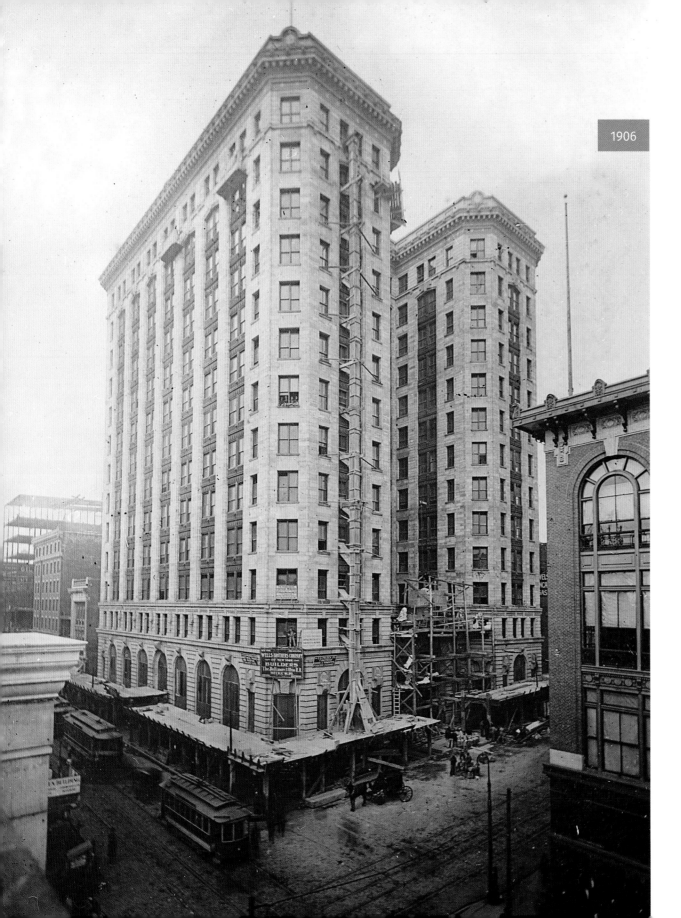

1906

B&O BUILDING
Headquarters of Baltimore & Ohio Railroad for 75 years

LEFT AND BELOW: The Baltimore & Ohio RR, burned out of their old office building by the 1904 fire, would relocate to a newer building at the northwest corner of Baltimore and Charles streets, completed in 1906. The railroad would continue to be a major economic presence in the city for many decades, employing thousands of office workers downtown as well as blue-collar workers in the shops and on the rails.

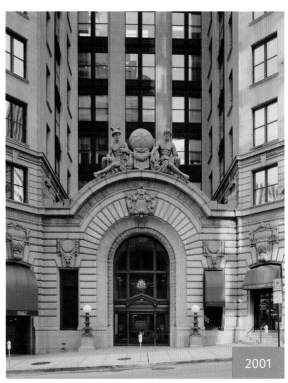

2001

RIGHT AND BELOW: The office building would survive to the present day, although the railroad, after several mergers, would become CSX Transportation and relocate most of its offices and personnel to Jacksonville, Florida, in January 1991. Today the building, still known as the B&O Building, houses the 202-room Hotel Monaco, three floors of office space, and a BB&T bank.

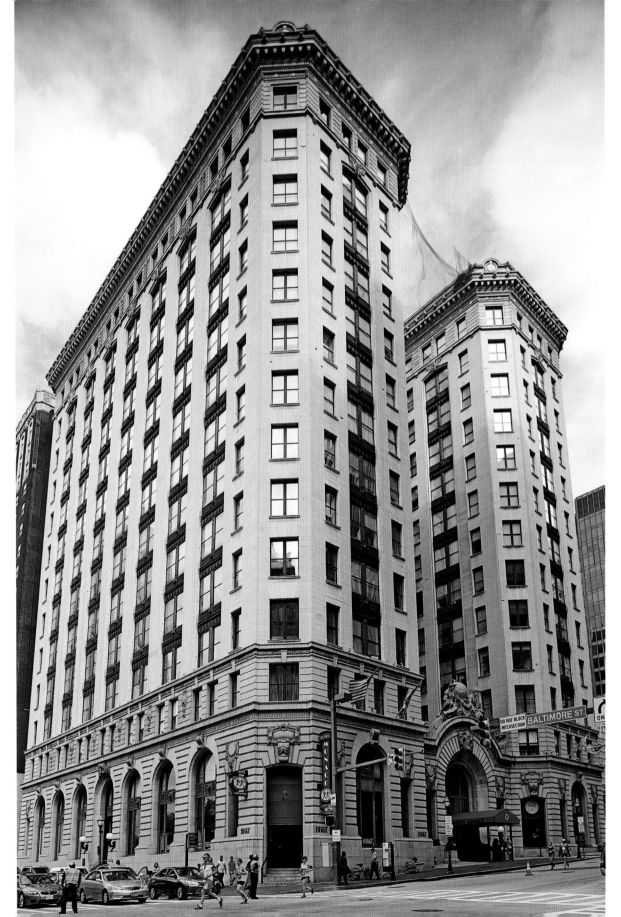

EUTAW AND SARATOGA STREETS
Included in the city's redevelopment of west downtown

BELOW: The intersection of Eutaw and Saratoga streets was still part of the economically vibrant downtown shopping district in June 1951, as two nuns cross the intersection. The streetcar shown is en route from the Canton neighborhood in the southeast to the intersection of Pennsylvania and North avenues to the northwest of this location. To the left is a transit maintenance truck waiting to swing into place to perform work on the overhead streetcar wires.

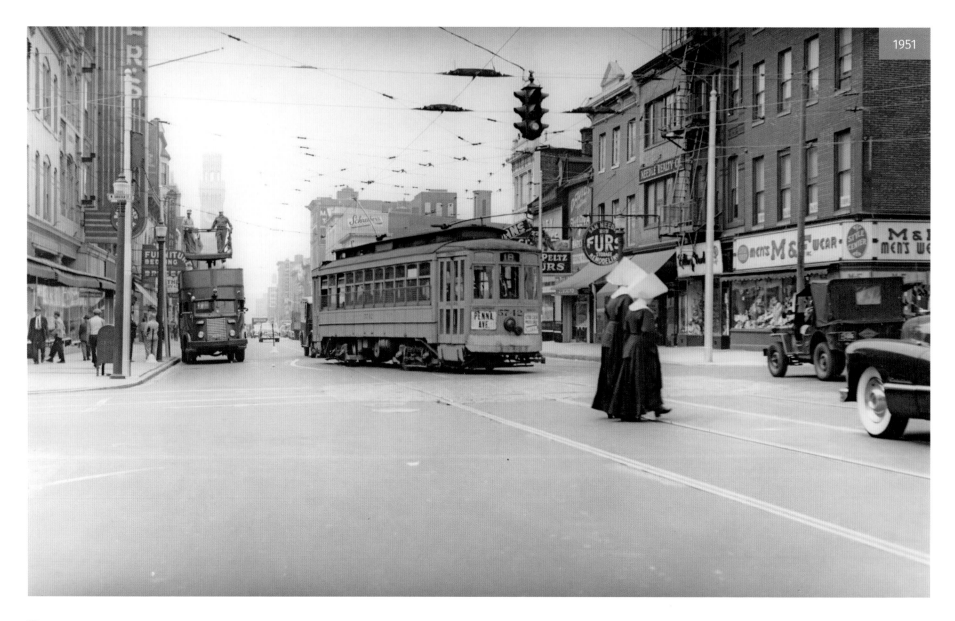

1951

BELOW: The west side of downtown was hardest hit by the decline of the inner city as a shopping and employment center, being replaced gradually by suburban flight and shopping malls. The streetcars were removed in the 1950s; the buses that replaced them can be seen in the newer scene. A program was initiated in 1998 by the city government to redevelop the western half of downtown, including this stretch.

A $4 million renovation of Lexington Market was completed in 2002. Exterior improvements were made to the market's entrance on Eutaw Street to make it more in keeping with the many nineteenth-century buildings surrounding it. In the distance is the Hilton Baltimore, a 757-room hotel and convention center that opened in August 2008.

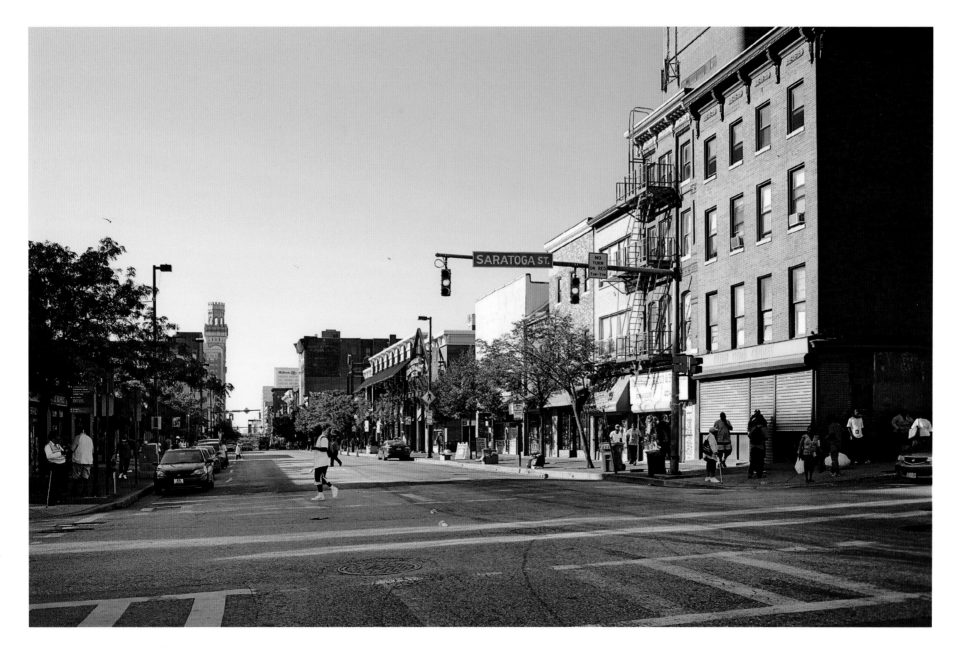

CATHEDRAL—BASILICA OF THE ASSUMPTION

The first Roman Catholic cathedral in the United States

LEFT: Designed by Benjamin H. Latrobe, the Basilica of the Assumption, built between 1806 and 1821, was the first Roman Catholic cathedral in the United States and is considered to be one of the finest examples of neo-classical architecture in the world. Cruciform in plan, the cathedral is constructed of Porphyritic granite. The front portico, composed of ten fluted columns and an Ionic pediment, was added to the original design in 1863. Along both sides of the cathedral are a series of stained glass windows set in recessed arched panels. A dome set on an octagonal drum tops the rear portico of the church.

RIGHT: Today, the area surrounding the cathedral, which includes the cathedral's associated buildings, has been designated the Cathedral Hill Historic District, listed in the National Register in 1982. The cathedral underwent a $34 million restoration from 2004 to 2006 and it continues to serve its original function.

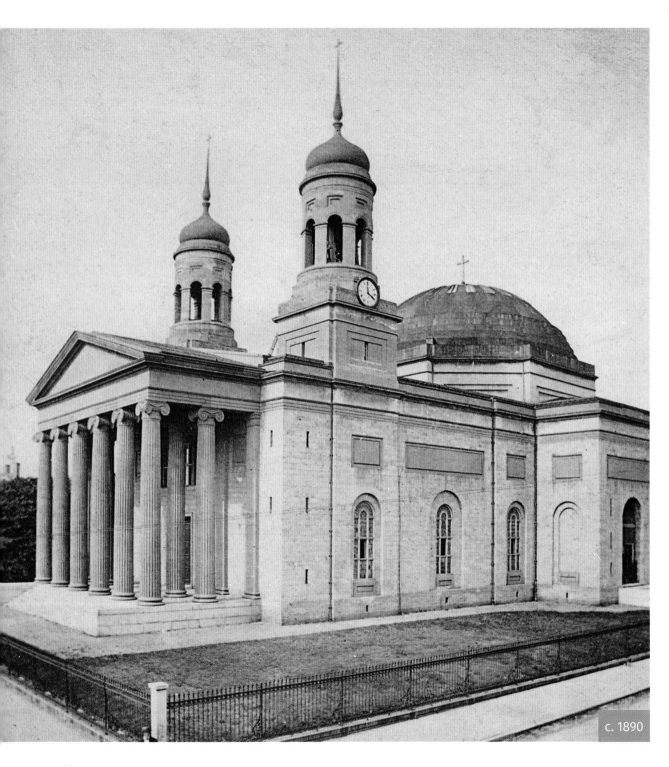

c. 1890

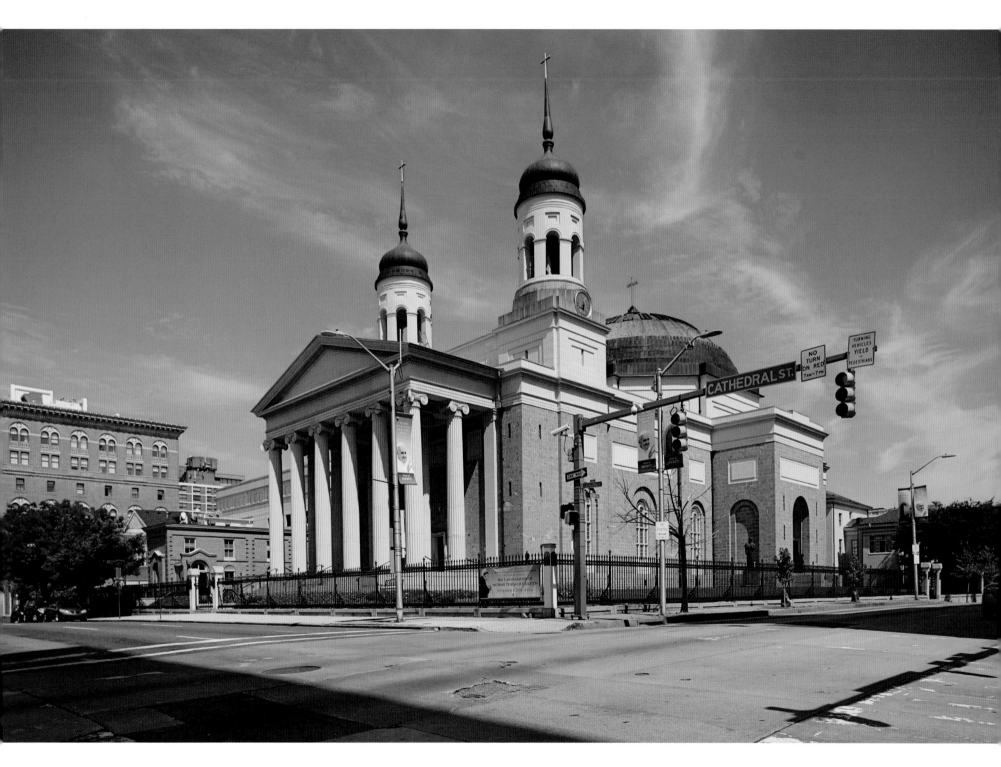

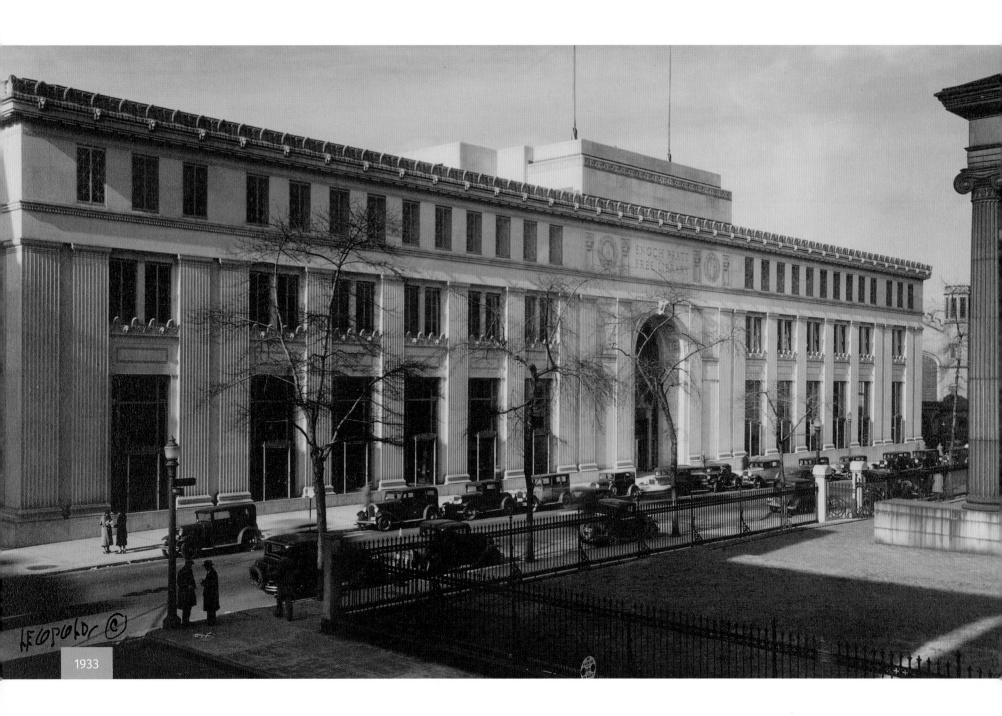

1933

ENOCH PRATT FREE LIBRARY

"New Central" has been welcoming library users since 1933

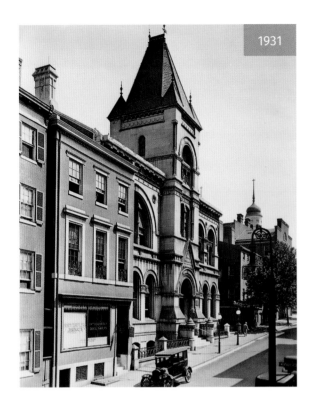

1931

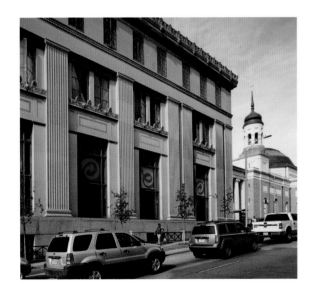

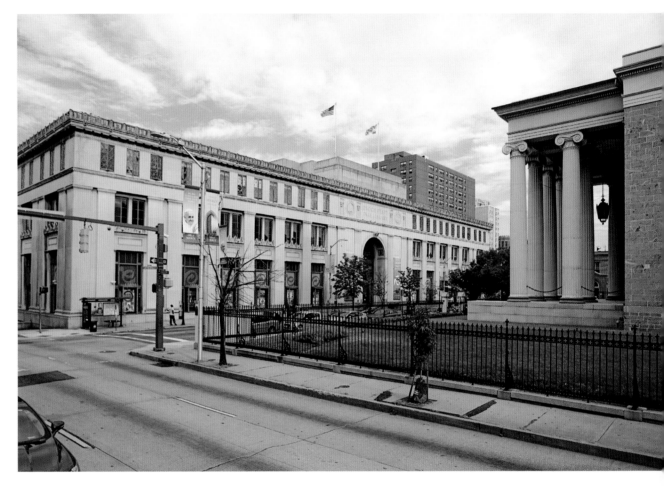

ABOVE LEFT: "Old Central," the original main branch of the Enoch Pratt Free Library, was built in 1881–1886 at 106 West Mulberry Street and originally housed 150,000 volumes in this Courthouse Romanesque structure designed by Baltimore architect Charles Carson. Due to its inability to house a growing collection, it was razed in 1931, months after this photo was taken.

OPPOSITE: Old Central's location provided part of the lot for the new Enoch Pratt Central Library on Cathedral Street, which opened in February 1933.

ABOVE AND LEFT: Still in use today, the 1933 structure, designed in part by library director Joseph Whelan, was designed to mimic the look of department stores with its wide spaces and picture windows. Started with a one million dollar endowment from philanthropist Enoch Pratt, "the Pratt" is now Baltimore's official public library, with branch locations scattered throughout the city. The former main entrance is now the location of a side wall of the building. Baltimore's cathedral, the Basilica of the Assumption, is visible on the right.

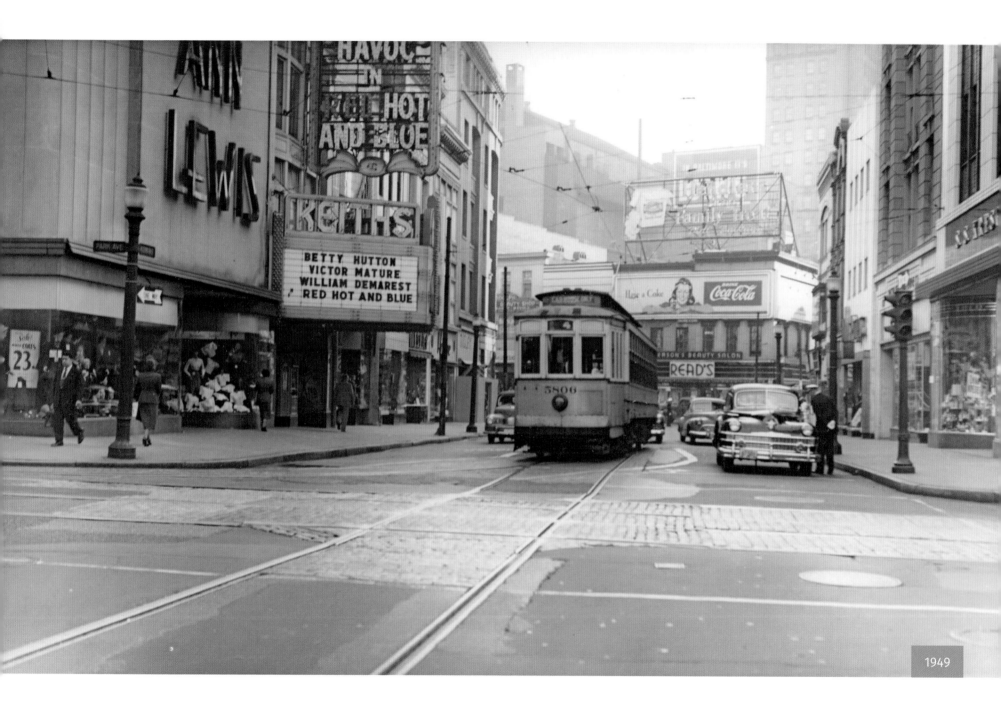

1949

LEXINGTON STREET AT PARK AVENUE
Open to traffic again after more than twenty years as a pedestrianized shopping street

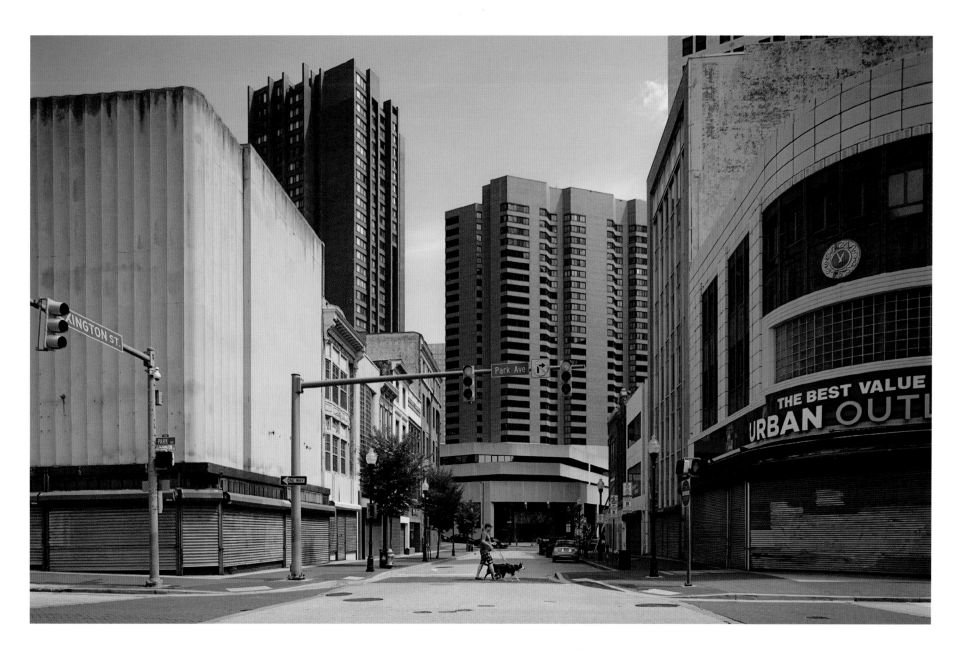

LEFT: This photo shows a streetcar (built in 1912 and due to be retired shortly after the photo was taken) on the No. 14 line heading west on Lexington Street, about to turn north onto Park Avenue in November 1949. To the left is Keith's Theater, to the right is the S.S. Kresge store, part of the chain that would eventually evolve into the nationwide Kmart chain.

ABOVE: The Keith's Theater was demolished for a parking garage. Most of the buildings to the rear were demolished for the construction of Charles Center, developed between 1956 and the late 1960s to supply office space for financial and governmental institutions. Not too surprisingly, its invitingly open but stark and bleak plazas failed to attract a critical mass of shoppers. Lexington Street, which was pedestrianized in the mid-1970s, was opened to traffic again in 2001.

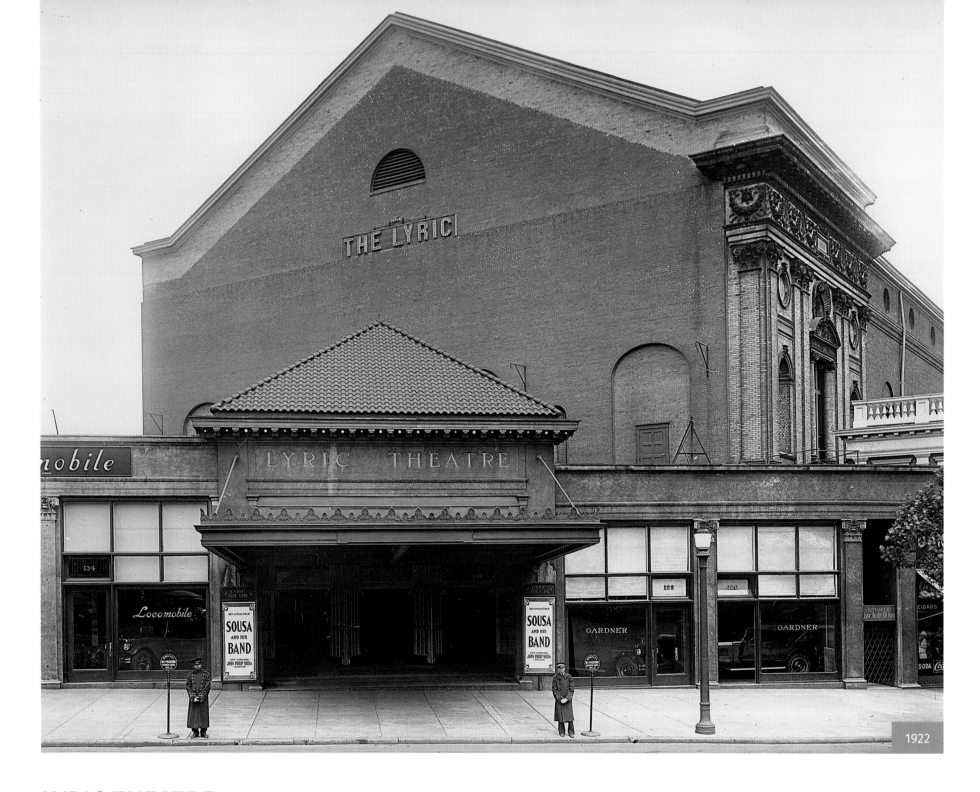

1922

LYRIC THEATRE

The theater has been rebuilt, remodeled and extended in several stages

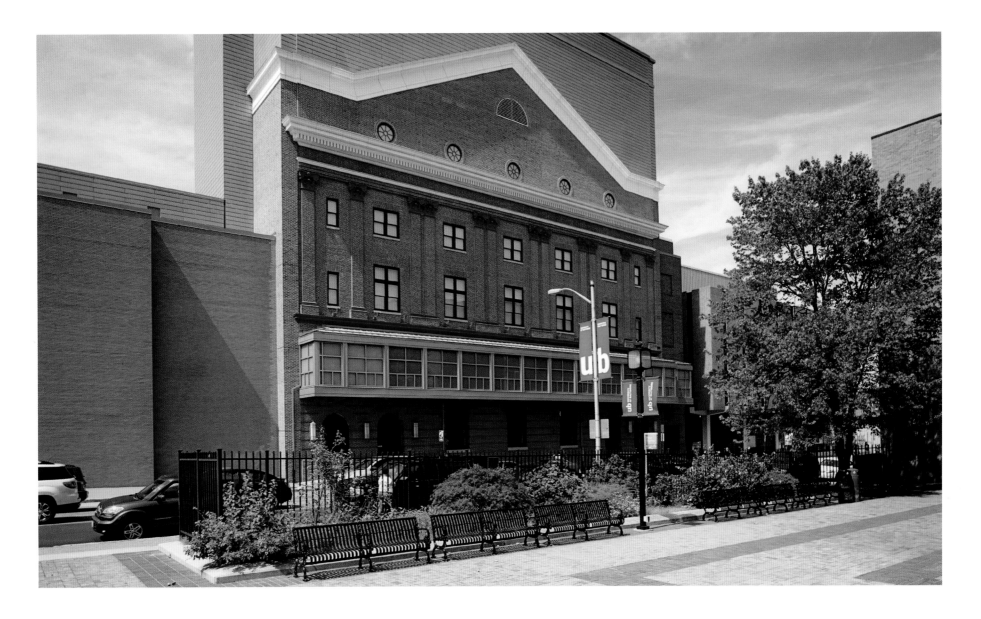

LEFT: The Lyric Theatre (once known as the Music Hall and later as the Opera House) opened in October 1894. Designed after the Neues Gewandhaus in Leipzig, Germany, the Lyric has the shape of a Baroque rectangular hall with side balconies. Although primarily a music venue—home to the Baltimore Symphony Orchestra from 1916 to 1982—the theater was used for a wide variety of events. In 1905 they included a boxing match between Mike Sullivan and Joe Gans, and the first demonstration of electric cooking before a Baltimore audience. Orchestra conductors praised the acoustical qualities of the building.

ABOVE: Many ears, however, judged the acoustics far less than stellar in later years, and the BSO moved to the new Meyerhoff Symphony Hall nearby in 1982. The theater underwent significant renovations in 1908, 1921, 1980–82, 2010–11 and 2014, with additional buildings hiding most of the original structure. Now known as the Modell Performing Arts Center at the Lyric, the theater has been hosting performances by Metropolitan Opera since 1904.

HOWARD AND FRANKLIN STREETS
Once a thriving theater district

BELOW: If Baltimore had a theater district, this northwest corner of Howard and Franklin streets was it. The corner building is the Franklin Hotel, renamed the Academy Hotel in the 1880s. At the far left we barely see the Grand Hotel Negresco–styled Maryland Theater, one of the nation's top vaudeville theaters built in 1903; adjoining

it is the Hotel Kernan. Both were projects of James L. Kernan. To the right we see the Auditorium Theater, also a Kernan project, and to its right the grandiose Academy of Music, a 3,000-seat theater which opened in January 1875.

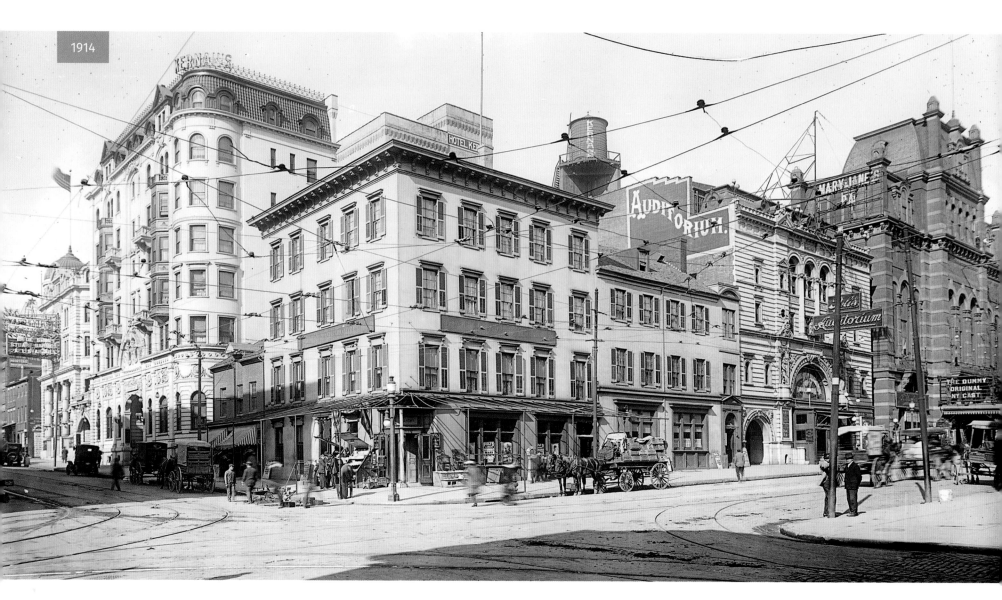

1914

BELOW: Change has swept in over a century later. The old Academy Hotel was left vacant and in a derelict state for many years before it was finally demolished in 2016. The Kernan Hotel, later renamed the Congress, has been developed into thirty-six one- and two-bedroom apartments. The Maryland Theater was razed for a parking lot in 1951. The Auditorium, later the Mayfair Theater, is but a crumbling shadow of its old self, having closed in 1986. The Academy of Music was demolished around 1926, but portions of its structure were incorporated into the Stanley Theater adjacent; it in turn was demolished in 1965.

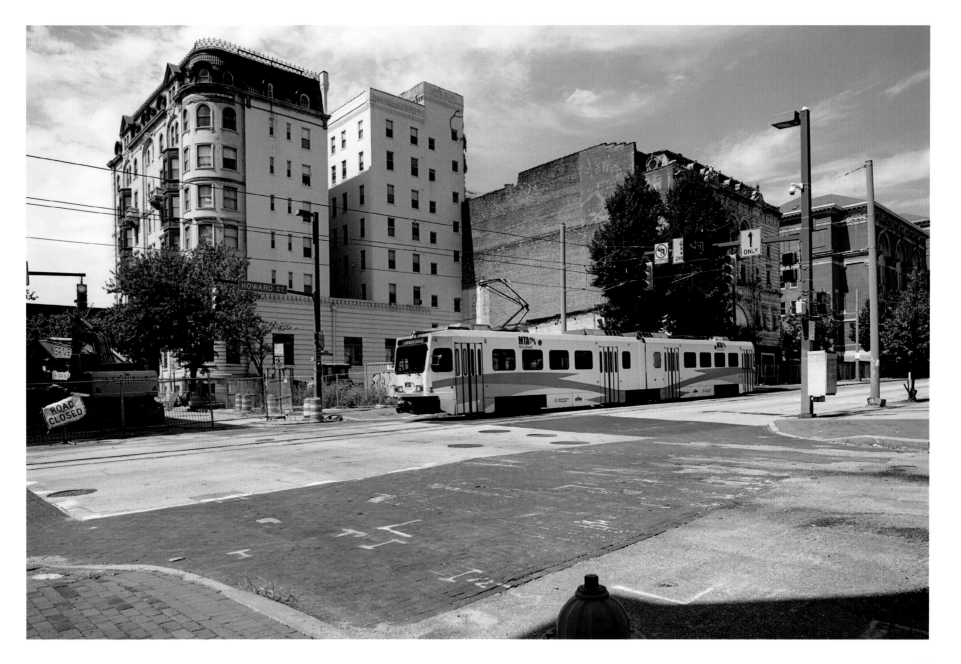

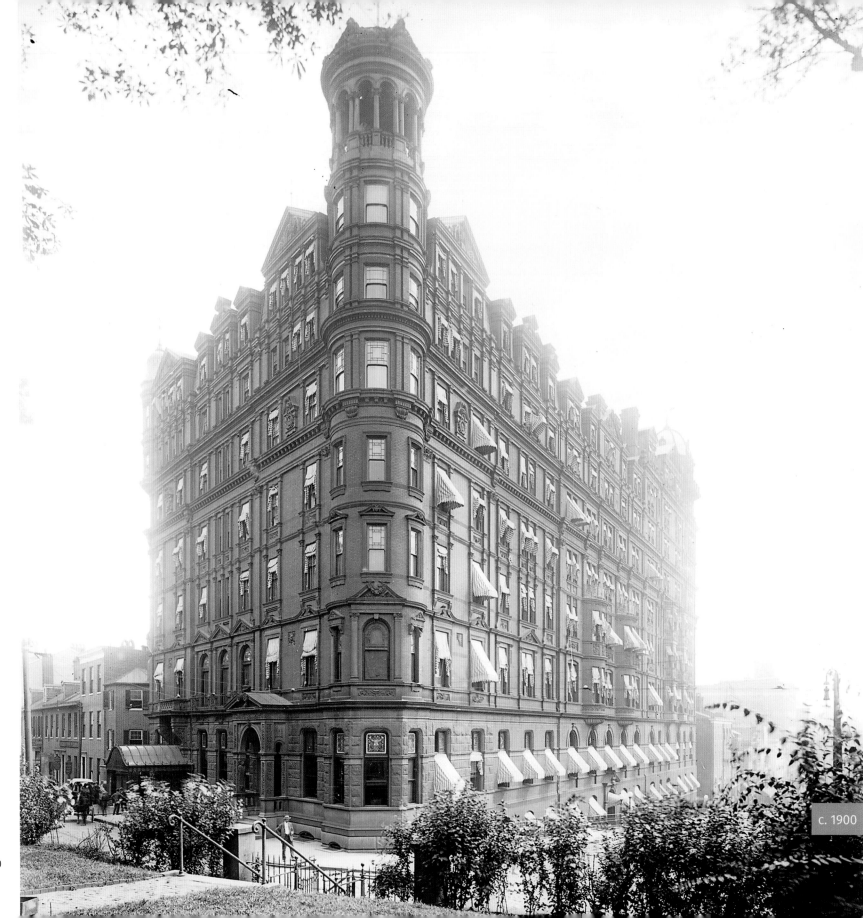

c. 1900

RENNERT HOTEL
Known as the "Palace of the South"

LEFT: Built in 1885 at the southeast corner of Liberty and Saratoga/Clay streets and enlarged in 1893, this Rennert Hotel, designed by architect E. F. Baldwin, replaced an earlier Rennert House, built on Fayette Street, which itself replaced another hotel across Fayette Street. Robert Rennert's hostelry was at the time nationally famous both as a rendezvous for politicians and for its excellent Southern-style cuisine.

RIGHT: Declining patronage, in part due to the passage of Prohibition in 1919, led to the hotel falling into tax arrears, and it closed in December 1939. The building was demolished in 1941, and a parking garage was erected in 1950. Today, even the garage, reviled over the years for its ugliness, is gone, replaced by a parking lot in 1996. Both views were taken from the front lawn of the St. Paul's Rectory, built in 1791.

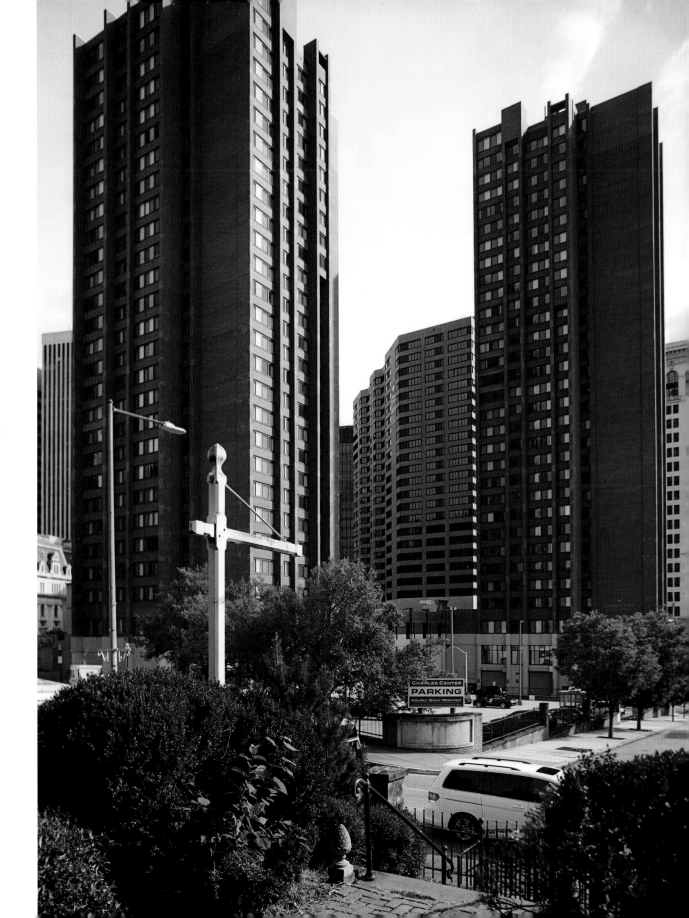

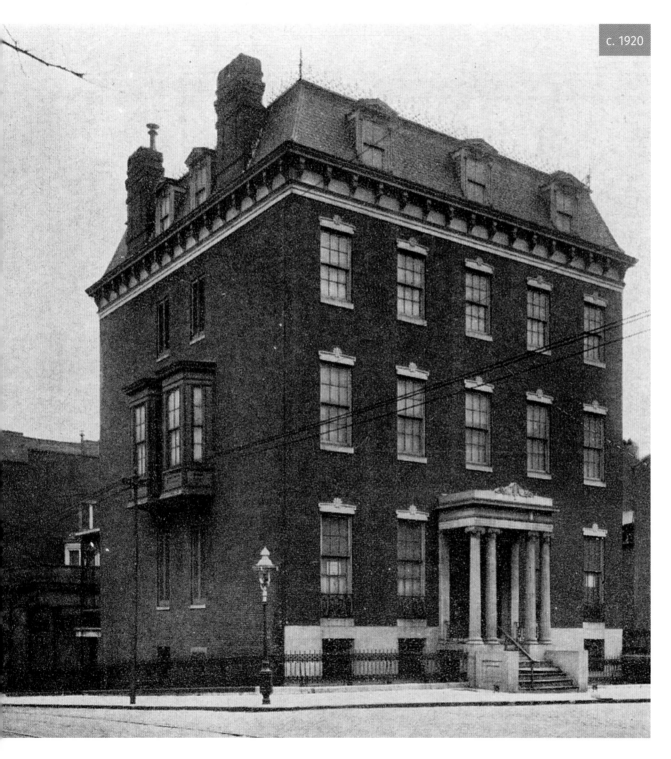

ENOCH PRATT HOUSE
Acquired by Maryland Historical Society in 1919

LEFT: Established in 1844, the Maryland Historical Society is the premier private historical organization in the state, now owning a collection of over 200,000 artifacts and an immense library of books, manuscripts, and photos. Originally housed in the Athenaeum, at St. Paul and Saratoga streets, the society relocated to the Pratt House in 1919. The handsome Greek Revival antebellum town house, one of the few surviving in Baltimore, was built by Enoch and Maria Louisa Pratt in 1846–1848; the fourth floor was added in 1868. After Mrs. Pratt died in 1911, the building was acquired by Mrs. H. Irvine Keyser and donated to the Maryland Historical Society.

RIGHT: The MHS would acquire and build adjacent display and office space throughout the twentieth century, working to preserve the house rather than use it as office space. In the 1990s, the society would acquire and preserve the adjacent Greyhound Bus Garage, a huge hall built with spectacular wooden arches in its roof structure, for additional display space. In 2000–2001 the Pratt House underwent modest restoration and repainting to accurate colors, and the first and second floors are furnished with period furnishings and displays.

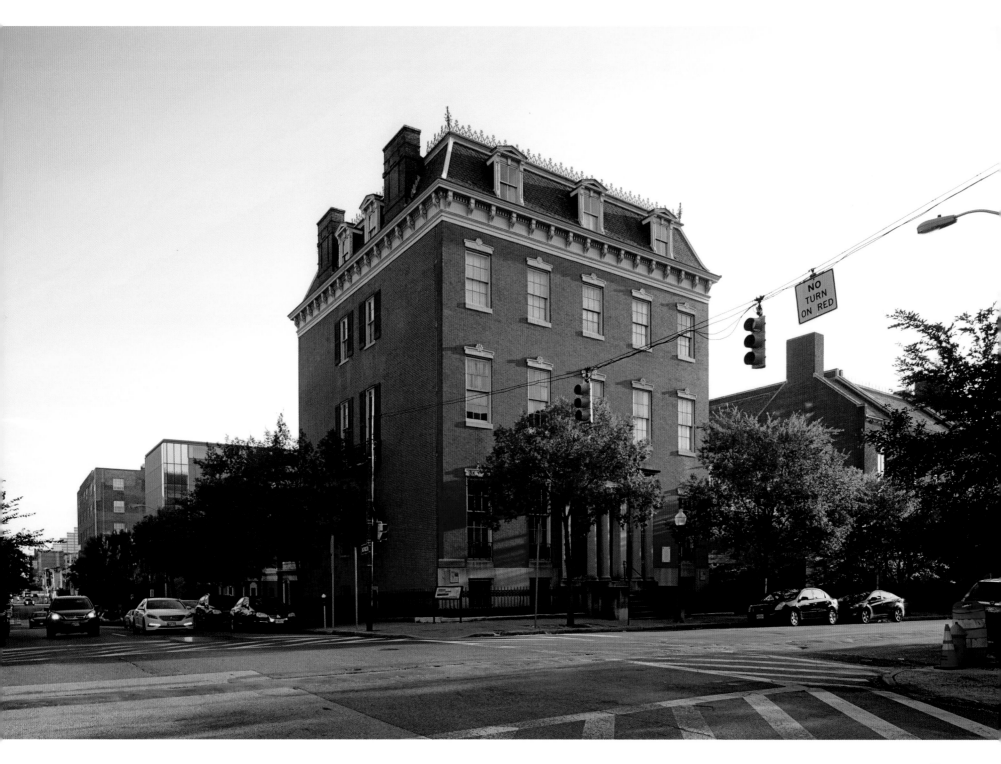

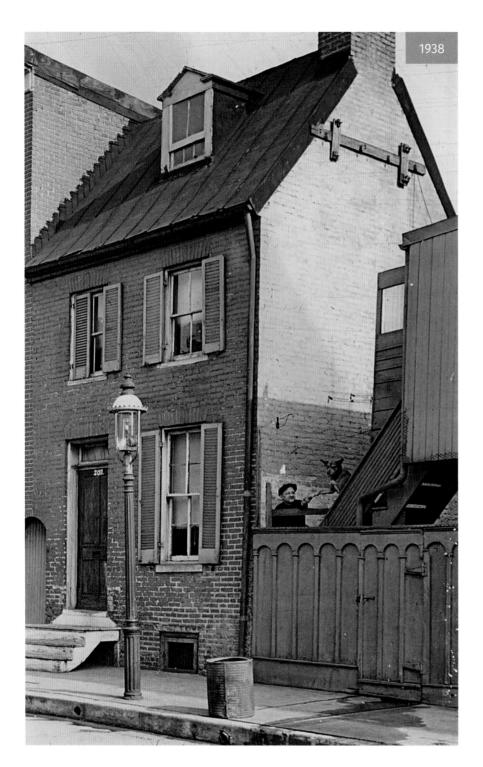

1938

EDGAR ALLAN POE HOUSE
Saved from demolition by the Poe Society

LEFT: "This little house in the lowly street with the lovely name" is how the author, poet and critic Edgar Allan Poe described the modest house he moved into at 3 North Amity Street (later renumbered 203) in 1833. Poe lived here with his aunt, grandmother and two cousins for almost three years and it was here that he wrote some of his early short stories, including "MS. Found in a Bottle" and "Berenice," that would help define the literary genres of mystery, horror and science fiction. Poe left Baltimore for Richmond, Virginia, in 1835 to take up his post as the editor of *The Southern Literary Messenger*. Built around 1830, the house remained a private residence until 1939 when it was acquired by the City of Baltimore.

RIGHT AND BELOW: When plans to demolish the house were announced in 1941 the Edgar Allan Poe Society stepped in and convinced the City of Baltimore to retain the house which they wanted to turn into a museum. Following extensive repairs, rewiring, and redecoration, the Poe House and Museum opened to the public in October 1949. The photo below shows Poe Society founder John C. French inspecting the front bedroom on the eve of the museum's opening. The Poe Society ran the museum for three decades and it was designated a National Historic Landmark in 1972. Today the museum is owned by the Baltimore City Department of General Services and is maintained by Poe Baltimore.

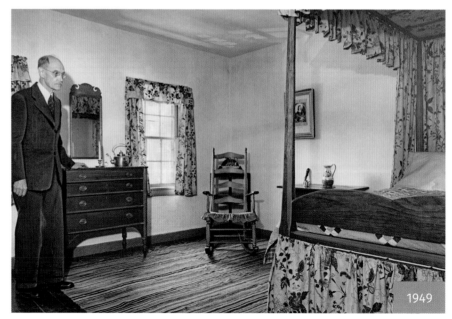

1949

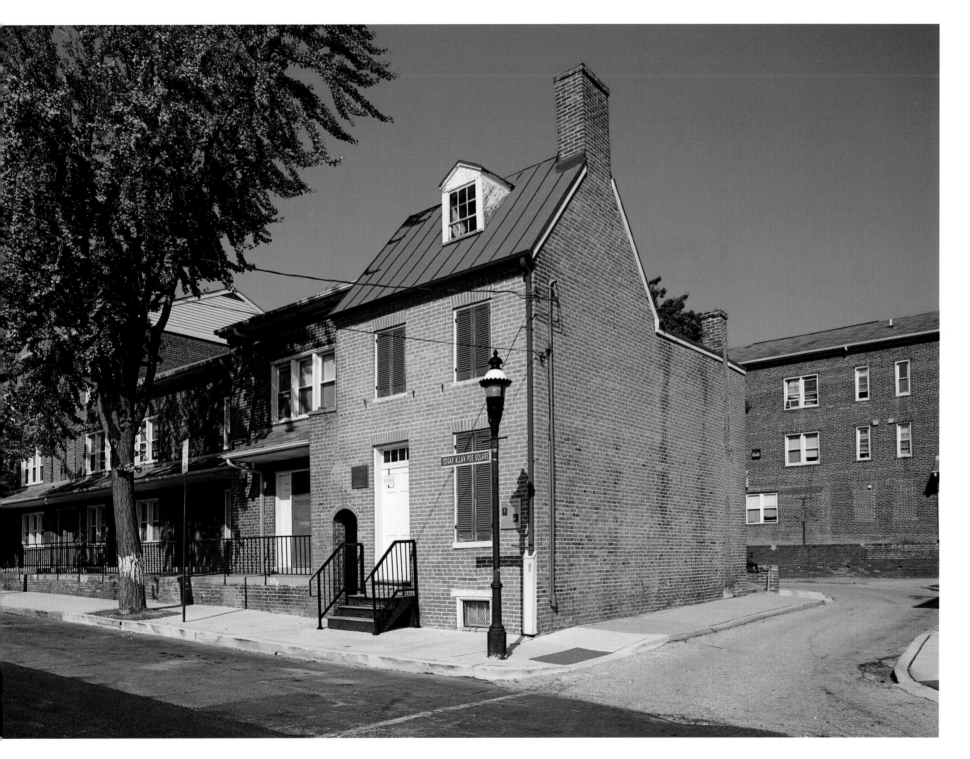

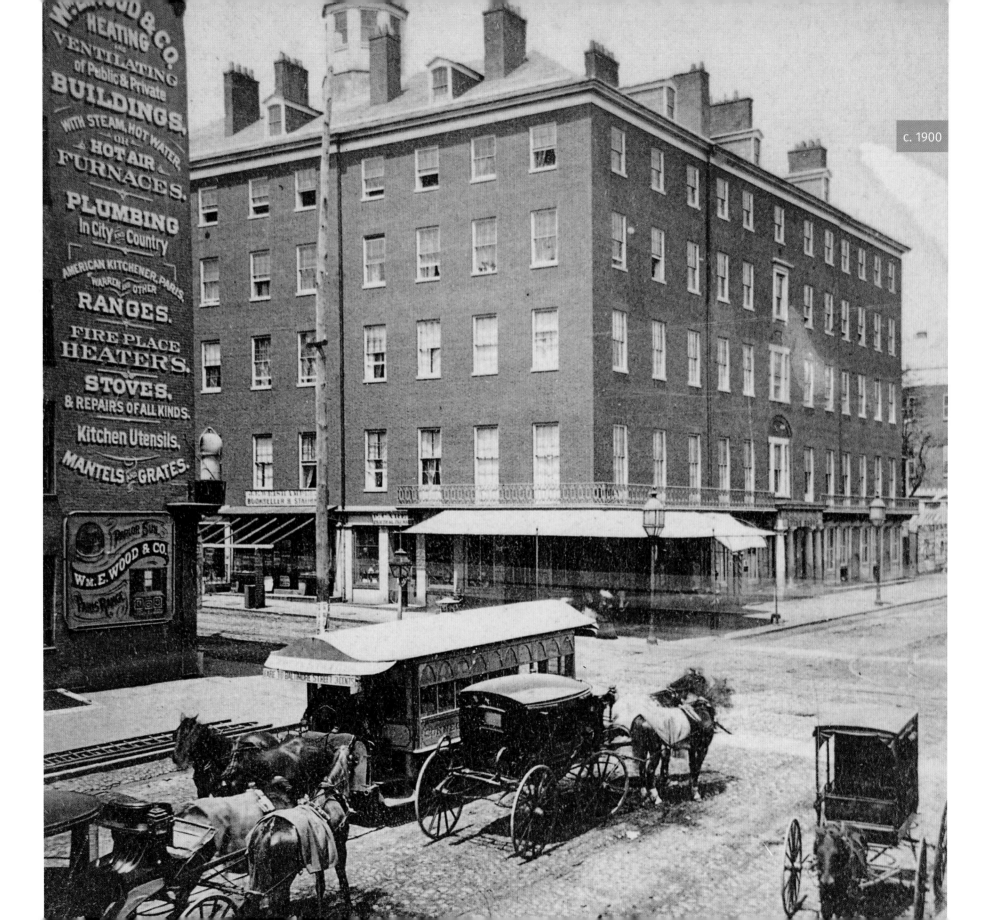

c. 1900

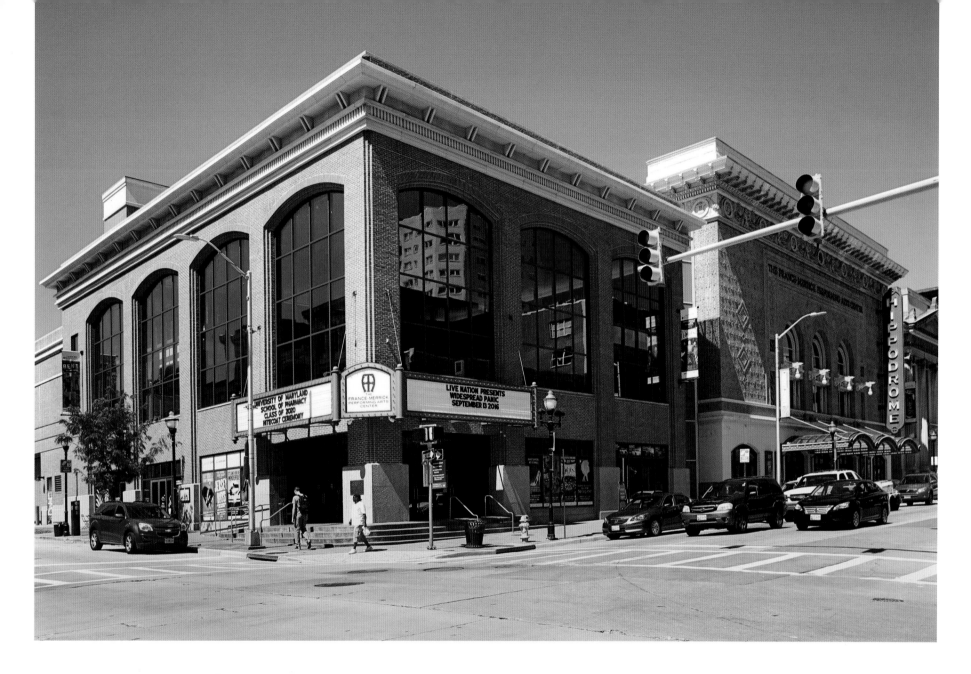

EUTAW HOUSE / HIPPODROME THEATRE
Frank Sinatra made his Baltimore debut at the Hippodrome in 1939

LEFT: Located at the northwest corner of Baltimore and Eutaw streets, the Eutaw House was built in 1835 and quickly became one of the city's most famous hotels. Among its many distinguished guests were Charles Dickens, Ulysses S. Grant, and Daniel Webster. It survived until 1912 when fire damaged the then-aging building. The northern part of the hotel was demolished for the construction of the Hippodrome Theatre in 1914; the remaining portion was demolished in 1916.

ABOVE: The Hippodrome Theatre, built as a vaudeville house in 1914, is one of the last remaining historic theaters on the Eastern Seaboard. During the 1930s the Hippodrome played host to performers such as Bob Hope, Dinah Shore, the Three Stooges, the Andrews Sisters, and Benny Goodman. The theater was renovated in 2004 and is now part of the France-Merrick Performing Arts Center, which sits next door on the corner site of the old Eutaw House hotel.

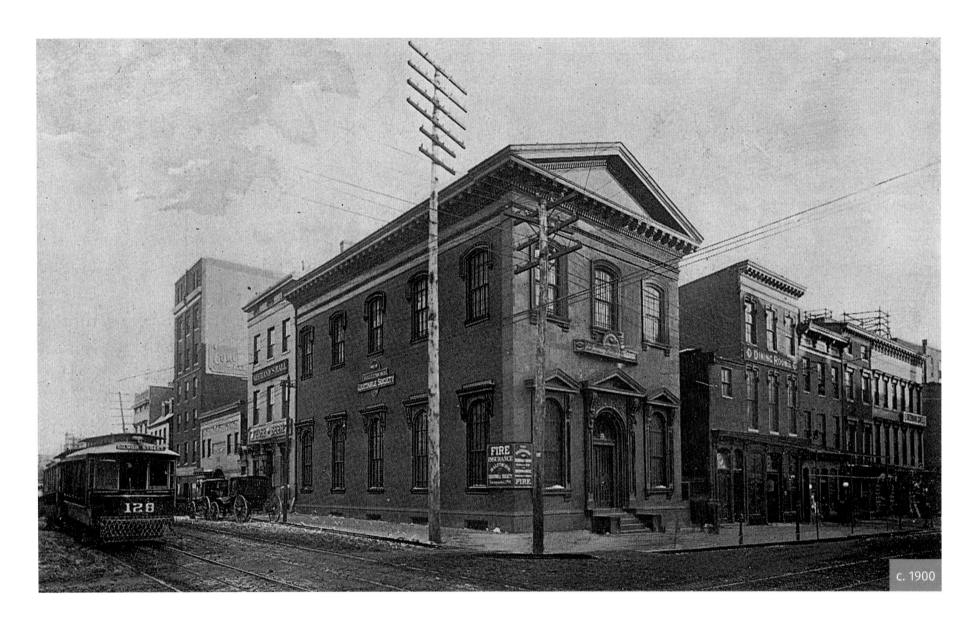

c. 1900

BALTIMORE EQUITABLE BUILDING

Baltimore Equitable remained here for 114 years

ABOVE: Located at the southeast corner of Eutaw and Fayette streets, this venerable Italian Renaissance Revival building was built in 1857 for the Eutaw Savings Bank. The bank would relocate across Eutaw Street, and from 1889 the original building would house the offices of the Baltimore Equitable Society, a pioneering fire insurance company founded in 1794. The company's distinctive "firemark," a cast-iron plaque with "1794" and clasped hands, still graces many historic buildings in the city.

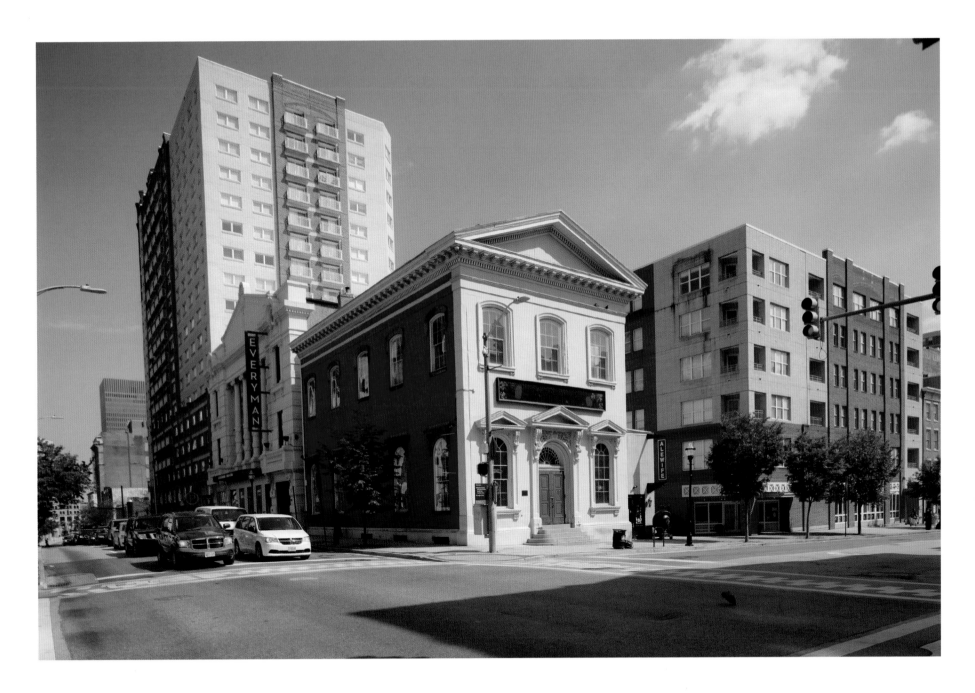

ABOVE: Now known as Baltimore Equitable Insurance, the oldest corporation in the state remained in this landmark building until 2003, when it moved to more modern offices on North Charles Street. The building is currently occupied by Alewife, a gastropub with more than forty taps of craft beer. The Everyman Theatre behind was originally opened as the Empire, a vaudeville and burlesque theater, in 1910. After various name changes and a period spent as a parking garage, the theatre closed in 1990 and was left vacant until the Everyman Theatre acquired it in 2006. Following major renovations, the Everyman opened in 2012.

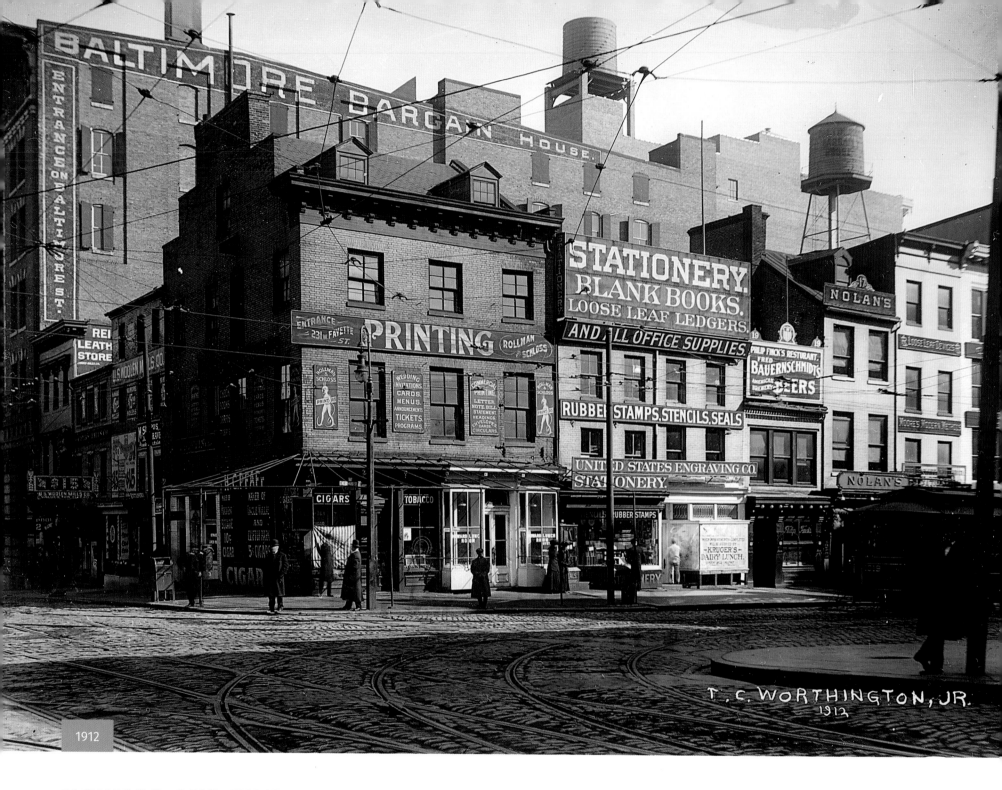

1912

HOWARD AND FAYETTE STREETS
Howard Street was a bustling shopping area in the early 1900s

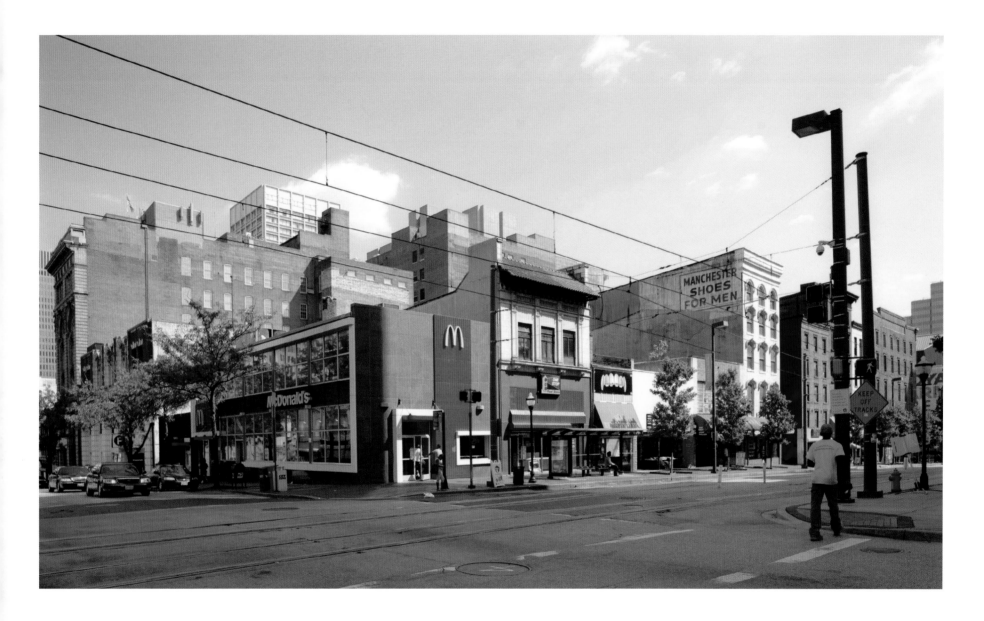

LEFT: Anyone lamenting the spread of modern billboards should board a time machine to 1912 and this southeast corner of Howard and Fayette streets to remind themselves that outdoor advertising is an old concept. Signs hawking cigars, printing and office supplies, leather and dry goods, and cash registers clutter the storefronts. Rising in the background is the Baltimore Bargain House, which in its heyday at the turn of the century employed over 1,000 in wholesale, retail, and mail-order. Its founder, Lithuanian immigrant Jacob Epstein, became one of Baltimore's great philanthropists, and donated a large art collection to the Baltimore Museum of Art.

ABOVE: Today a McDonald's restaurant, built in 1973, occupies the corner. The former Bargain House has been cut down to three stories and converted into a parking garage. The taller building beyond it, with a similar profile to the original Baltimore Bargain House, is the Baltimore VA Annex, offering care and support for veterans. The Howard Street corridor has seen a steady downward decline in economic fortune, both before and after the construction of the Central Light Rail Line (opened in 1992), down its middle.

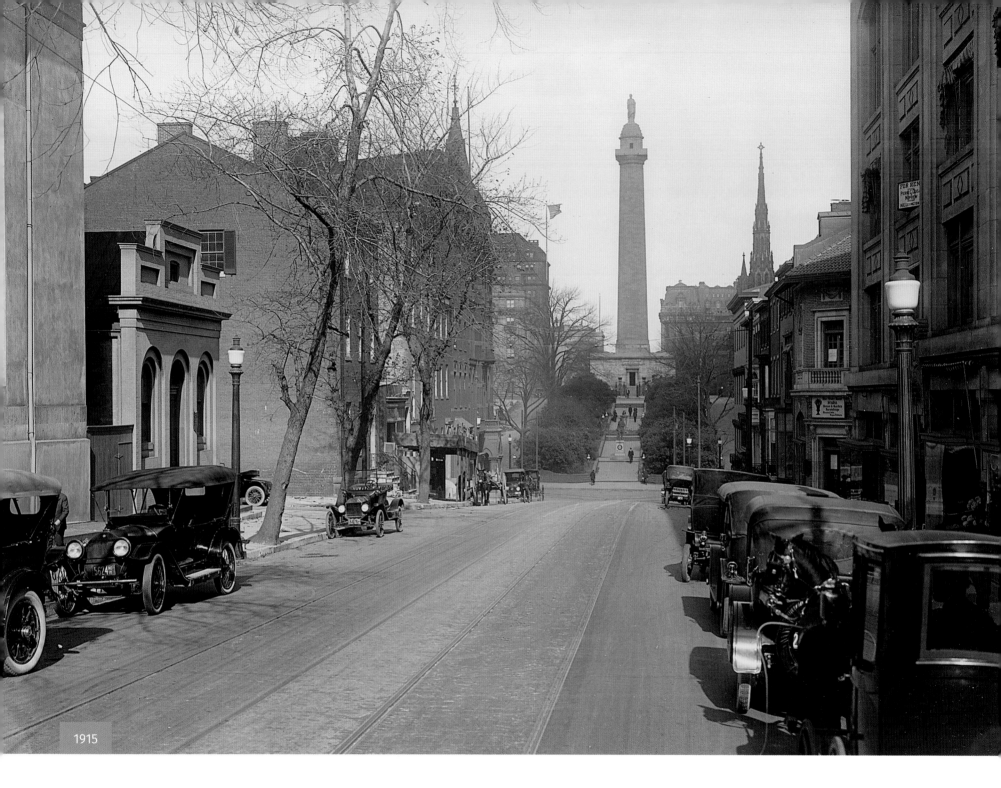

1915

WASHINGTON MONUMENT

The first major monument to honor George Washington

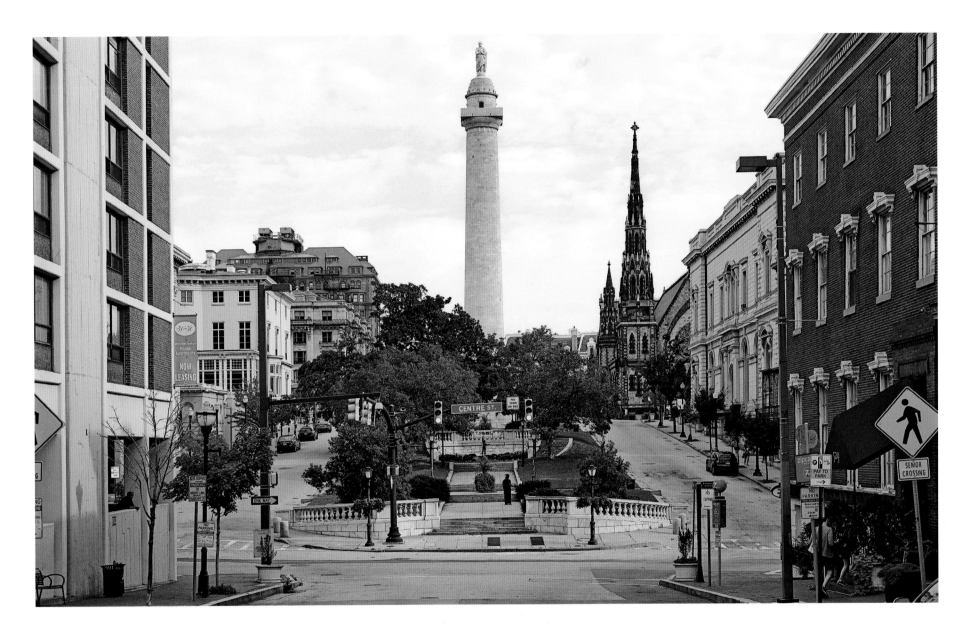

LEFT: Originally planned for the square that would end up with the 1814 Monument, but relocated atop what was then known as Howard's Hill, the Washington Monument would precede its well-known namesake in Washington, D.C. by over forty years. Robert Mills designed the 178-foot tall memorial and his original drawings show a much more ornate creation than the simple Doric column we see today. He even envisioned Washington atop the monument dressed as a Roman warrior in a chariot of victory.

ABOVE: The final design for the statue we see today shows George Washington standing dressed in a Roman toga in the act of handing over his commission as commander in chief. The sixteen-foot marble statue was executed by the Italian sculptor Enrico Causici. The cornerstone was placed in 1815 and the monument was completed in 1829; it would be the first built in the country to honor the first president. The neighborhood is now known as Mount Vernon, after Washington's estate in Virginia.

VIEW WEST FROM WASHINGTON MONUMENT

The 178-foot monument gives unparalleled views over the city

BELOW: Looking west from the top of the Washington Monument around 1903, we can see the theater district of Howard Street standing out at left center, with the rolling hills of the western suburbs stretching west toward the Patapsco River valley. The domed tall structure on the north side of Monument Street originally housed Johns Hopkins University's astronomical observatory.

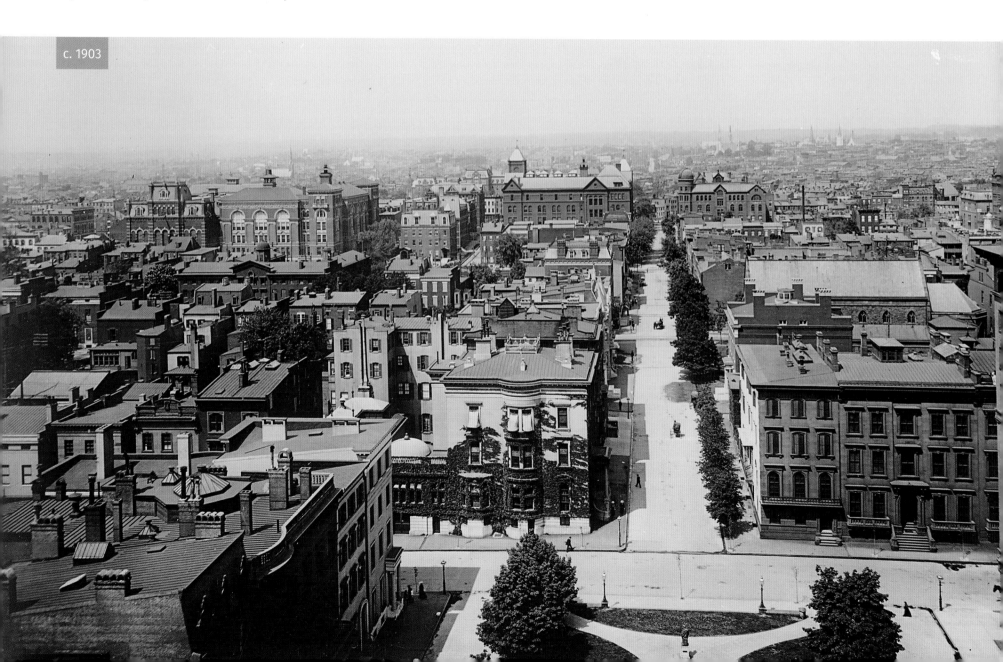

c. 1903

BELOW: The interior of the monument was closed in 1985 for renovation and repair, reopening in 1993 with exhibits on the history of Washington and the Washington Monument. If strength permits, one can climb the 228 marble steps to the top for spectacular views of the city. The red brick building prominent at left center, built as the Mount Vernon Apartments about 1930, is due to open as the Commune Hotel in 2017. The Gothic Revival steeple far right belongs to the First Presbyterian Church, completed in 1875.

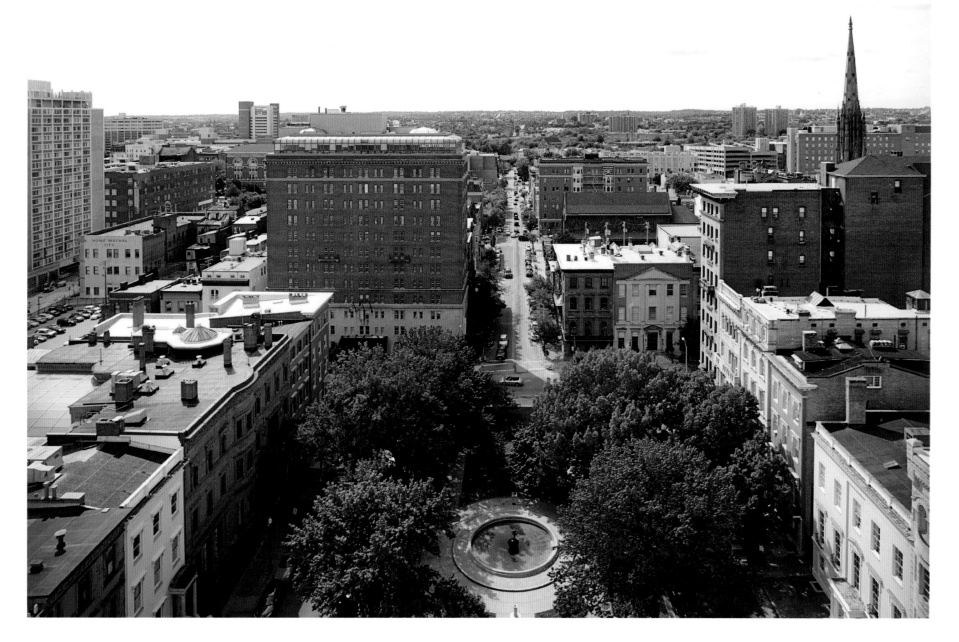

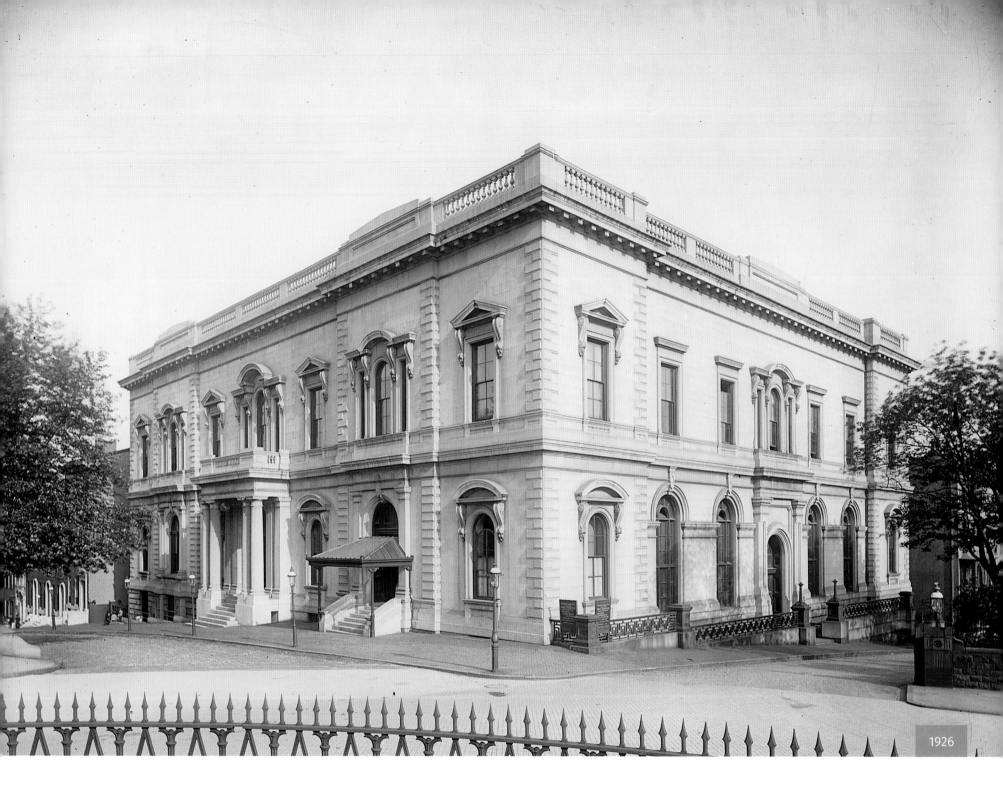

1926

PEABODY INSTITUTE / CONSERVATORY OF MUSIC

The oldest conservatory in the United States

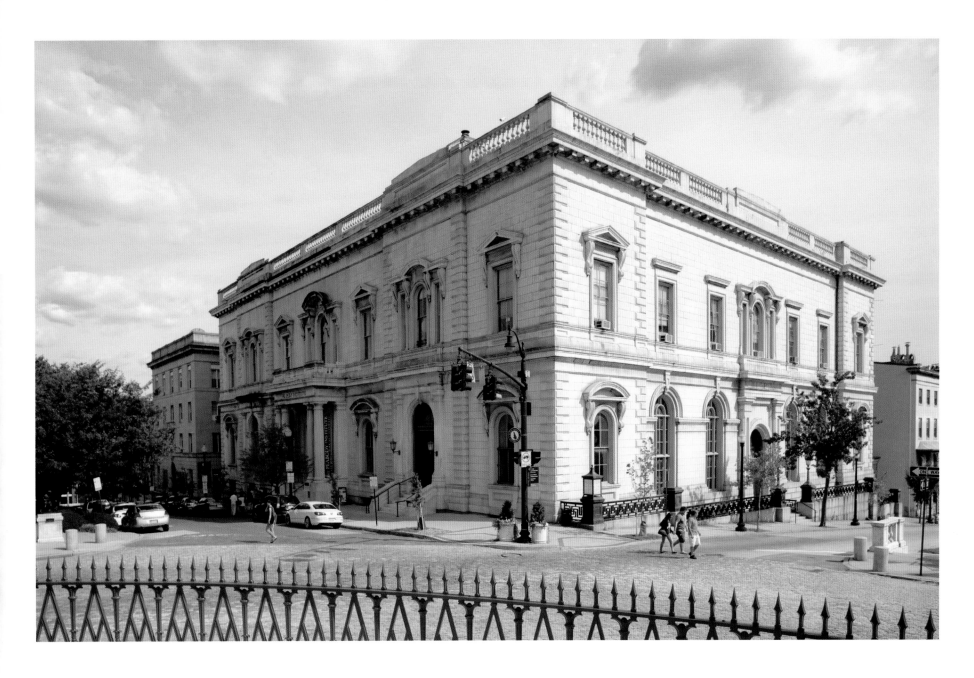

LEFT: Built from 1859 to 1861 to the designs of E. G. Lind, the Peabody Conservatory housed the Peabody Institute, founded in 1857 by George Peabody as a school for the arts. Located on Mount Vernon Square at Charles Street, the library became such a draw for scholars that the location of Johns Hopkins University was reportedly chosen for its proximity to the Peabody Institute.

ABOVE: Today, the Peabody Institute is best known as the Peabody Conservatory of Music (it became an affiliate of Johns Hopkins University in 1977), and turns out many of the world's finest musicians. Through its constituent divisions, the Preparatory and the Conservatory, it trains musicians of every age and at every level, from small children to seasoned professionals.

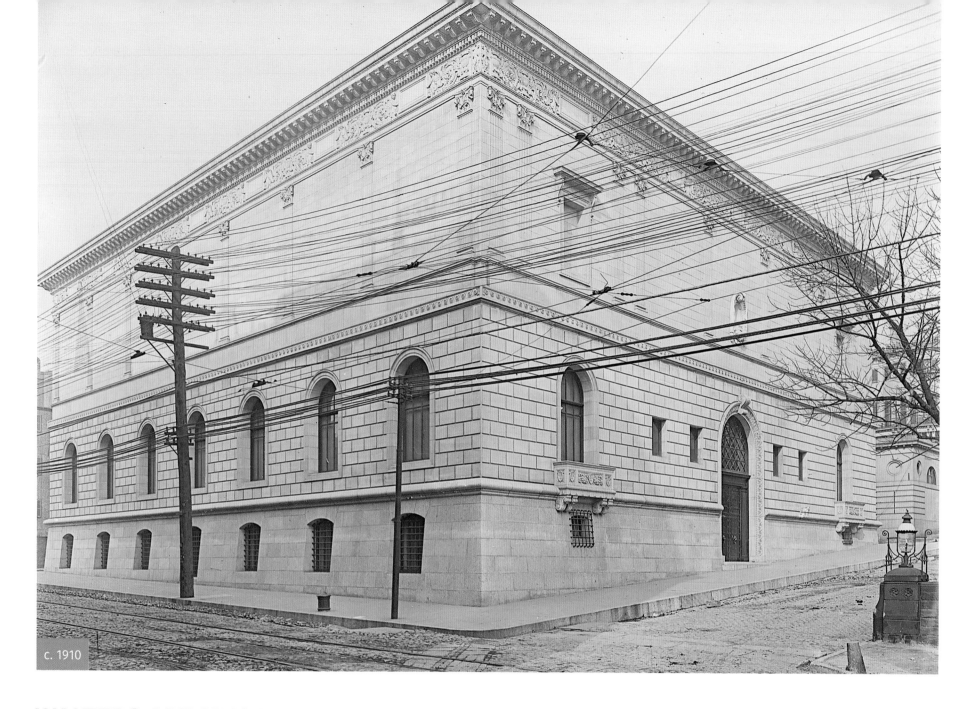

c. 1910

WALTERS ART MUSEUM

Showcasing works of art from the third millennium B.C. to the early twentieth century

ABOVE: Henry Walters, a local business magnate and second-generation art collector, built this Renaissance-style building at the northwest corner of Charles and Centre streets in Mount Vernon to house his own massive art collection. Opened on February 3, 1909, after three years of construction, the Walters Art Gallery was originally a private gallery, opened to the public only on occasion for charity benefit admissions. In this manner, he continued the open-house tradition begun by his father, William Thompson Walters, in 1874.

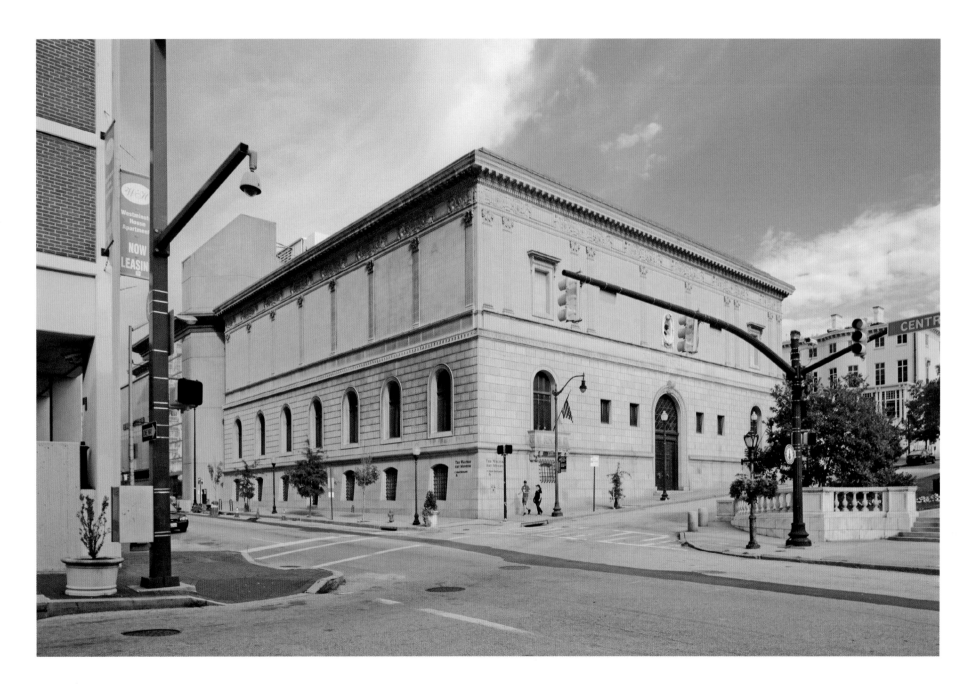

ABOVE: Walters died in 1931, leaving the collection and gallery to the city, and a board of trustees appointed by the city oversaw the transformation from a private collection to a public museum of art. An addition to the original gallery was begun in the late 1960s and opened in 1974; in 1984 the adjacent Hackerman House, built between 1848 and 1850 for Dr. John Hanson Thomas, was donated to the city for addition to the gallery. Now known as the Walters Art Museum, it is regarded as among the finest art collections and museums in the world. Since 2006 the museum has offered free admission all year round.

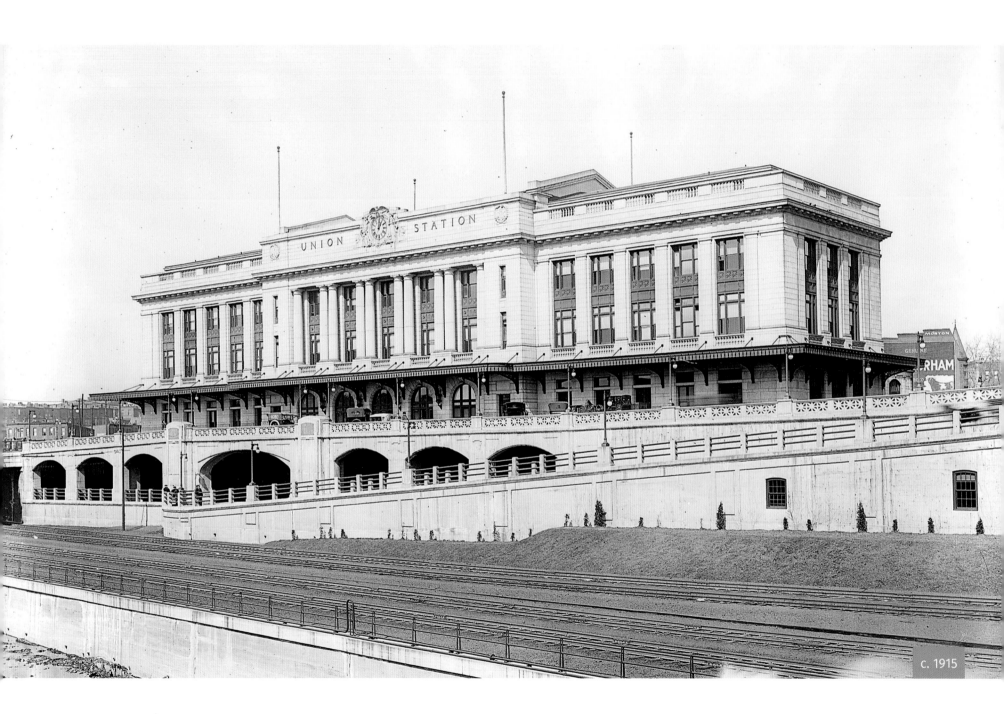

c. 1915

UNION / PENNSYLVANIA STATION
The seventh-busiest rail station in the United States

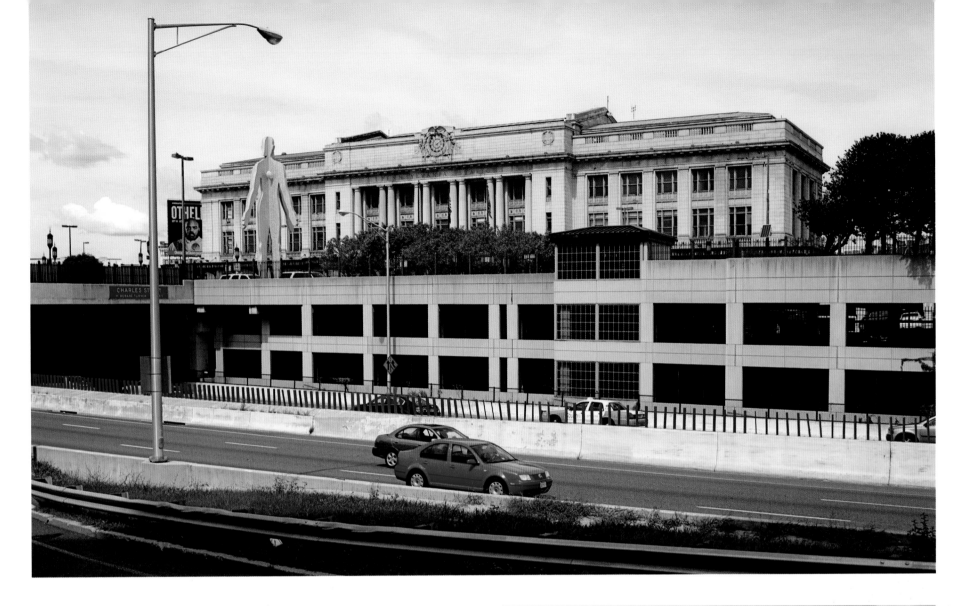

LEFT: Upon completion of two long tunnels to the east and west to form a through route between Philadelphia and Washington, Union Station was opened by the Philadelphia, Wilmington & Baltimore RR (later the Pennsylvania RR) in 1873 between Charles and St. Paul streets. The original wooden structure was replaced by a brick structure in 1885, which was replaced by the present-day Beaux-Arts granite structure, built by the PRR in 1908–1911 and seen here a few years after completion. The Jones Falls river is just visible in the bottom left-hand corner.

ABOVE AND RIGHT: Later renamed Pennsylvania Station after its owning railroad, the station survives today as a busy station in use by Amtrak, Maryland Rail Commuter, and MTA Light Rail trains. The Jones Falls Expressway has covered its namesake waterway, and a parking garage and plaza replace former freight trackage in the foreground. The 51-foot tall *Male/Female* sculpture that greets visitors arriving by train was commissioned as the centerpiece of the station's redesigned plaza in 2004.

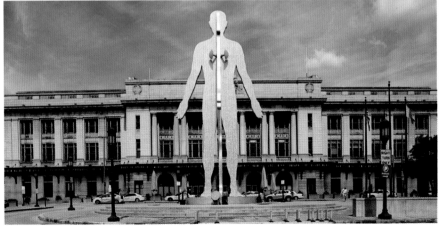

BOLTON STREET AT McMECHEN

The Bolton Hill neighborhood was once home to F. Scott Fitzgerald

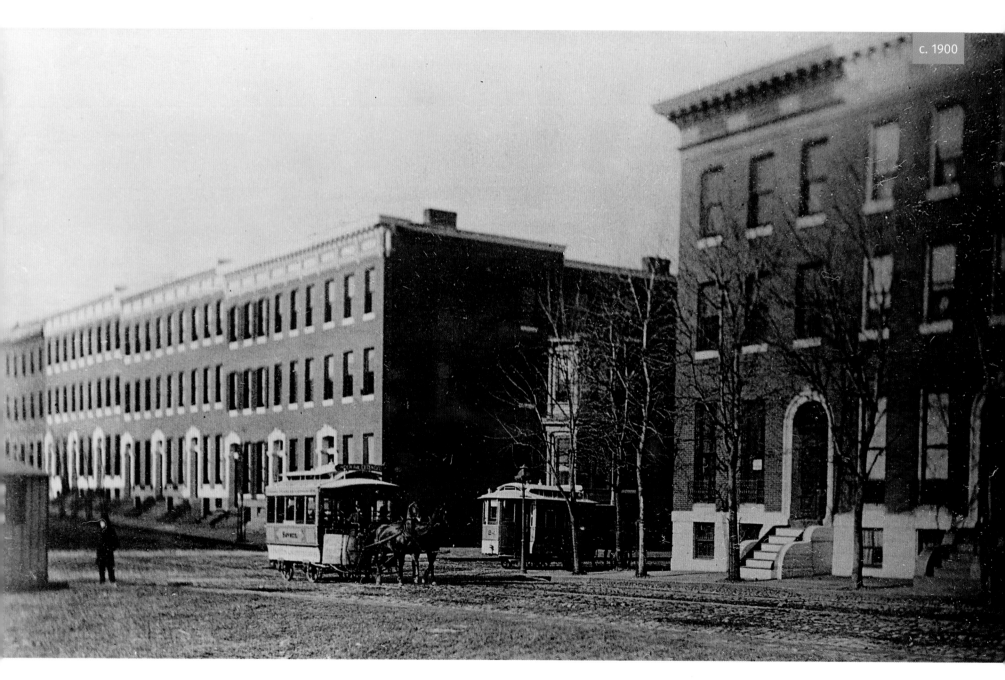

c. 1900

LEFT: The Bolton Hill Historic District, in the northwestern part of the original city, is predominately a residential district laid out in what was originally open farmland. Development began in the 1830s and reached its height in the late nineteenth century with the construction of a horsecar line in 1872 from the neighborhood to the business district. Architecturally, it contains numerous groups of Baltimore's finest two- and three-story town houses, as well as some of its largest mansions.

BELOW: Within the district there are still fine examples of designs from local and nationally known architects. In the early 1900s the neighborhood was home to artists and writers such as Zelda and F. Scott Fitzgerald. Although the neighborhood was listed in the National Register in 1971, the nearby intersection of Linden and McMechen was eradicated by a shopping complex and an apartment high-rise before that designation.

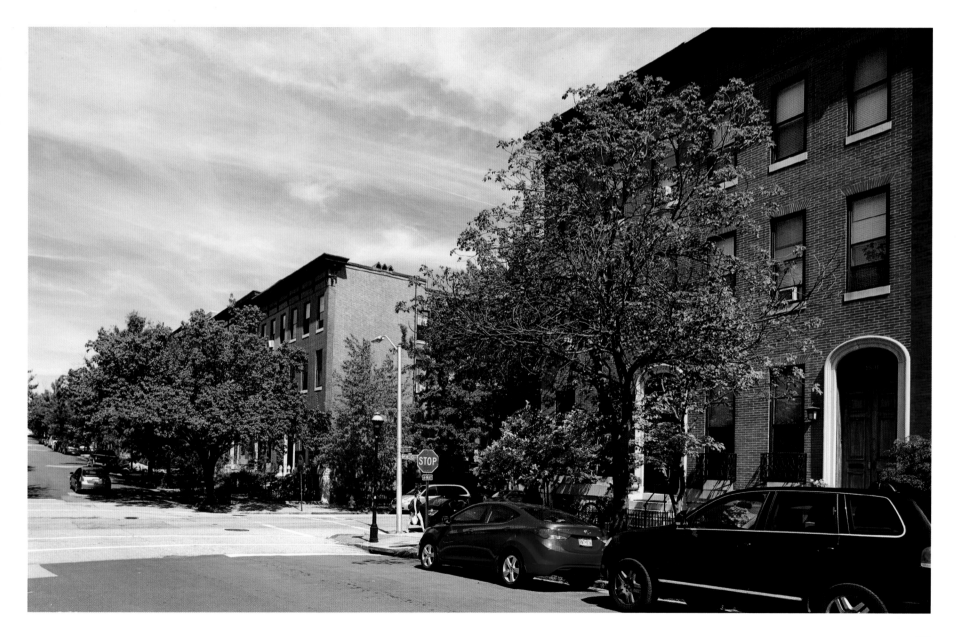

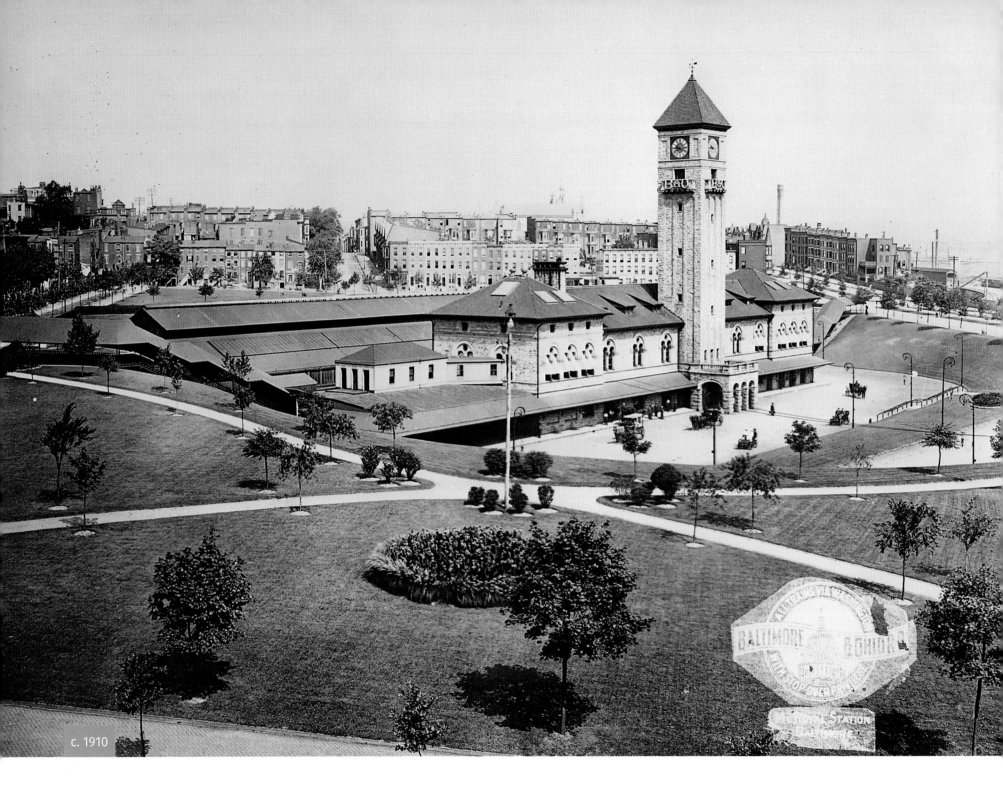

MOUNT ROYAL B&O STATION / MARYLAND INSTITUTE COLLEGE OF ART

The station's 150-foot clock tower is still a Baltimore landmark

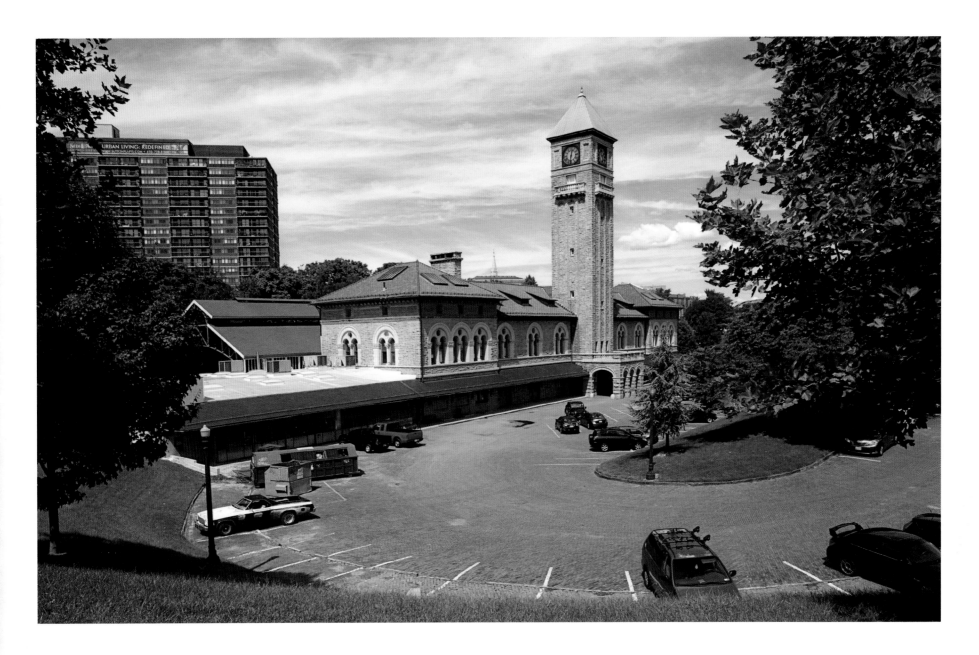

LEFT: Designed by Baltimore architect E. Francis Baldwin, this elegant stone Romanesque-Renaissance station opened in September 1896 as part of the Baltimore Belt Line, a B&O Railroad bypass of central Baltimore. Located at the north end of the tunnel under Howard Street and intended as the B&O's primary intercity passenger station, it remained a high-class facility right through to its closure in April 1961.

ABOVE: Happily for preservationists, the station was sold to the Maryland Institute College of Art, which had relocated from downtown to a then-crowded building a block away from the station. Reopened in 1967, the interior has been heavily rebuilt to accommodate art studios and galleries, but the station and its clock tower remain neighborhood landmarks. Amazingly, the original 1896 trainshed behind the station remains over a still-active freight railroad after the shed's restoration in the 1980s.

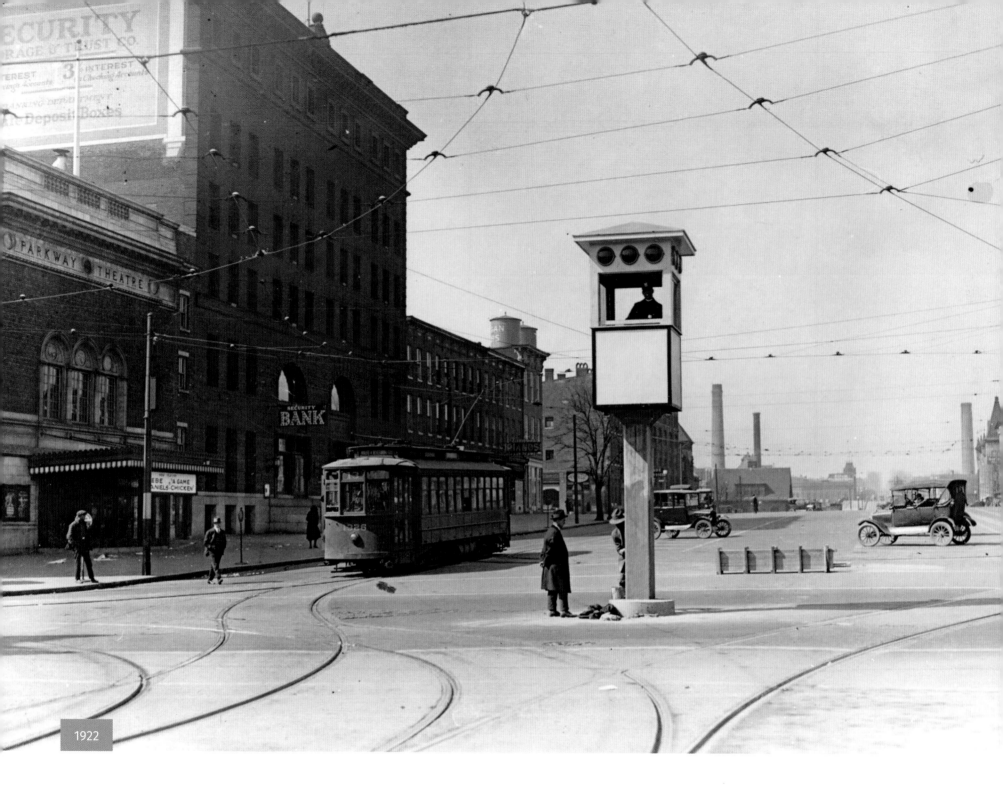

1922

NORTH AVENUE AT CHARLES

Baltimore's first manually operated traffic light was installed here in 1922

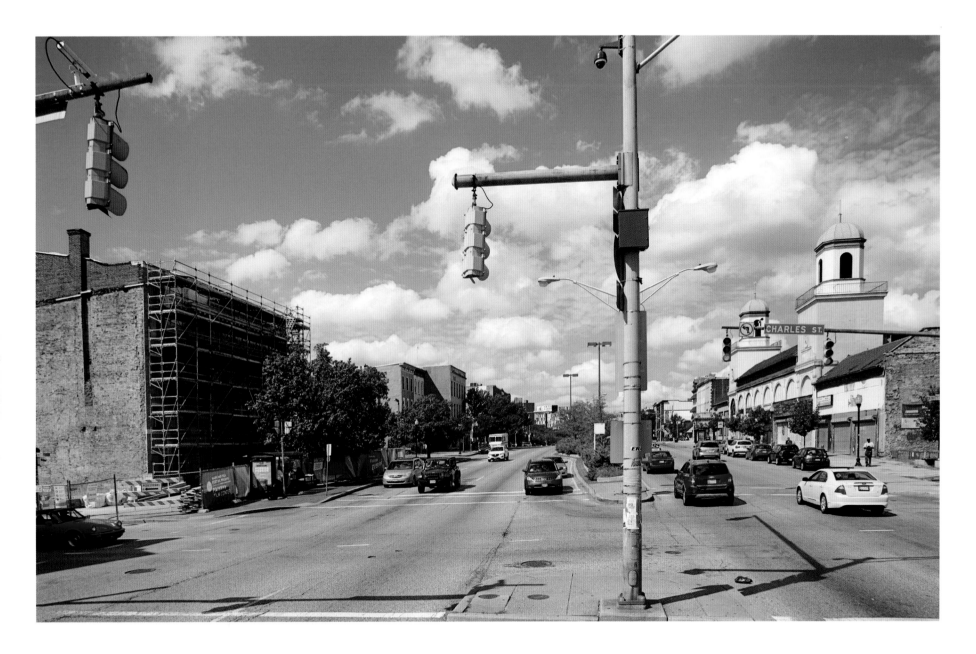

LEFT: North Avenue was originally the northern boundary of the city of Baltimore. It later developed into a major commercial thoroughfare to the north of Pennsylvania Station. At left in this view looking west from Charles Street is the 1,100-seat Parkway Theatre, opened in 1915. Baltimore's first traffic light, manually operated, was installed here in 1922; it was automated in 1928, starting a trend of traffic lights that would become the bane and benefit of motorists since.

ABOVE: North Avenue today psychologically separates the downtown area from the northern stretches of the city. The Parkway Theatre closed in 1978 but is currently being renovated and is due to reopen in 2017. A McDonald's restaurant, hidden behind trees on the left, occupies the middle of the block where the bank and office building stood, and run-down and vacant businesses line the blocks leading to the newer bridge over the Jones Falls Expressway and valley.

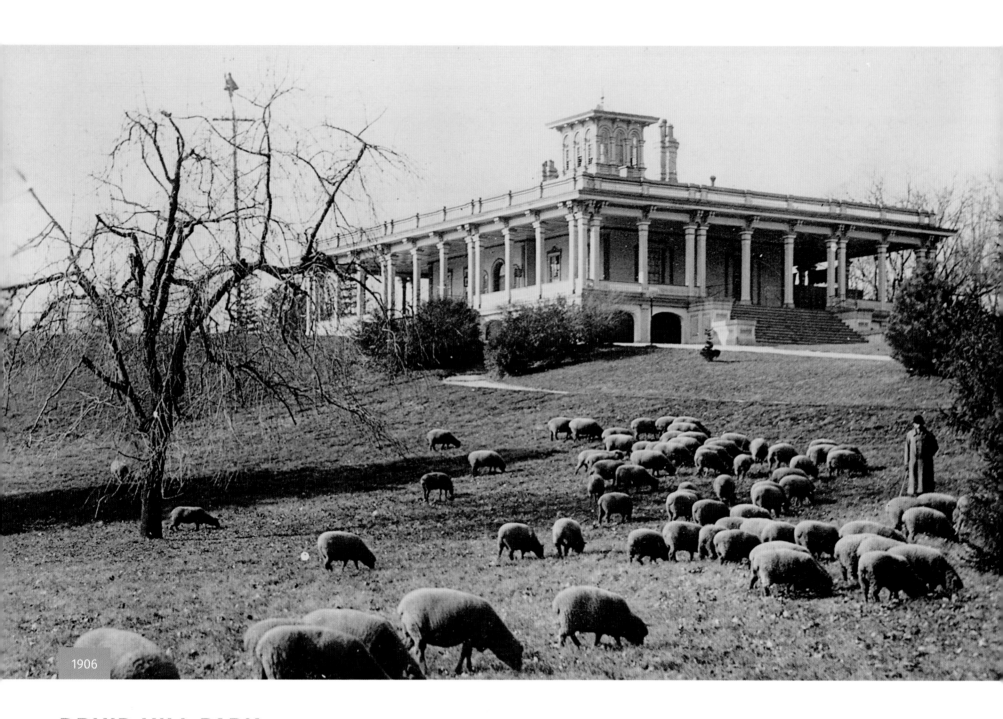

1906

DRUID HILL PARK

The 1815 Mansion House is the focal point of the park

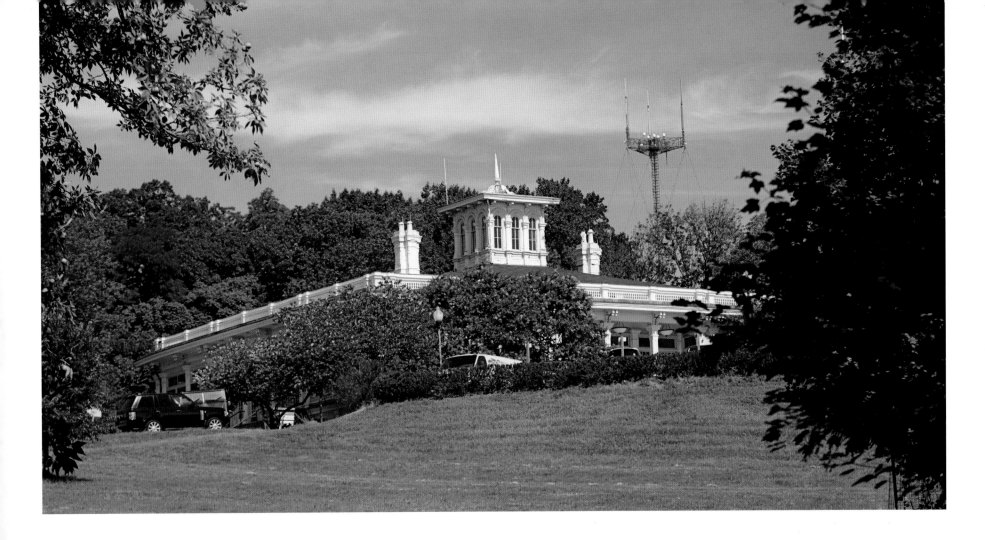

LEFT: Druid Hill Park, listed in the National Register in 1973, represents the vanguard of great urban parks in the United States. In 1860, the Baltimore Park Commission purchased the Druid Hill estate with funds gleaned from a then-unique policy of parkland purchasing with revenues raised through taxation of private mass transit companies. The estate had been laid out in the manner of an English garden, the focal point being the Mansion House, built in 1815 by Nicholas Rogers, and seen here in 1906. It later housed the zoo's bird house and its business offices. Shepherd George McCleary is seen tending a flock of sheep.

ABOVE AND RIGHT: The park today contains miles of carriage, pedestrian, and bridle paths, a lake, and picnic groves. The original designers made every attempt to utilize the natural terrain with minimal intrusion. There are many structures within the park: remaining eighteenth-century constructions associated with the original estate, and those added during the conversion to a public park. The Mansion House, which can now be hired out for weddings and other events, is used as administrative offices for the Baltimore Zoo, which also occupies the park.

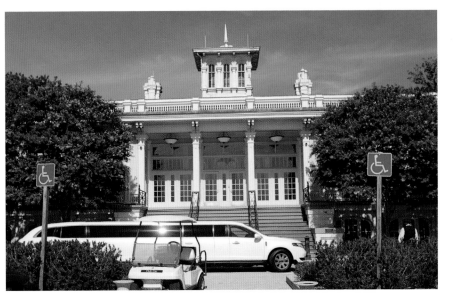

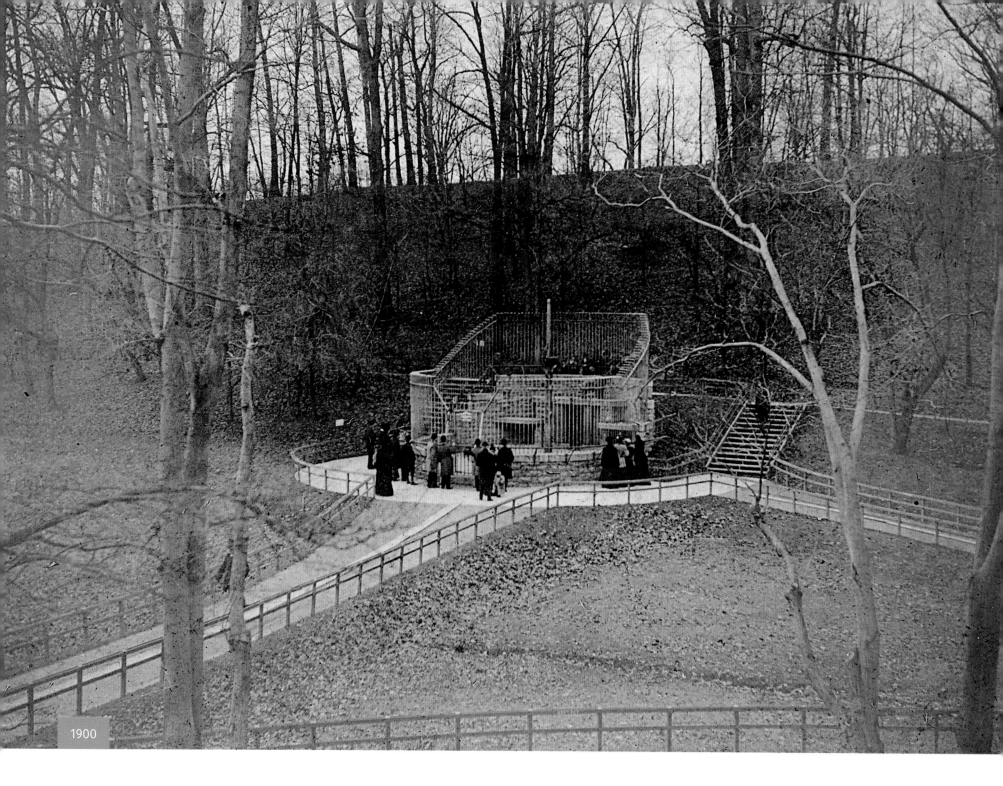

1900

BALTIMORE ZOO

The third oldest zoo in the United States

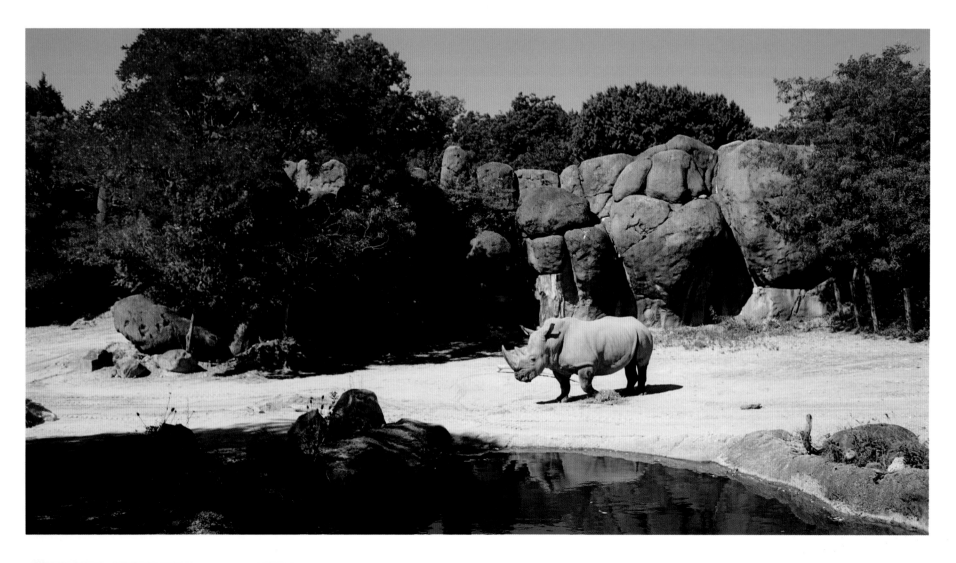

2001

OPPOSITE: Of the many large parks laid out throughout the city, Druid Hill Park would become the largest and most popular. It was created from 515 acres purchased by the city in 1860 from Lloyd Rogers. The Druid Hill Zoo, later named the Baltimore Zoo, was established in 1876 and opened in 1881. Starting as an informal managerie of animals, it later developed into a formal zoological institution.

ABOVE: Now known as the Maryland Zoo in Baltimore, it is the third-oldest zoo in the United States, and houses over 1,500 animals and birds. Such creatures as elephants, peacocks, rhinoceroses, otters, chimpanzees, prairie dogs, and Kodiak bears delight visitors. Breeding programs are in place to protect endangered species as well. The round cage seen in the photos from 1900 and 2001 is in a closed-off section of the zoo that is no longer open to the public.

121

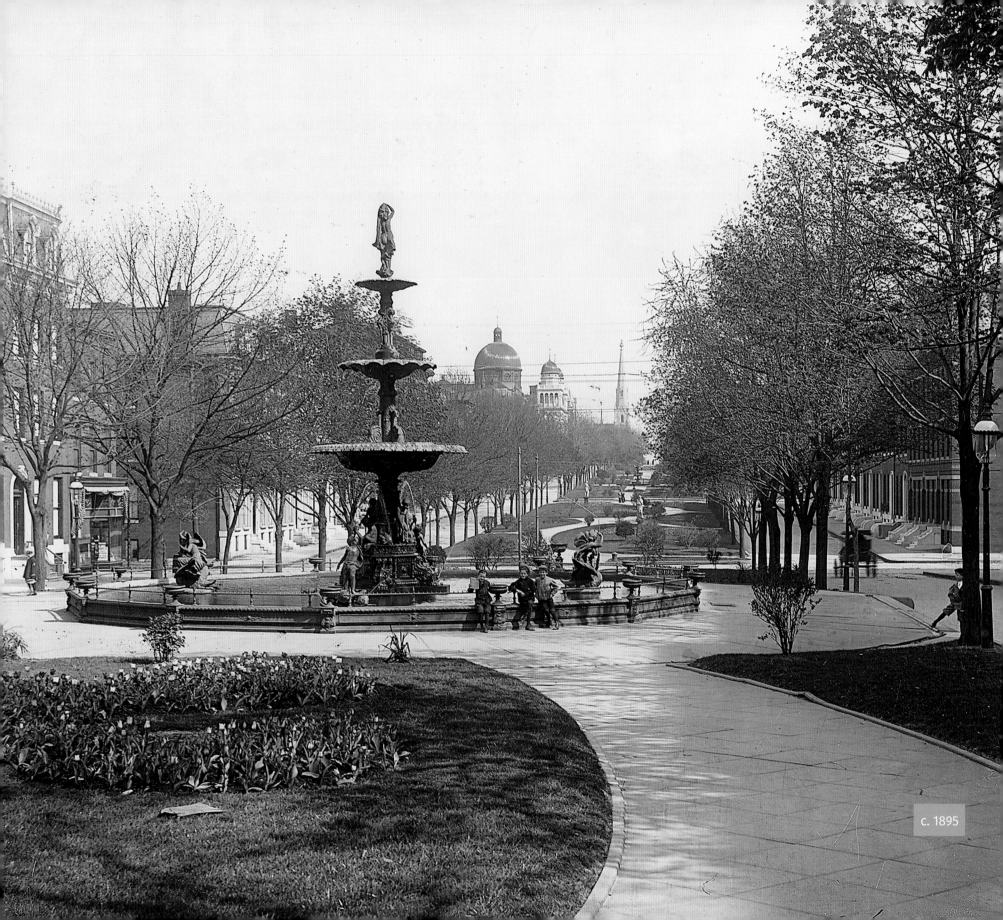

c. 1895

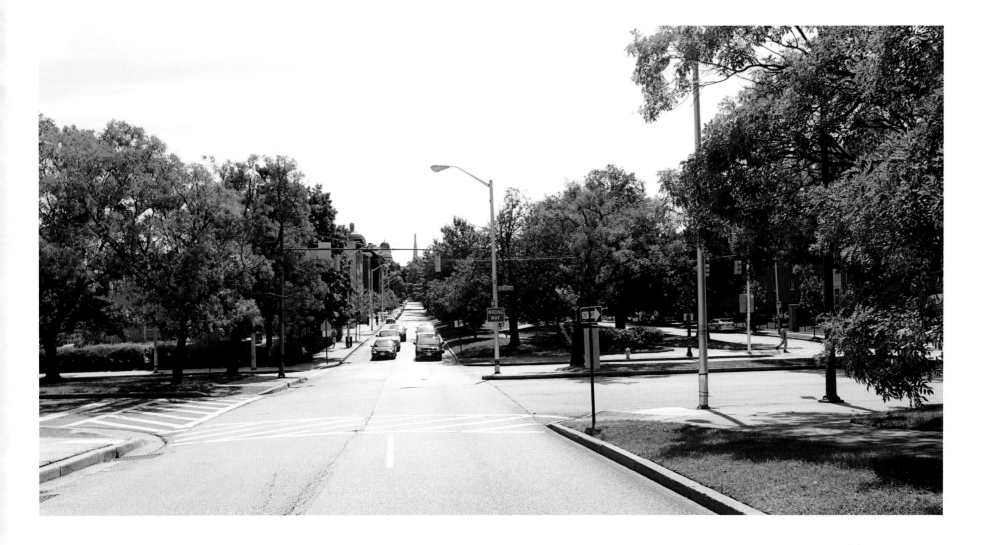

EUTAW PLACE

The shaded boulevard was a gift from Henry Tiffany

LEFT: The northwest part of Baltimore city in the 1880s was a mixture of large estates and streets of row homes. A major feature of the area was Eutaw Place, where a large boulevard with shade trees and statuary extended from Dolphin Street to the northern city line, the gift of Henry Tiffany to the city in 1853. In this view looking south at the intersection of McMechen Street can be seen the dome of the Temple Oheb Shalom synagogue, built in 1891.

ABOVE: Although much of Eutaw Place retains its nineteenth-century charm, the modern view of the same location is dramatically different. More modern buildings have replaced many of the row houses. The fountain in the earlier view collapsed under the weight of ice and snow in 1945, but similarly designed flower pots still dot the median today. Fortunately, the drive also spared a nearby monument to Francis Scott Key. The Temple Oheb Shalom relocated to the Park Heights neighborhood of northwest Baltimore and sold its building to the Maryland Prince Hall Masonic Lodge in 1960.

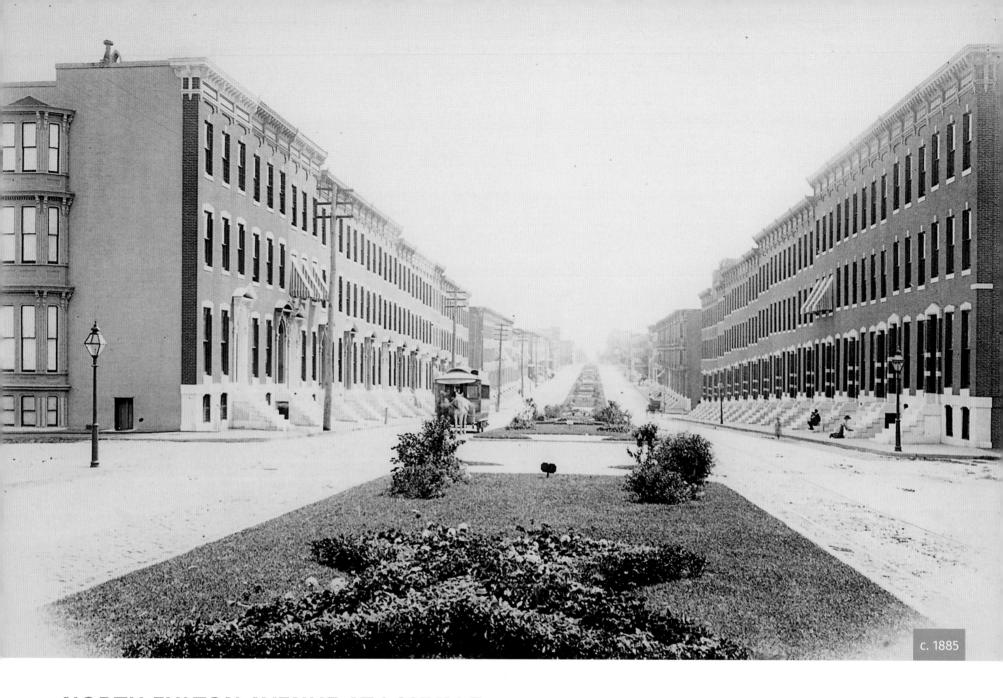

c. 1885

NORTH FULTON AVENUE AT LANVALE

A well-to-do neighborhood in the late nineteenth century

ABOVE: An answer to an expanding and shifting populace, row houses flourished between the Civil War and World War II. They were quickly and efficiently built, provided good returns on developers' investments, and offered affordable housing for hundreds of thousands of blue- and white-collar workers and their families. This view north on Fulton Avenue exemplified the well-to-do neighborhoods of what were the suburbs of 1885. Fulton Avenue's park-like median was laid out around 1875 as the Frick horsecar line was extended into the Sandtown-Winchester district. Note a resident on the right engaged in the still-practiced Baltimore tradition of scrubbing the white marble row-house steps.

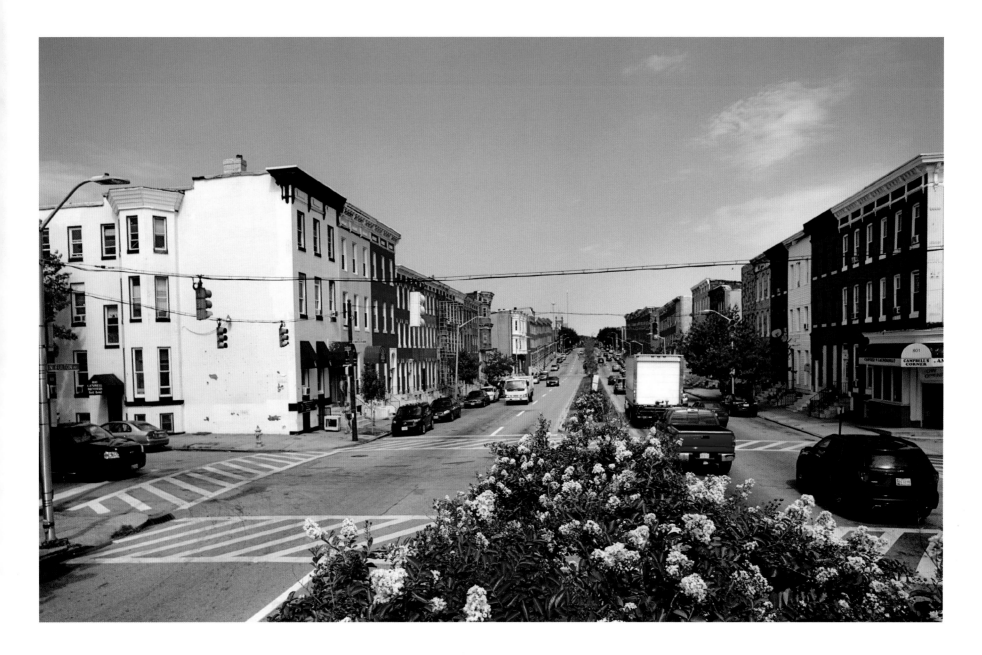

ABOVE: The years have served to give individual buildings their own identities, but as a great many have been converted from single-family houses to multiple-apartment dwellings, the demographics of the area have changed completely. Large swathes of housing in this area are derelict, or have been demolished or abandoned. Although the 900 block of Fulton has been handsomely renovated recently, more than half the buildings in the blocks to either side are vacant and boarded up.

CHARLES STREET NORTH FROM LOMBARD

Only one building in this view survived the fire of 1904

BELOW: The Baltimore fire of February 7–8, 1904, is regarded as the last of the major city fires in America, save for the earthquake-aided burning of San Francisco in 1906. The fire began in a dry-goods store on the south side of German (now Redwood) at Liberty, now today's Civic Center. Aided by flying embers, high winds, and frigid temperatures hampering firefighters, it spread to and gutted virtually the entire downtown district, as far east as the Jones Falls and down to the waterfront. The Washington Monument can be faintly discerned through the smoke in this view looking north on Charles Street shortly after the fire ended.

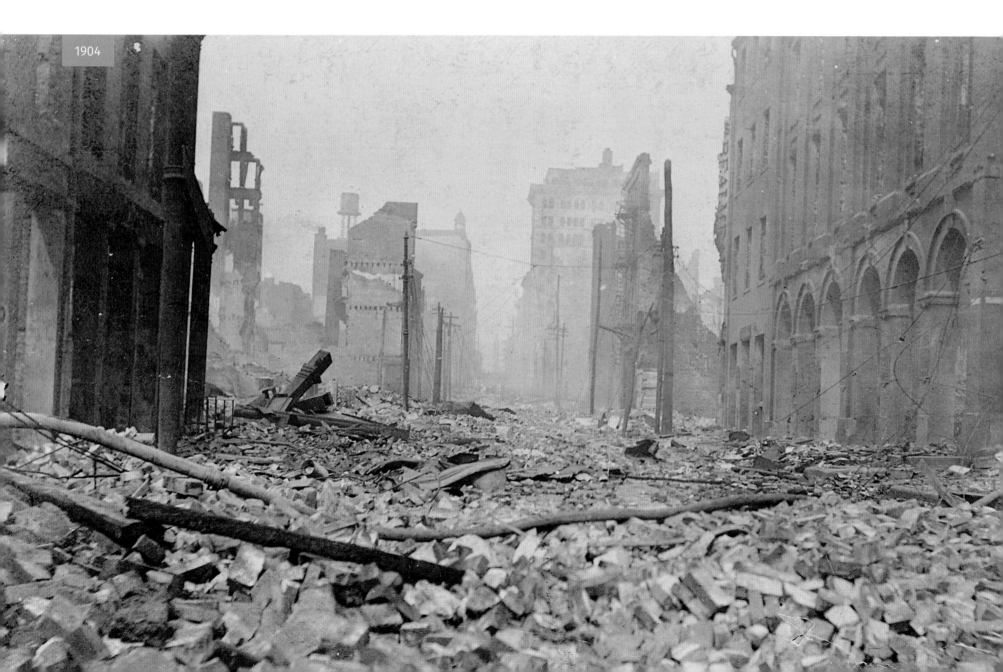

1904

BELOW: Charles Street remains a major economic and traffic thoroughfare today, though one-way northbound. High-rise office buildings surround the location of the original photograph. The only building in this picture to have survived the fire of 1904 is the Jefferson Building, the eleven-story pale brick building further down on the right. Previously known as the Union Trust Building, it was constructed in 1899 on the northeast corner of Charles and Fayette Street.

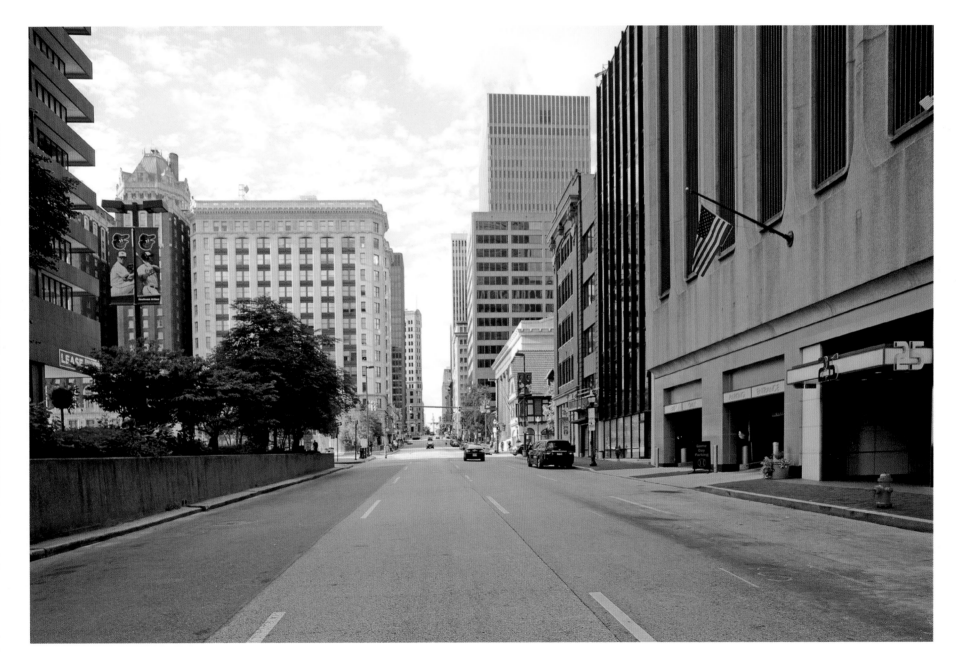

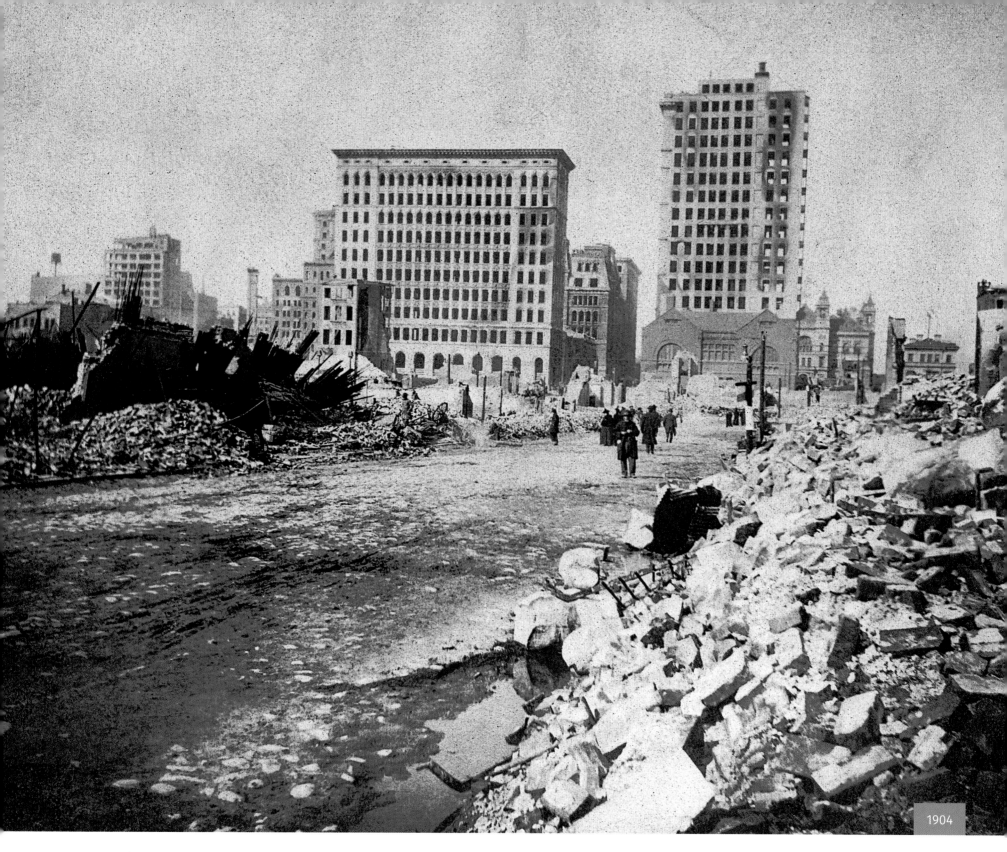

1904

NORTH ON CALVERT

The original Maryland Trust Building anchors these two views

LEFT: This photo dramatically shows the destruction wrought by the 1904 fire. To the rear of this view from the area of what was Franklin Lane and Lombard Street, looking generally north by northwest along Calvert, we see some of the few buildings to survive the fire. The large building left of center is the original Maryland Trust Building of 1900. The tallest building is the Continental Trust Building of 1901, which was called "completely fireproof" when built in 1901, but became a hollow shell after temperatures inside reached an estimated 2,500 degrees Fahrenheit during the height of the inferno.

ABOVE: Two survivors of the 1904 fire are still visible in this view. The original Maryland Trust Building, now the Spring Hill Suites, a ninety-nine-room Marriott Hotel, is on the left. The three top floors of the Continental Trust Building (now called One Calvert Plaza) can be seen top right. The ten-story building in front of it is the Keyser Building, constructed a year after the 1904 fire, it is now part of the RLHC hotel chain. The 1885 Romanesque red-brick Mercantile Trust & Deposit Co. Building, seen in front of the Continental Trust Building in the 1904 photo, was converted into a theatre for the Chesapeake Shakespeare Company in 2016.

ORIOLE PARK

Destroyed by a spectacular eight-alarm fire in 1944

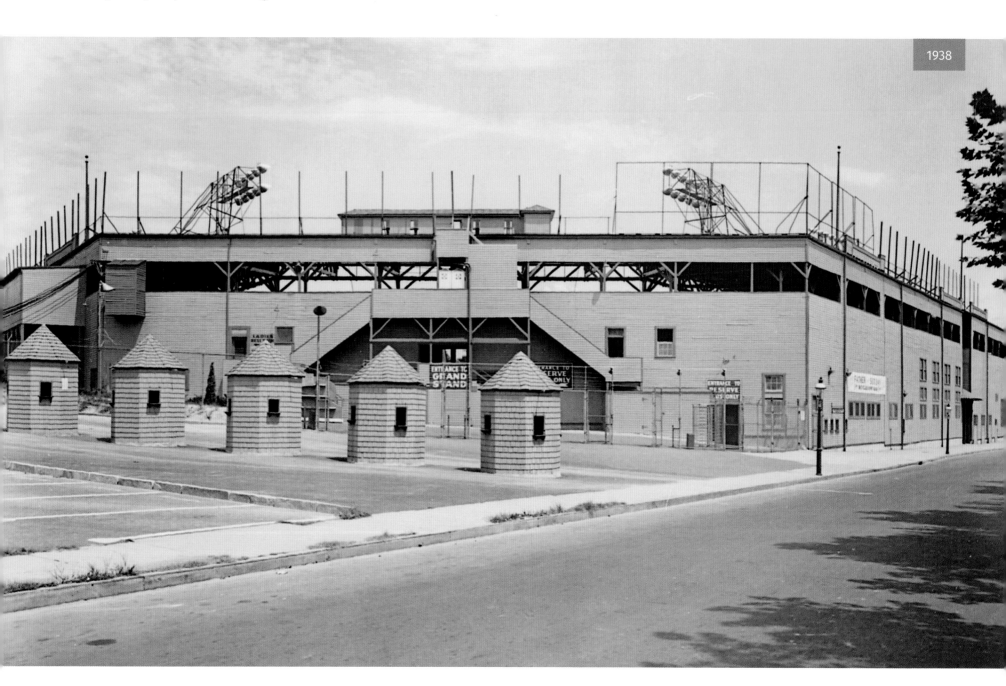

1938

LEFT: Baltimore has had a checkered professional baseball history, alternating between minor and major league teams until the St. Louis Browns moved to town in 1954. Beginning in 1920, this stadium, built in 1916 at the intersection of 29th Street and Greenmount Avenue (west of Greenmount), hosted the International League predecessor team. Seen here in 1938, the stadium perished in a spectacular eight-alarm fire on the morning of July 4, 1944.

BELOW: Much of the records and memorabilia of years of professional baseball in Baltimore also perished in the Oriole Park blaze. After the fire, baseball games took up residence in nearby Municipal Stadium on 33rd Street, built in 1922 and replaced by Memorial Stadium in 1950. Today's professional baseball games are played in Oriole Park at Camden Yards. Memorial Stadium was demolished in 2002 and the site of the old Oriole ballpark is now occupied by an industrial building.

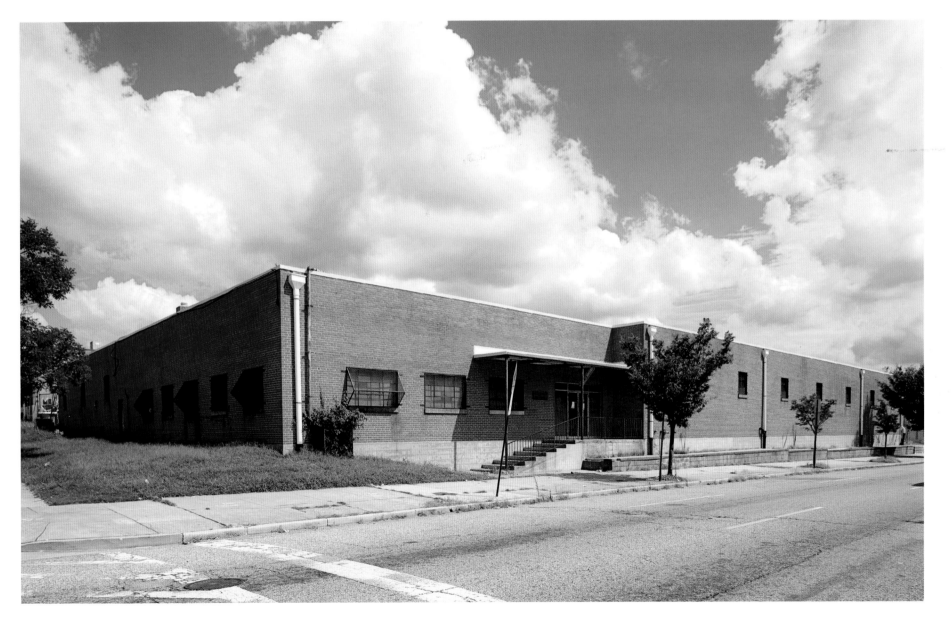

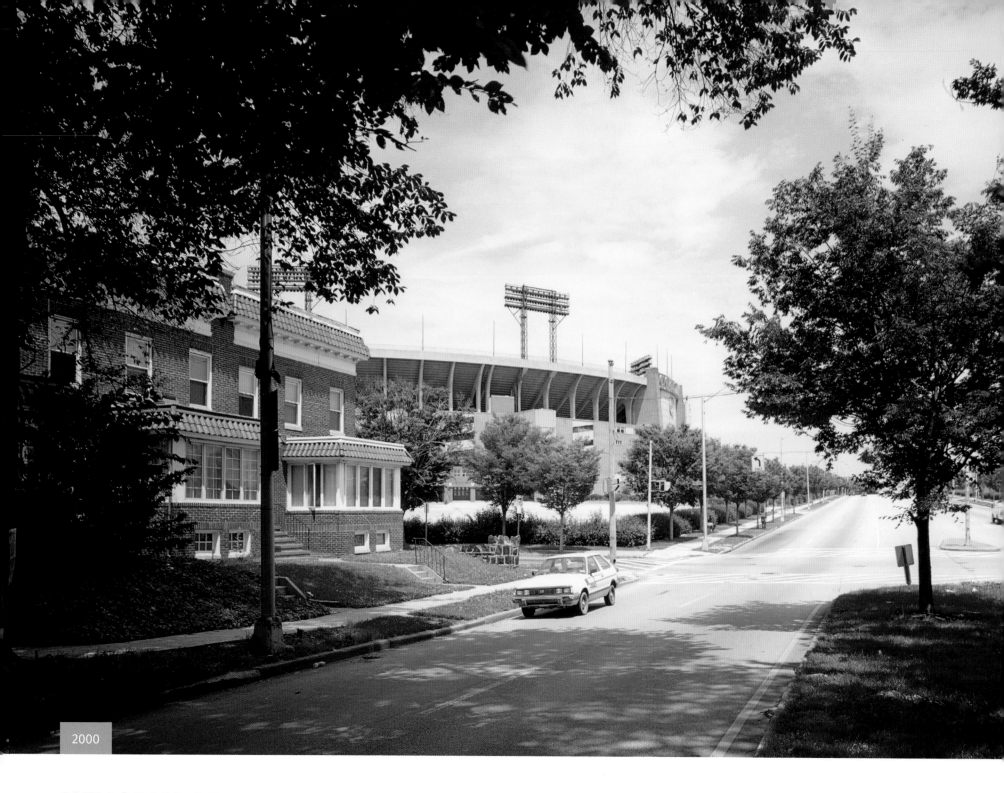

2000

MEMORIAL STADIUM

"The World's Largest Outdoor Insane Asylum"

LEFT: Memorial Stadium, "the grand old lady on 33rd Street," was built between 1950 and 1954 on the site of the former Municipal Stadium of 1922. The new 31,000 capacity stadium was home to the Baltimore Orioles baseball team and the city's NFL team, the Baltimore Colts, as well as being used for college football and Canadian Football League games. It became famous for its rabid Baltimore Colts fans, which earned it the title of "The World's Largest Outdoor Insane Asylum." The stadium remained home to the Baltimore Colts until they moved to Indianapolis in 1984, and to the Baltimore Orioles until they moved downtown to the new Oriole Park at Camden Yards in 1991. "The grand old lady" went on to become home to the Canadian Football League's Baltimore Stallions and then the Baltimore Ravens, the city's new NFL team, but when the Ravens moved to a new stadium adjacent to Camden Yards in 1997, Memorial Stadium was left empty.

ABOVE: After the Ravens' departure, the City of Baltimore received several proposals for reuse of the stadium, including a school recreation ground and a live music venue, but a decision to raze it was made in 2001 and by the following year it was gone. Remnants of the building, including its enormous plaque honoring war veterans, were used to help create an artificial reef in the Chesapeake Bay. The site is now occupied by a housing community for seniors and the Harry & Jeanette Weinberg Family Centre. A recreational sports field, the Cal Ripken Senior Youth Development Field, also opened on the site in 2010.

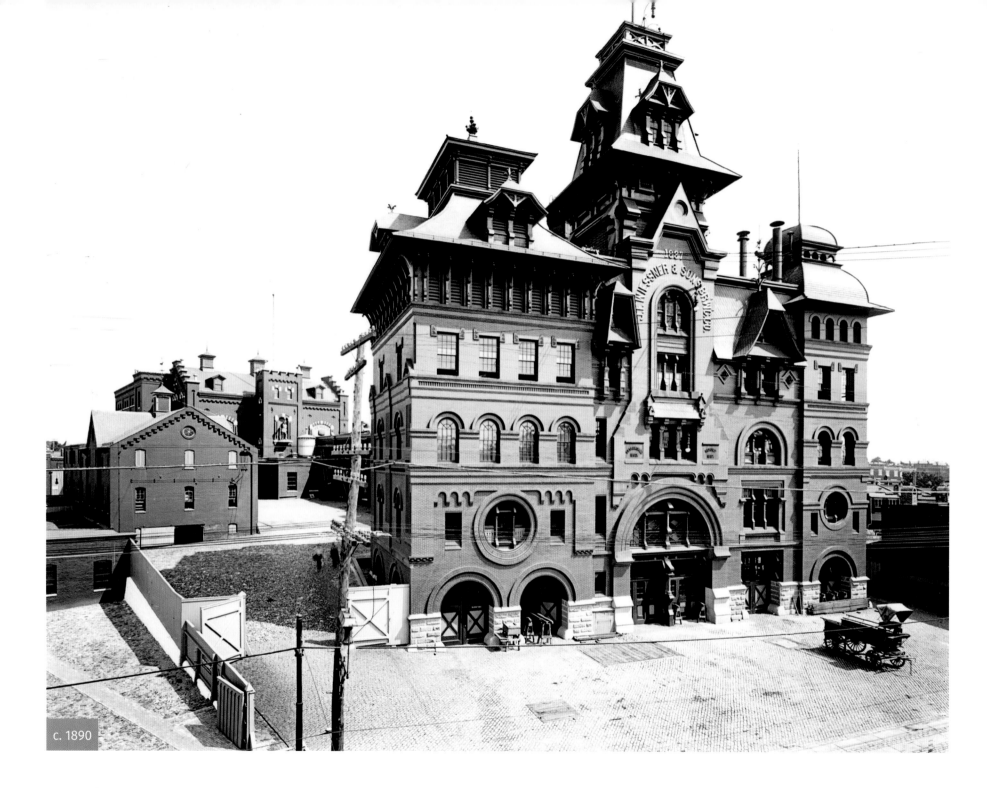

c. 1890

WIESSNER BREWERY BUILDING

An active brewery from 1887 to 1973

LEFT: Well over a hundred breweries have operated in Baltimore since 1742. A brewery was founded on this site, at 1700 North Gay Street, in 1863 by John Frederick Wiessner, a German immigrant. By 1887, Wiessner's brewery had outgrown its original building, and he replaced it with the present five-story structure. The building's height and the organization of its interior spaces were a factor of brewing requirements, but its remarkable exterior expresses late Victorian tastes and the sensibilities of the age in which it was built. The central tower housed a 10,000-bushel grain elevator. Several other breweries were also in the neighborhood at the time.

RIGHT: The brewery produced 110,000 barrels of beer in 1919, but was unsuccessful in riding out Prohibition in the 1920s and was sold to the American Malt Company in 1931. In the mid-1930s a more modern brewing facility was created behind the old facade. After changes in ownership, the Allegheny Beverage Company was the last to occupy the brewery, producing American Beer with the old and new equipment until 1973. Although the property was listed on the National Register of Historic Sites upon its closing, it remained a vacant ruin for decades. Finally, in July 2001, the city announced plans to rehabilitate the structure. The building has now been beautifully restored and serves as the headquarters for Humanim Inc., a nonprofit human services organization. The last large regional brewery in the area, the Heilemann Brewery south of the city, closed in the 1990s; today, the only breweries in Baltimore City are a small number of pub breweries producing craft beer for consumption on-site or locally.

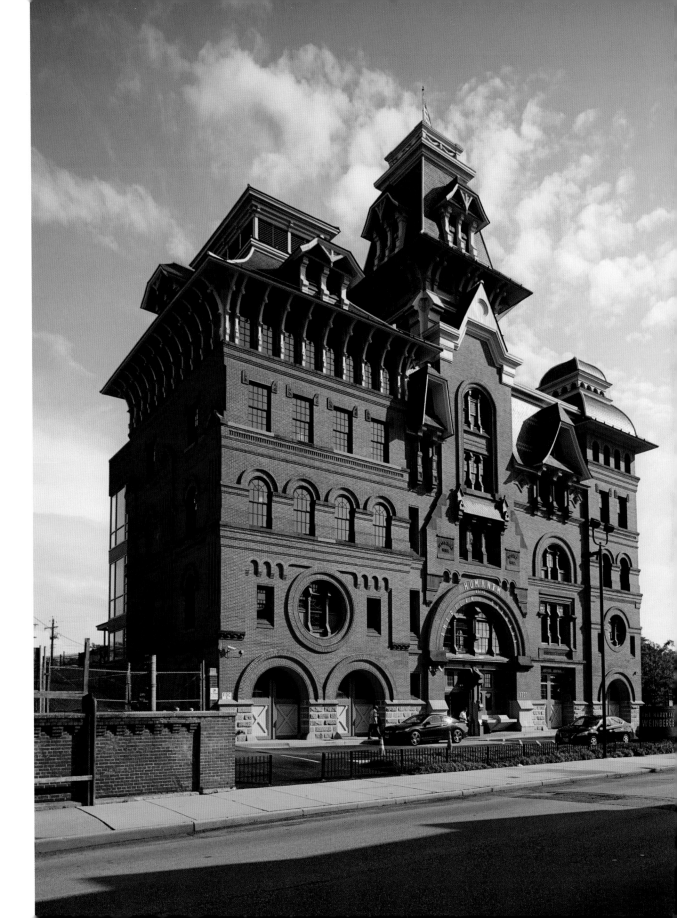

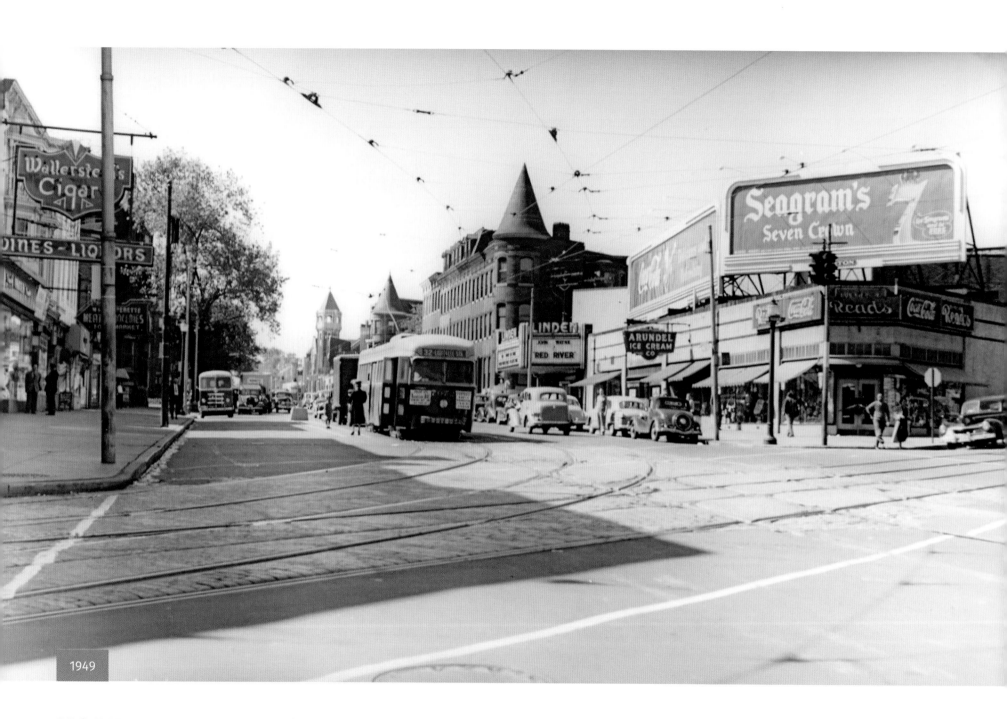

1949

NORTH AVENUE AT LINDEN
Urban renewal transformed this once-bustling area

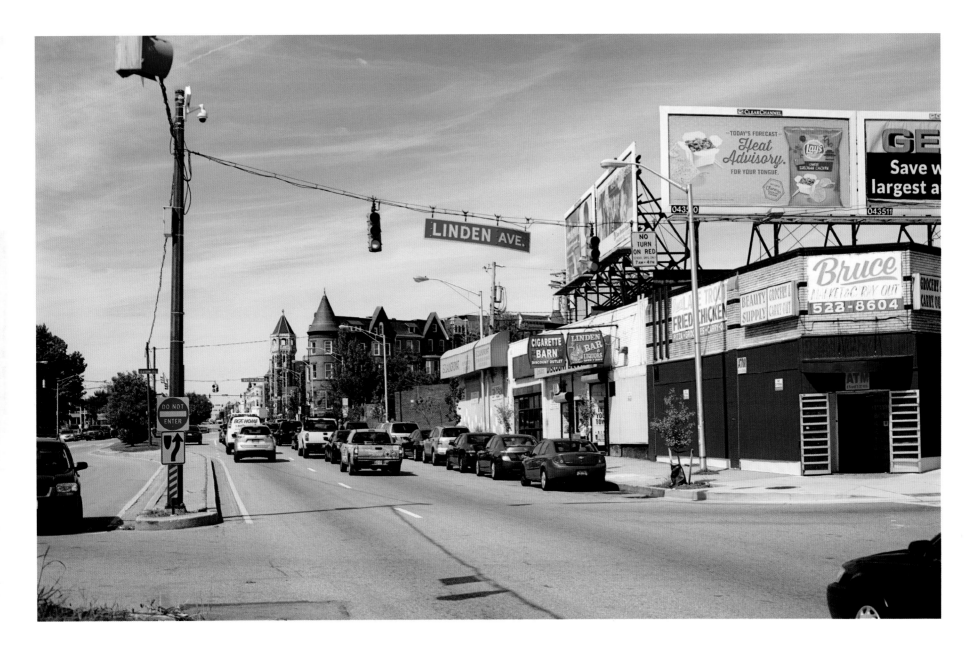

LEFT: North Avenue featured several neighborhoods along its length, each with its own cultural and economic centers. Among them was the intersection of North and Linden avenues, near Bolton Hill and Mount Royal, shown here in September 1949. A PCC-type streetcar is shown inbound on the #13 route in this view looking west. The elaborate tower in the distance belongs to the Babcock Memorial Presbyterian Church on the northwest corner of North and Madison avenues.

ABOVE: Urban renewal would virtually lay waste to this area in later years. Nothing remains of the block to the left in the old photo. The front lobby of the Linden Theater survives, converted to a laundromat; the theater portion is now the laundromat's parking lot. One of the two prominent towered brownstones survives, as does the church, now the Union Temple Congregation, in the distance.

NORTH AVENUE AT WALBROOK

No less than three movie theaters graced this intersection

1951

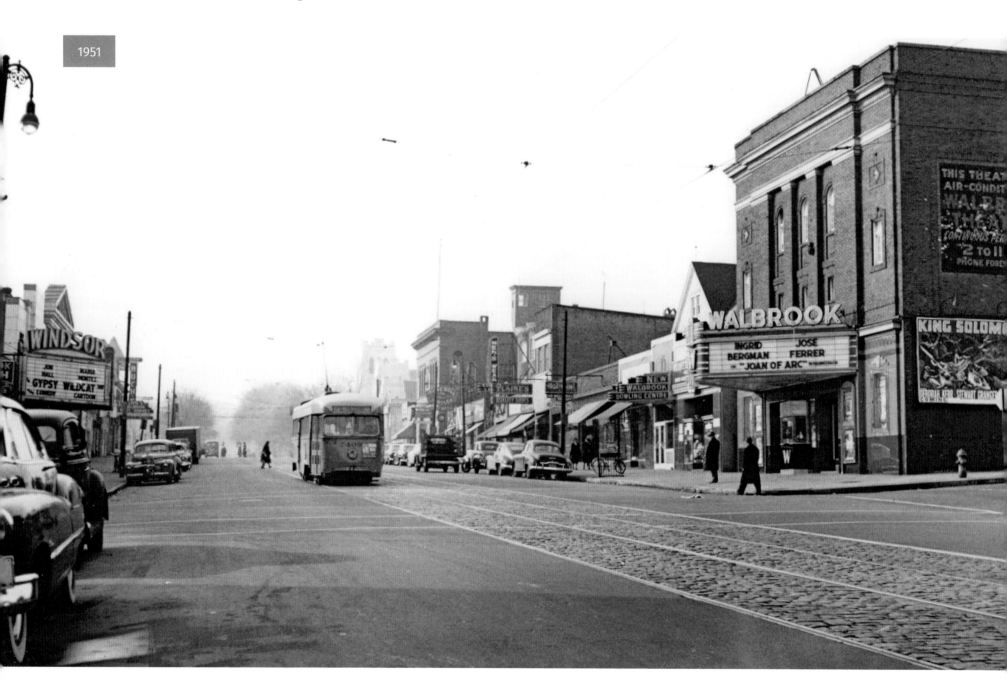

LEFT: Farther west on North Avenue, we see the neighborhood of Walbrook, started as a late nineteenth-century development, which grew rapidly after it became a hub for several streetcar lines reaching from the city to points northwest. On a quiet Sunday afternoon in January 1951, we see another PCC car heading east on North Avenue past no less than three movie theaters: the Walbrook on the right, built in 1916, and the Windsor and the Hilton on the left.

BELOW: The Windsor and the Hilton theaters closed in the 1950s, but the Walbrook would hold out until its closure in 1964. The buildings still stand, but have been converted to other uses—the Windsor is a hair and beauty supply store, the Walbrook, the Highway Church of Christ. There are only a handful of traditional movie theaters left in Baltimore, the rest having been supplanted by suburban multiscreen theaters.

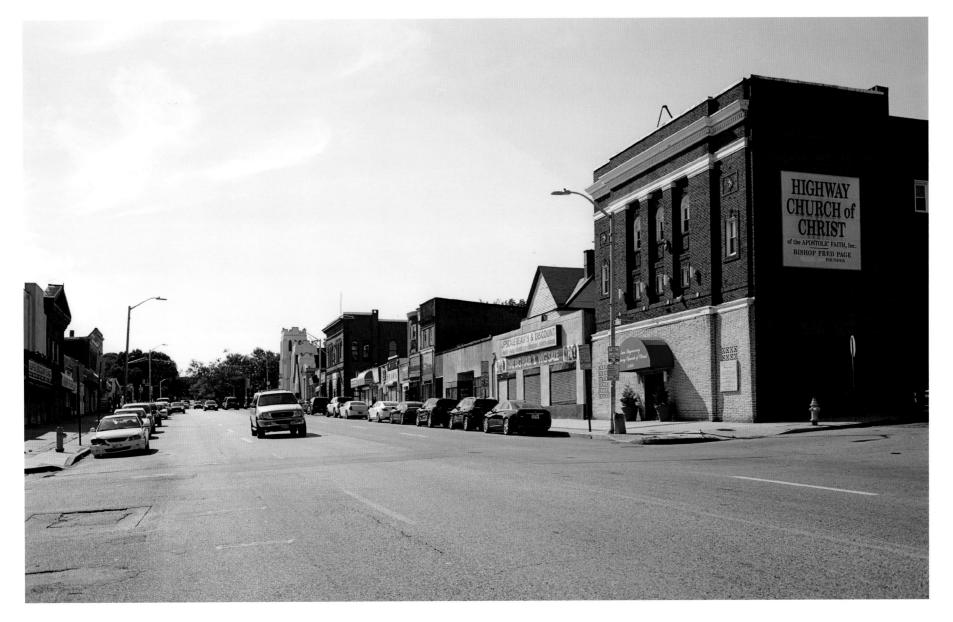

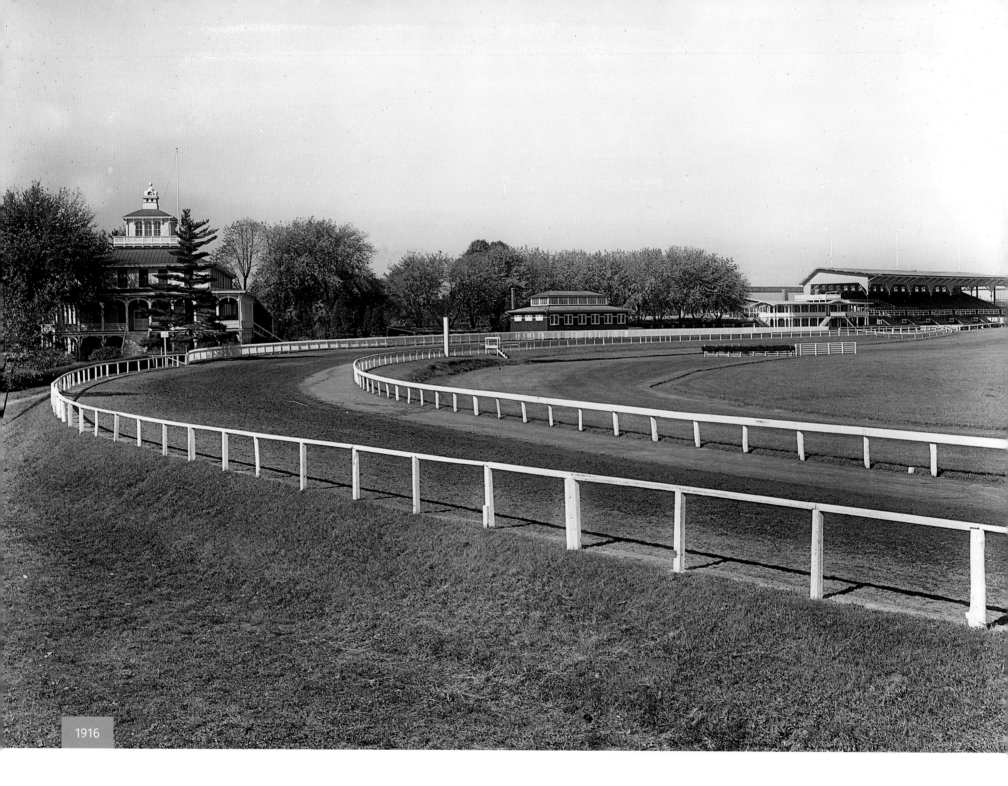

1916

PIMLICO RACETRACK

Home of the Preakness Stakes since 1873

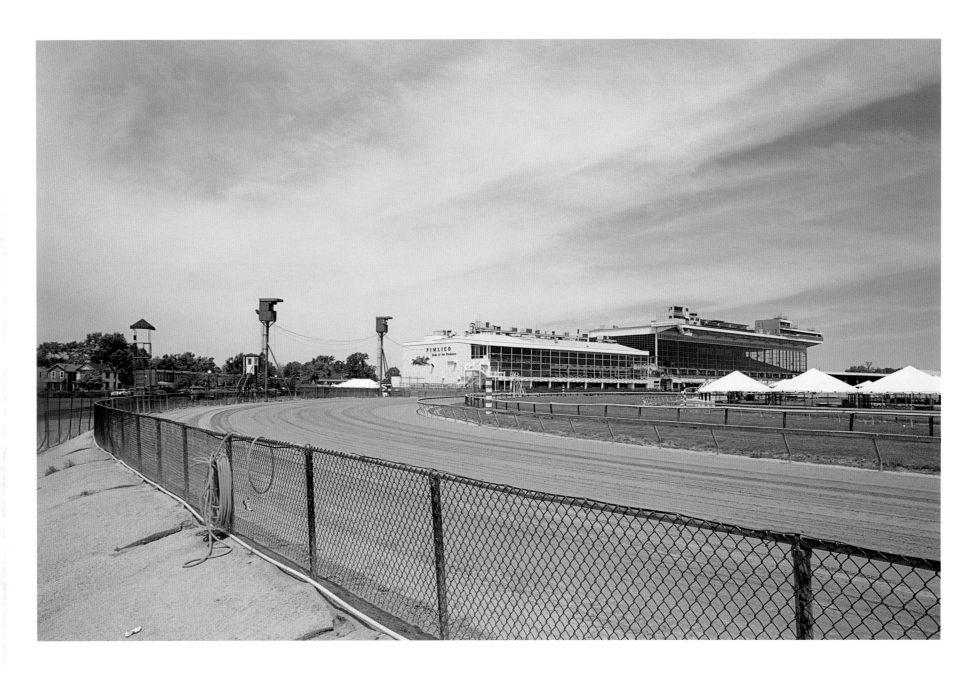

LEFT: Sometimes called "Old Hilltop" for its former midfield mound, Pimlico Racetrack opened in 1870 as a major horse-racing track. The first running of the Preakness Stakes was on May 27, 1873, and the annual race has become part of horse-racing's "Triple Crown." This view from 1916 shows the original clubhouse to the left, with the grandstands to the right.

ABOVE: Built in 1873, the clubhouse, which embodied nineteenth-century gallantry and Southern antebellum charm, would burn to the ground in 1966. Today, Pimlico still hosts horse racing; during the annual Preakness, the infield hosts tens of thousands of revelers. The grandeur and greenery of the earlier photograph's location has been replaced by a parking lot.

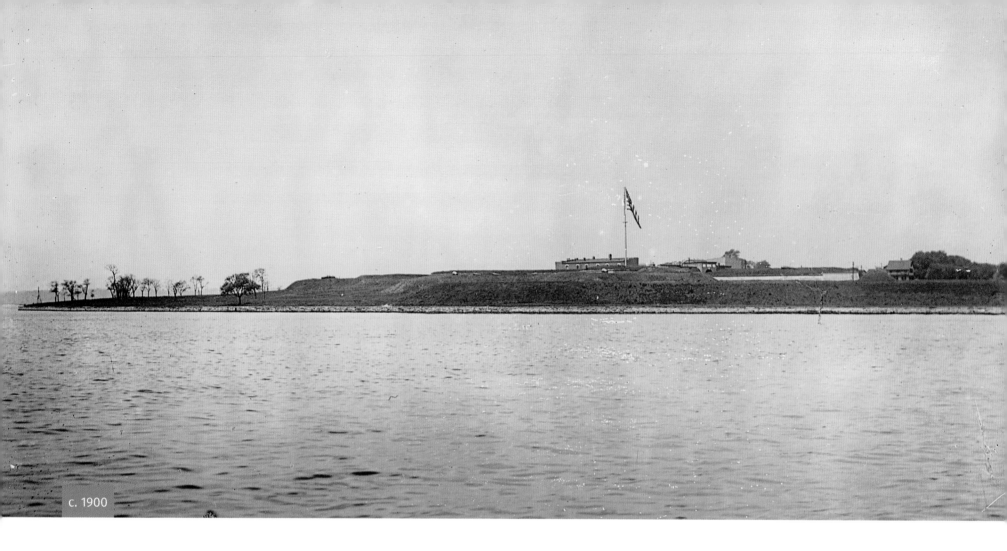

c. 1900

FORT McHENRY

The U.S. national anthem was penned here during the War of 1812

ABOVE AND RIGHT: Fort McHenry, built between 1794 and 1803 to defend Baltimore and its harbor from attack, had its place in history secured by the writing of "The Star-Spangled Banner" by Francis Scott Key. Written during the fort's bombardment in the War of 1812, the song was adopted as the U.S. national anthem in 1931. Following the Battle of Baltimore during the War of 1812, the star-shaped fort never again came under enemy attack. However, it remained an active military post off and on for the next century. The buildings seen are barracks enlarged after the War of 1812; the semicircular building is the powder magazine.

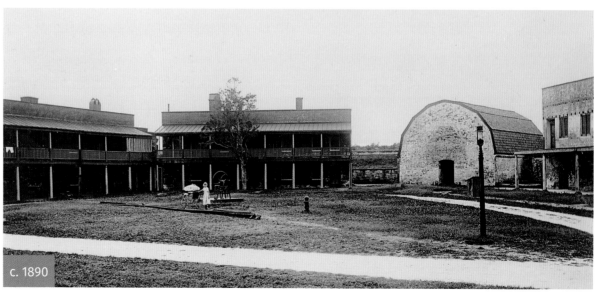

c. 1890

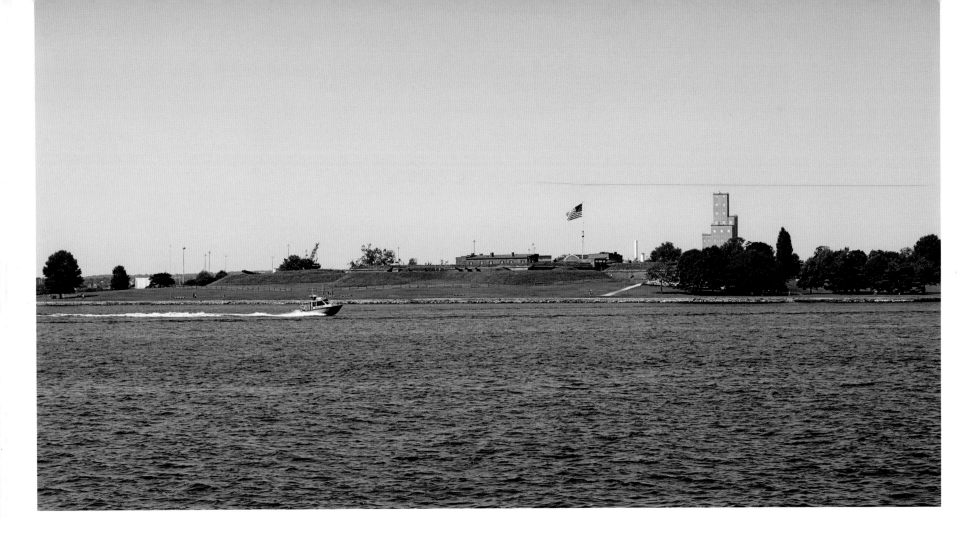

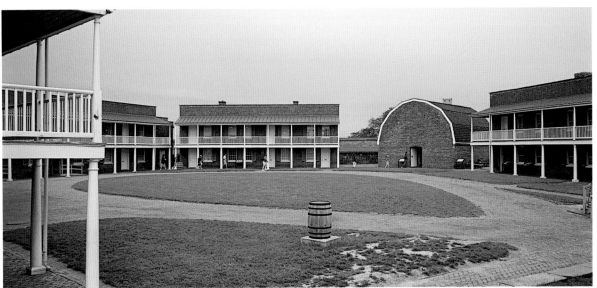

ABOVE AND LEFT: Fort McHenry served as a prison camp for captured Confederate soldiers during the Civil War, and from 1917 until 1923 the surrounding property housed a massive U.S. Army General Hospital to serve returning veterans of World War I. It became an area administered by the National Park Service in 1933, two years after Key's poem became the national anthem. Of all the areas in the National Park System, Fort McHenry is the only one designated a national monument and historic shrine.

INDEX